W9-DHM-655

BK 745.6 S398
CALLIGRAPHY
SCHWANDNER
 1958 .00 FV

3000 014517 30014
St. Louis Community College

745.6 S398 EV.
SCHWANDNER
CALLIGRAPHY
 10.00

WITHDRAWN

Junior College District of St. Louis
Library
4386 Lindell Boulevard
St. Louis 8, Missouri

PRINTED IN U.S.A.

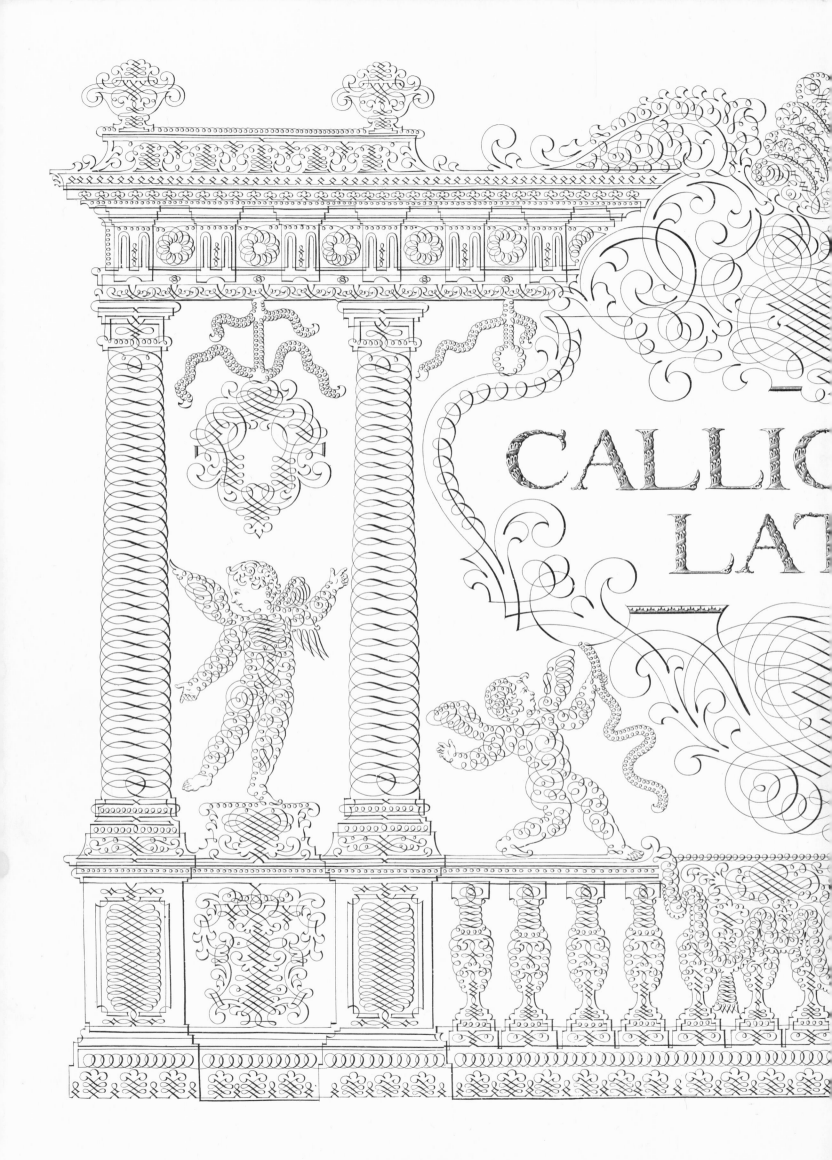

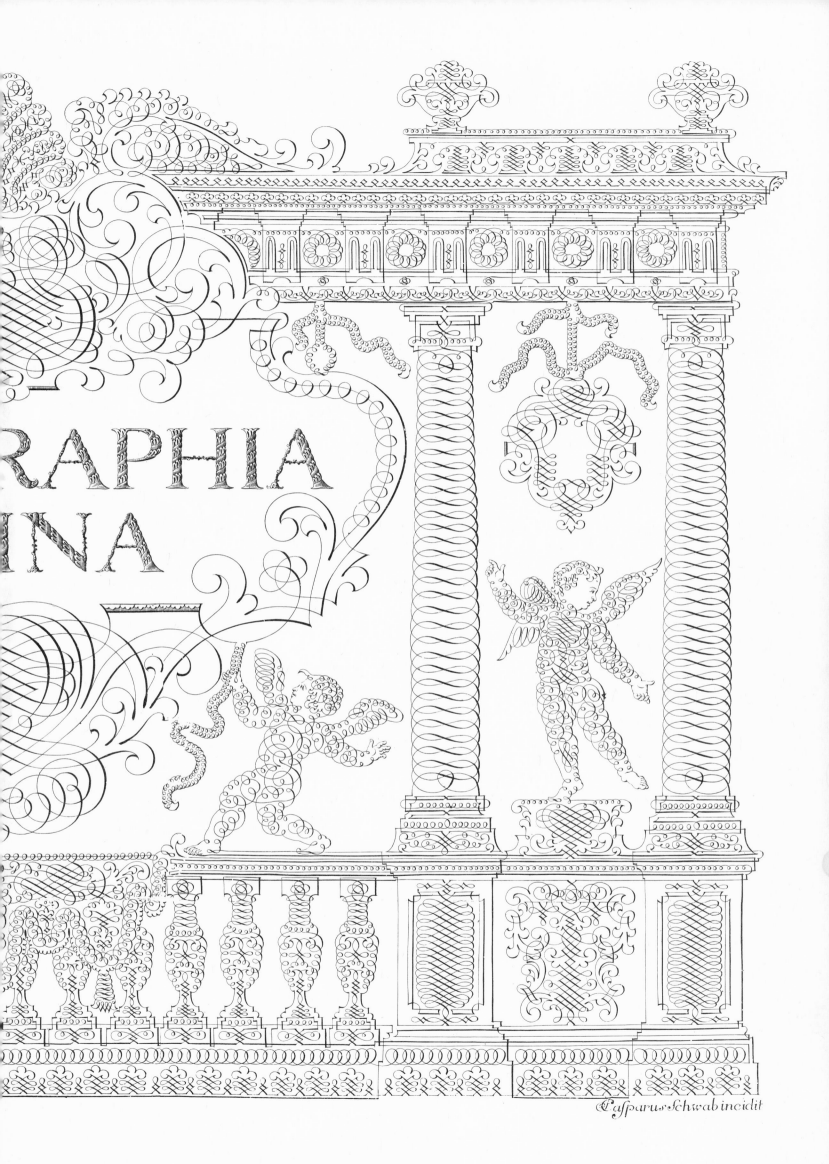

RAPHIA
INA

Casparus Schwab incidit

Calligraphy

Calligraphia Latina

By

Johann Georg Schwandner

Dover Publications, Inc., New York

Copyright © 1958, by Dover Publications, Inc.

All rights reserved under Pan American and
International Copyright Conventions.

Published simultaneously in Canada by
McClelland & Stewart, Ltd.

This new Dover edition first published in 1958, is an
unabridged republication of *Calligraphia Latina* pub-
lished in 1756 with the introduction translated into
the English for the first time by E. F. Bleiler.

The publisher is indebted to Mr. Walter Schatzki of
New York for calling this important work on calli-
graphy to his attention. Mr. Schatzki further informs
us that he has seen an inscribed copy of CALLI-
GRAPHIA LATINA, with a note in the handwriting
of J. G. Schwandner, revealing that the calligraphic
plates were drawn by Ferdinand von Freisleben, and
engraved by J. Kaspar Schwab. J. G. Schwandner
[1716-1791], who wrote the introduction, was Librar-
ian of the Imperial Library at Vienna.

This edition was designed by Geoffrey K. Mawby and
J. Lloyd Dixon. Paper was supplied by the S. D.
Warren Company, Boston, through the Canfield Paper
Company, New York. Lithographed by the Murray
Printing Company of Forge Village, Massachusetts,
binding by Publishers Book Bindery, Inc., New York.

Manufactured in the United States of America.

Dover Publications, Inc.
920 Broadway
New York 10, New York

THE IMPERIAL PRIVILEGE

WE, FRANCIS, CHOSEN BY DIVINE CLEMENCY EMPEROR OF THE ROMANS, AND KING OF GERMANY AND OF JERUSALEM, DUKE OF LORRAINE AND BARROIS, ARCHDUKE OF TUSCANY, PRINCE OF KARLSTADT, MARQUIS OF NOMENY, COUNT OF FALCKENSTEIN, etc. etc.

We recognize and make known to all men by these presents: A distinguished scholar, author of a book titled LATIN CALLIGRAPHY, has presented a humble petition to this effect: that he has had prepared at great cost and labor, for the public good, a book containing many well-cut copper plates; and that he fears lest others, misled by base desire for gain, shall attempt to make ill-use of his liberal labors, and shall attempt — to his enormous injury — to reprint the said work either as a whole or in parts. The said author therefore beseeches Us to protect him, most clemently, by OUR IMPERIAL PRIVILEGE. We have determined to grant his just and humble petition, lest his great labor and expense be deprived of its just fruit by the ill will of his rivals, who may imitate his edition. Therefore, by OUR IMPERIAL AUTHORITY, We firmly command, prohibit, and restrain each and every seller of books, printer, engraver of copper plates, and other persons who deal at all with books or copper plates, and forbid them, FOR A TIME OF TEN YEARS, computed from this day, to reprint, or to permit others to reprint, or to carry elsewhere to be printed, or to sell, or permit to be sold, this above-mentioned book, under this or any other title, as a whole or in part — without obtaining the permission and consent in writing of the forementioned author or his heirs. Should any person venture to despise this declaration and to violate this OUR PRIVILEGE AND INTERDICTION, We decree that he shall be deprived of those falsely printed examples, no matter where (by the power of the said

author or with the aid of a magistrate of the place concerned), and shall be punished by a FINE OF SIX MARKS OF PURE GOLD. This fine shall be divided equally between Our Imperial Treasury and the injured party. This shall hold if OUR PRIVILEGE is printed in each copy of this work or book, and if the customary five copies are deposited in Our Imperial Chancellery. We therefore order each and every subject of the Holy Roman Empire, and Our own faithful followers, both ecclesiastical and secular, of whatever status, rank, dignity, or order — especially those who are magistrates and administer justice either in their own name, or in the place of superiors, or in the name of the law — to permit no one to violate, to spurn, or to transgress upon this OUR IMPERIAL PRIVILEGE with impunity; but, if they discover anyone bold enough to disregard Our bidding, to punish him with the fine We have proscribed, and force him to abandon his unlawful ways — if they would themselves avoid Our gravest indignation and the fine We have mentioned. By the testimony of Our Hand, written below, and by the impression of Our Imperial Seal, these articles are given at Vienna, on the 11th day of the month of April, in the Christian year MDCCLV, in the Xth year of Our Reign.

FRANCIS

Count Colloredo

By Order of His Sacred
Imperial Majesty

Paul Anthony Gundel

To the reader
Johann Georg Schwandner

I

If anyone examines the many varied studies by which a virtuous man maintains the parts of a good citizen or improves society, he will soon learn that the severer disciplines have no monopoly upon mankind: that just as many men are engaged in cultivating the pleasing and elegant arts. And even if there is disagreement about the relative values of natural philosophy or the arts, he will see that everyone agrees upon this point: the truly noble man wishes his labors to bear fruit for others, and the word "honorable" should not be applied to men who have wasted their lives in idleness, but only to those who, for the sake of their fellows, have tried to spread the arts and sciences.

The varied studies which men pursue

II

Among the more elegant of those arts which commend and ornament a man of quality, CALLIGRAPHY—I am sure there will be no dispute — scarcely deserves to be assigned to the lowest place. It is true that CALLIGRAPHY only brings beauty to the eye, rather than swaying the mind, but it should not be despised on that account. Kind reader — suspend what unfavorable opinions you may have, and bear with me for a time. Grant me a few pages so that I can prove to you the honorable associations of CALLIGRAPHY, rather than going immediately to feast your eager eyes upon the plates which follow.

The quality of calligraphy

III

THE ART OF WRITING is ancient, and it arose at the same time as those symbols which we call LETTERS: many scholars have demonstrated this from study of ancient monuments. And the man who could write, or the SCRIBE, was held in high honor by the ancients. According to Sigonio,[1] THE SCRIBAL OFFICE, or the SCRIBATUS, was a position of rank among the ancient Romans, standing only below the tribunes of the treasury. Perhaps this came about because the scribes guarded the public tablets and records for the magistrates, perhaps because the scribes held, so to say, the law in their hands by suggesting laws to the magistrates.[2] The scribes of the Romans were designated in many different ways. Sometimes they took their names from the magistrates before whom they appeared, as QUAESTORS, PRAETORS, or AEDILES, while at other times they were named from the offices which they held: LOGAGRAPHAE, SUBADJUVAE, FORMULARII, CHARTULANII, ACTUARII, EXCEPTORES, SINGULARII, REGENDERII, and many other names, most of which do not admit of an exact rendering in our modern tongues. Nor should the scribes of the PONTIFEX MAXIMUS be slighted; they took preeminence over the others, and were called PONTIFICES MINORES, or minor pontiffs. From their order the supreme power of the Roman Empire fell upon OPILIUS MACRINUS, the predecessor of Eleagabalus, bearing him to the pontificate and other dignities of the imperial power.[3] But we have said enough about the institutions of the Romans. Should the reader wish more details, let him refer to the work of Herman Hugo, S. J., of Brussels (as annotated by the learned Trotz) which supersedes similar works by other men of learning.[4] Here the reader should find ample material to satisfy him.

IV

If we search the remains of other peoples of the ancient world, we learn that at all times the name SCRIBE has been full of honour. Irish canon law, to give an example, metes out the same price for the shed blood of a SCRIBE as for a bishop or a high king. It also inflicted the same punishment upon anyone

bold enough to steal the property of a king, or a bishop, or a SCRIBE — or who unlawfully seized their goods or injured their persons.[5] We also read in the annals of Genoa by Niccolo Guercio[6] that the SCRIBANIA or office of the SCRIBANIUS (or scribe) was a high PALACE OFFICE. And among the Franks, the Chancellor, or cancellarius — an official of the highest dignity, comparable to the logothete[7] among the Byzantines — was called simply the SCRIBA ADJURATUS or the scribe-at-law. Charlemagne had such a scriba adjuratus in Eginhart the Saxon,[8] who, according to the testimony of the most important men of his day, was busied in the affairs of the chancellery.[9] And from the Franks this use has descended down even to our own lands and princes. At the end of the 13th century, to give an example, when Albert the First, Duke of Austria, defended the ancient liberties of the city of Vienna and awarded it new privileges, Magister Otto von Metlich,[10] Cancellarius of the Prince (through whom public letters are issued) assumed no other title than SUPREMUS SCRIBA or Highest Scribe.[11] Even today in the Kingdom of Bohemia and the Marchionate of Moravia, to say nothing of the Archduchy of Austria, there are no more honorable offices than those which retain the ancient title of SCRIBATUS.[12] They are usually conferred upon men of the knightly order, and then only upon those who are highly skilled in the laws and affairs of their land. The reader can thereby see that while other offices of government, like the chancellor, have low origins, the SCRIBE has never been of mean stature. Among the ancient Franks, indeed, the term was applied to high officials, and the SCRIBAE ADJURATI, if they did not lay claim to first place among counsellors,[13] occupied the next best, or at the very least an eminent station. But we have digressed too far, and must return to CALLIGRAPHY.

V

CALLIGRAPHY is a word of Greek root, coming from ΚΑΛΟΣ,[14] beautiful or delightful to look upon, and ΓΡΑΦΩ, I write, I paint. It means nothing other than the art and manner of writing with beauty and grace. For this reason copyists of old, who toiled laboriously to prepare ornate and elaborate decorated manuscripts were often called ΚΑΛΛΙΓΡΑΦΟΙ (in Latin, Calligraphi), and their art CALLIGRAPHY. Both

The nature of calligraphy is opposed to that of tachygraphy

the Greeks and Romans made use of many different kinds of writing, but we have limited and confined this survey to but two ways of writing: CALLIGRAPHY and TACHYGRAPHY, which are, in a sense, opposites. For while CALLIGRAPHY is dedicated to elegance of writing and illuminating, TACHY-GRAPHY, from the Greek **ΤΑΧΥΣ** (rapid, coursing) is devoted to speed. It is used for taking rapid notes, especially in a court of law, and for this reason is sometimes also called the NOTARY HAND. And while the characters drawn in CAL-LIGRAPHY are elegant, with large letters that do not touch their neighbors, TACHYGRAPHY, by a natural adaptation, uses casual, gracile, elongated letters which for speed's sake are joined to one another.

VI

Examples of Greek calligraphy

It is our pleasure to indulge those readers who like exactness, and shall proceed to a few minor points which can only hint at the riches of both these arts. About GREEK CALLIGRAPHY: In the Imperial Library in Vienna[15] there is preserved a remarkable ancient manuscript, the herbal manuscript of Dioscorides, the celebrated physician from Cilicia. The history of this is known to us. It was written under the patronage of JULIANA ANICIA, the daughter of the Western Emperor Anicius Olybrius, some time in the sixth century of the Christian Era. It was written in beautifully executed unaccented large Greek letters, and was ornamented with PICTURES OF PLANTS drawn as naturally as possible, and with other pictures of various sorts, even to a small portrait of JULIANA ANICIA herself. This manuscript was discovered around the year MDLXII by the Imperial Legate Augier de Ghislin, Seigneur de Busbecq, who found it in the possession of a certain Jew of Constantinople. Through the generosity of either FERDINAND THE FIRST or (more probably) MAXIMILIAN THE SECOND it was redeemed for one hundred pieces of gold, and taken to safety in Austria.[16] Other specimens of this sort, that is to say Greek codices in Germany, France, England, and the Low Countries, have been described by two learned anonymous Benedictines of St. Maur in their treatise upon diplomacy which appeared not many years ago in Paris.[17] Whoever desires more information can consult this work at his leisure.

VII

From the Greeks let us proceed to those remains of LATIN CALLIGRAPHY which still survive. We must assign first place to the celebrated PANDECTS, or Digests of ROMAN JURIS-PRUDENCE, whose most ancient manuscript is of uncertain date. When Amalfi was captured by the Pisans in MCXXXV,[18] this manuscript was seized by the Pisans as booty; and when, in turn, the Pisan Republic was overwhelmed by the Florentines in the year MCCCCVI, the Pandects were taken to the Tuscan metropolis. They were considered both a famous trophy of victory and a symbol of the transfer of sovereignty from Pisa to Florence.[19] To this day the manuscript remains in Florence in the CURIA or PUBLIC PALACE of the Republic, which is now called the PALAZZO VECCHIO, where it is carefully guarded with other great treasures.[20] But we must not spend too much time on even this great work, but must mention another surviving work of Latin calligraphy which is almost equal to the Pandects of Justinian and Tribonius in age. This is the splendid CODEX of OROSIUS in the Medici Library in Florence. From this manuscript, which has been adequately praised by Mabillon,[21] the most ingenious Sigebert Haver-kamp, under the patronage of S. Alberto Mazzoleno, borrowed calligraphic specimens as illustrations for his most elaborate edition of Orosius.[22]

Examples of Latin calligraphy in Italy

VIII

It pleases us greatly to be able to mention our own GER-MANY, whose scholars worked just as assiduously and skillfully in Latin calligraphy as the copyists of foreign lands. Our libraries and archives are, so to speak, overflowing with calli-graphic specimens, as witness the ample collections of the Imperial Library of Vienna, and the Guelpherbytana and Saxe-Gotha libraries. The learned Besselius,[23] covering the sacristy and library of the cathedral of Wurzburg, and the monasteries of St. Emmeran, Gottwick, Tegernsee, and St. Peter's of Salz-burg—to say nothing of the regions of Northern Germany—has given the learned world tables of many kinds of Latin cal-

Examples of Latin calligraphy in Germany

ligraphy. Besselius includes works from the Fourth to the Thirteenth Christian Century, and lists so many specimens that no one unless controversial or blind enough to call day night, could accuse us Germans of having neglected calligraphy. Much rarer than calligraphic manuscripts, however, are books and manuscripts written in TACHYGRAPHY. We do not wish to abandon the subject without at least mentioning one specimen, so we will merely cite those two parts of the instrument of sale for the lands and buildings in Rimini, written under the Emperor JUSTIN THE SECOND, at Ravenna in DXXII. This document has been quoted by Filippo del Torre, Bishop of Adria, in his dissertation upon the coin of Annia Faustina.[24]

An instrument which is written in tachygraphy

IX

Calligraphy was cultivated at one time almost solely by monks and priests

We have already called attention to the resourceful investigations of such learned scholars as Hugo and Trotz into the history and craft of calligraphy. We need not wander farther from our subject by giving more detail. Let us add only that the ancient Hebrews, at all times, from the very beginning of writing, cultivated calligraphy extensively and held its practitioners in high esteem. We cannot ignore the members of the monastic orders, however, but must mention their wonderful legacy to us; for the finest manuscripts (of both sacred and profane authors) have been prepared by the zeal of monks of various orders, especially those of the Order of SAINT BENEDICT. Copious testimony for their praiseworthy activity exists. Saint Gregory of Tours[25] says of Saint Aridius—one time minister to the Frankish King Theodobert, later an abbot—"NEVER DID HE YIELD HIMSELF TO SLOTH AND EASE: INSTEAD HE SPENT WHAT HOURS OF FREEDOM HE HAD IN READING, OR IN DOING THE WORK OF CHRIST, OR IN PERFORMING MANUAL TASKS, EVEN TO COPYING MANUSCRIPTS WITH HIS OWN HAND. HE DISTRIBUTED MANUSCRIPTS WHICH HE HAD WRITTEN AMONG THE DIOCESES NEAR HIS SEAT." Ekkehard the Younger, who lived in the days of the Ottos, reports that under Burckhart, Abbot of St. Gallen in Germany, the fingers of the copyists were graced with gold and gems. And Saint Bernard, who lived about the same time,[27] though not a monk copyist, built up a large library of both divines and philosophers. The acts founding the monastery at Murano conclude a listing of the treasures in its library with this exhorta-

tion: "THE PIOUS MAN SHOULD COPY BOOKS AND RENDER THEM MORE PLENTIFUL: HE SHOULD IMPROVE UPON THEIR WRITING, SHOULD ORNA-MENT THEM AND ANNOTATE THEM: FOR THE SPIRITUAL LIFE IS NOTHING WITHOUT BOOKS."[28] Many witnesses testify that in all times monks gained merit by writing error-free and beautiful books, and the good faith of these authors is confirmed by Haeftenius.[29] Lest we seem to neglect our own land, however, let us call attention, first, to that single ancient monastery at Melk, whose BENEDICTINE scribes have enriched our libraries and collections for some six hundred years. The learned Father Martin Kropf has brought their work to light with his usual brilliance, and posterity, as a result, can understand the past glories of these monasteries.[30]

X

One might think that the monks have been given enough credit for their PURSUIT OF CALLIGRAPHY, but who would disagree when we point out that these same monks also preserved the other arts and sciences. During the dark ages these lay long hidden in the monasteries, preserved by the vigilant monks against the ignorance which raged beyond their walls. It is common knowledge that the ancient Germans held exercise of arms in higher esteem than literary studies, while cruel civil wars (especially those among the sons of Louis the Pious) and Norman invasions caused the Latin tongue to become silent; almost all who were connected with its discipline vanished at the same time. Only the clerics and the monks were left, and their professions bound them to cultivate the arts and sciences, which they kept alive by their labors.

Calligraphy is by no means an ignoble art

XI

We have already mentioned briefly how these monks culti-vated, preserved, and in a fortunate hour transmitted to us not only calligraphy, but almost all arts and sciences. But to claim the true, solid glory that lies in the study of CALLIGRAPHY, let us name only one man; no greater or more splendid culti-vator of the arts could be found. We mean the GREAT FOUNDER of the Holy Roman Empire: CAROLUS PIUS FELIX AUGUSTUS, or, as he is more generally known,

How Charlemagne practiced calligraphy

Charles the Great, or Charlemagne. In his youth he devoted much time to studying languages and the arts,[31] and in later years he turned that conquering hand which had overthrown so many enemy armies to forming, in his leisure hours, calligraphic letters.[32]

XII

An explanation of a difficult passage in Eginhart

I hope that none of my readers think me so ignorant as to be unaware that this confused passage from Eginhart's life of Charlemagne is ambiguous and subject to many interpretations by different scholars. But the clear sense of the oldest codex in Vienna[33] and the full weight of the distinguished Lambecius[34] and the most erudite Schminckius[35] uphold my interpretation. Further, it is only sane and reasonable to recognize that Eginhart was speaking not of ordinary writing, but of those very elaborate, beautiful capital letters which are usually painted in decorative fashion; and these are unquestionably within the province of calligraphy. It may also be remembered that Charles on one occasion granted life to the famous calligrapher Paulus Diaconus, even though this Paul the Deacon was in rebellion against him. It also can easily be seen in the same works of Eginhart that Charlemagne was well versed in ordinary writing. In Chapter XXIX, for example, Eginhart tells that CHARLEMAGNE WROTE DOWN the ancient heroic songs, in which the deeds and wars of kings were sung, and then committed them to memory.

XIII

The literary utility of the art of calligraphy

It remains for us to speak about the usefulness of CALLIGRAPHY—not indeed that obvious homely use—but the role that CALLIGRAPHY has played in literature. Even today libraries are resplendent with most elegant and correct manuscripts of CALLIGRAPHY, and these, as has been proved times without number, far outvalue ordinary manuscripts when priced by judicial estimators. And this beauty has caused much ancient literature to be preserved. God knows that we would have lost even more ancient documents if their remarkable beauty had not attracted men who loved them and guarded them. Indeed, even the bare hope for gain has preserved many

manuscripts, and has moved even barbarians to preserve cal-
ligraphic parchments for their great value as booty. We might
also claim that the divine invention of printing received its first
graces and subsidies from CALLIGRAPHERS. This statement
requires no detailed proof.Let me add only a piece of common
knowledge: that the bright unusual capitals in which John
Schoensperger of Nuremberg first printed the great epic about
the Emperor Maximilian the First in MDXVII[36] were cut in
exact imitation of the letters of a noted calligrapher, and
thereby contributed a beautiful font for the printers.

XIV

Even the Turks, who are less kindly to the arts than other *The study of calligraphy as a*
people, and to some extent do not permit books to be printed, *source of honor to all its users*
prize and reward their skilled writers greatly. And the Jews,
dispersed as they are throughout the world, award high praise
to calligraphy and its students. It is thus in no way strange that
in our own land, where a newer and happier rebirth has already
been granted to the Muses, there are many men of high posi-
tion and weighty responsibility who do not consider it beneath
them to devote as much of their leisure as possible to this beau-
tiful, distinguished, and delightful art.

XV

Albert the Third, Archduke of Austria, used to make trifles *Castigation highly deserved by*
upon the lathe, according to report,[37] as a relaxation, while biog- *persons who scoff at the arts*
raphers[38] aver that the Emperor Leopold the Great, the re-
nowned ancestor of the EMPRESS MARIA THERESA, THE
MINERVA of our time, was a musician of no small ability.
Is there anyone foolish enough to reproach such princes who
were great in both war and peace for taking their ease in this
manner? Or is there anyone so insensible and shortsighted as to
criticize Charlemagne's calligraphy without blushing? Yet, as
we once discovered accidentally while reading Leodius,[39] there
were certain ministers, some 250 years ago, who condemned the
arts. When they heard Frederick the Second (the Palatine
Elector) and John, Marquis of Brandenburg, commended for
their skill in music, these men disparaged music and said that
it rendered men effeminate, and was fit only for weaklings.

Charles, the Infante of Spain, later the Emperor Charles the Fifth, wished this argument to be settled, and ordered both parties to play the Infantry Game. It was a sorry day for Munckevall and the other imperial ministers, for they left the field in disgrace, with blackened eyes, swollen lips and cheeks. The beating which they suffered showed that the Germans had not been weakened by the study of music. We, who follow a gentle and quiet muse, do not intend to call out those vile calumniators of calligraphy into the same arena of honor. We know well that they will be banished to the centaurs and lapiths by the decree of persons of quality and accomplishment who follow the arts and sciences. But enough! Farewell, kind reader, and embrace me and all champions of calligraphy in your perennial favour. Written in Vienna, Austria, on the 6th day before the Ides of September, MDCCLV.

<div style="text-align: right">J. Schwandner</div>

Footnotes

[1] Carlo Sigonio, *De antiquo jure civium Romanorum* . . . [Paris, MDLXXIII] Book II, Chapter 9.

[2] Cassiodorus Senator, a contemporary of Theodoric, King of the Ostrogoths, wrote to Deusdedit, Scribe at Ravenna: "The office of the scribe is a trust for all men . . . If everyone present disagrees, you carry the day, since you loose the chains about legal matters. Indisputable testimony, the voice of the ancient charters themselves, when it emerges unchanging from your sanctuary, is accepted reverently by all parties in a dispute, and litigants, even if they are complete rogues, are still constrained to obey it." Cassiodorus Senator, *Magni Aurelij Cassiodori Variarum, Libri XII* [Paris, MDLXXXIX, folio], Letter XXI, p. 276.

[3] Julius Capitolinus, in his life of Opilius Macrinus, in *Historiae augustae scriptores sex* [Paris, MDCIII].

[4] Hermannus Hugo, S. J., *De prima scribendi origine & universe rei literariae antiquitate, cui notas, opusculus de scribis etc. adjecit C. H. Trotzius* [Trotz], [Utrecht, MDCCXXX-VIII].

[5] Edmundus Martene & Ursinus Durand, *Thesaurus novus anecdotorum, complectens regum ac principum aliquorumque virorum illustrium epistolas et diplomata* [Paris, MDCCXXIV-XXXIII], Vol. IV, Col. 6.

[6] Leodovicus Muratori, *Rerum Italicarum scriptores ab anno Aerae Christianae quingentesimo ad millesimum quingentesimum* [Milan, MDCCXXIII-LI], Vol. VI, Col. 541.

[7] Nicetas Acominatus, *Libri VIII de rebus, gestis Manuelis Comneni* [Basel, MDLVII].

[8] There are many manuscripts which bear this title: *Vita & gesta Caroli cognomento Magni, per Eginhardum illius quandoque alumnum atque SCRIBAM ADJURATUM, Germanum, conscripta.*

[9] Joannes Weinckens, *Vir fama super aethera notus Eginhartus, quandam Caroli Magni Cancellarius . . . illustratus et contra quosdam authores vindicatus* [Frankfurt am Main, MDCCXIV, folio], Chapter I, Sections 3 & 4.

[10] Born near Melk, a town in Austria, where there is a celebrated Benedictine monastery.

[11] We must also cite this comment, which is still preserved, in his own hand in the city records of Vienna: "Dieser Brieff ist gegeben ze Wienn mit Maister Otten handt von Metlich unsers Obristen Schreiber, da von Christus Geburt waren tausend Jahr in den sechs und neuntzigsten Jahr. An den ersten Sonntag in der Fasten, als man singt das Ambdt invocabit." [This document is done at Vienna, in the hand of Magister Otto von Metlich, Our Highest Scribe, this being the two hundredth and ninety-sixth year of the second millenium since the Birth of Christ. On the first Sunday in Lent, when the office Invocabit is sung.] Cf. *Memorabilia de Templo et Turri ad S. Stephanum Vienna Austriae* [Vienna, MDCCXXI], p. 55 ff., and *Conspectus Historiae Universitatis Viennensis* [Vienna, MDCCXXII], Part I, p. 3.

[12] In Bohemia and Moravia "Der obristen Landschreiber;" in the Archduchy of Austria, below Enns, "Der Landschreiber."

[13] Weinckens, op. cit. Section 3.

[14] This word, in turn, is derived from ΚΑΛΕΩ "I call," for does not beauty call the eyes of all to it?

[15] No. 3 of the Greek manuscripts in the Medici collection.

[16] Petrus Lambecius, *Commentariorum de Augustissimi Bibliotheca Caesarea Vindobonensi* [Vienna, n.d.] Book II, Chapter VI, pp. 489, 519ff.

[17] [R. P. Tassin and C. F. Toustain], *Nouveau Traité de Diplomatique . . . par deux Religieux Benedictins de la Congregation de S. Maur* [Paris, MDCCL, quarto], Book I, Chapter VI, p. 686.

[18] See Henricus Brencmannius, *Gemina dissertatio, altera de republic Amalphitana, altera de Amalphi a Pisanis direpta* in J. G. Graevius, *Thesaurus antiquitatum et historiorum Italiae* [Netherlands, MDCCXXV], Vol. 9, Pt. 4.

[19] See the dedication to *Digestorum seu Pandectorum libri quinquaginti ex Florentinis Pandecti repraesentati,* edited by Laelius Franciscus Taurellus [Florence, MDLIII].

[20] The precious case or sheath in which the Florentines preserve these Pandects, together with the magnificent wrapper to the manuscript, are fittingly described by Brencmannus in his *Historia Pandectarum* [Utrecht, MDCCXXII], Bk. I, Chapter X, p. 64 ff., where he also reproduces specimens of the calligraphic characters themselves. Also Book II, Chapter II, p. 109 ff., and all of Chapter V.

[21] Jean Mabillon, *De re diplomatica, libri sex* [Paris, MDCLXXXI-MDCCIV], Vol. V, p. 354.

[22] *Pauli Orosii historiarum libri VII*, edited by Sigebert Havercampus. [Leiden, MDCCXXXVIII, quarto], last part of the preface and page 70.

[23] Godefridus Besselius, Abbot of Gottwick, in *Chronici Gotwicensis* [Tegernsee, MDCCXXXII, folio], Vol. I, pp. 34, 36, 37, 39, 43, 46, 47, 50, 52, 61, 62.

[24] Philipus a Turre [Filippo del Torre], *De annis Imperii Marci Aurelii Antonini Elogabali . . . Dissertatio apologetica ad nummum Anniae Faustinae* [Padua, MDCCXLII, quarto], Chapter VIII.

[25] In Gregory of Tours, *Opera omnia*, edited by Thierry Ruinart [Paris, MDCXCIX, folio], Section VI, p. 1287.

[26] Melchior Goldast, *De casibus Monasterii S. Galli*, Chapter XI, in *Rerum Alamannicarum Scriptores aliquot vetusti*, edited by H. C. Senckenburg, [Frankfurt & Leipzig, MDCCXXX], p. 50.

[27] J. J. Mascov, *Commentarii de rebus Imperii Romanó-Germanici a Conrado Primo usque ad obitum Henrici Tertii* [Leipzig, MDCCXLI], p. 106.

[28] Marquardus Herrgott, *Genealogia diplomatica Augusti Gentis Habsburgici* [Vienna, MDCCXXXVII], Vol. I, p. 317.

[29] P. Haeftenius, *Disquisitiones Monasticarum Libri IX*, Tractat II, Disquisition 4.

[30] Martinus Kropf, *Bibliotheca Mellicensis* [Vienna, MDCCXLVII, quarto].

[31] Eginhart, in *Vita Caroli Magni*, edited by Schminckius [Utrecht, MDCCXI, quarto], Chapter 25, p. 166 ff.

[32] Eginhart, ibid, pp. 118-119: "He not only wrote upon tables, but also was wont to keep small tablets under the cushions of his couch, so that when he had free time, he could turn his hand to painting letters."

[33] Eginhart, *Vita Caroli Magni*, a manuscript in the Imperial Library of Vienna, No. CXLVIII, in historical Latin mss.

[34] Op. cit., Book II, Chapter V, pp. 263-4, notes.

[35] Schminckius, in his notes to Eginhart, pp. 119-20.

[36] In the common tongue, "Theuerdanck, or, the Perils and a Portion of· the History of the Right Virtuous and Highly Famed Knight and Hero Theuerdanck," [Nuremberg, MDXVII, folio].

[37] J. J. Fugger, *Spiegel der Ehren der Ertz-Hauses Oesterreich* [Nuremberg, MDCLXVIII, folio], Book IV, p. 389.

[38] Franciscus Wagner, *Historia Leopoldi Magni Caesaris Augusti* [Augsburg, MDXXXI, folio], p. 791. Also, E. G. Rinck, *Leben und Thaten Leopolds des Grossen* [Leipzig, MDCCXIII, octavo], Part I., p. 126.

[39] Hubertus Thomas Leodius, *Annalium de vita et rebus, gestis . . . Friderici II, Electoris Palatini* [Frankfurt, MDCXXIV, quarto], Book III, pp. 51-2.

JOANNIS GEORGII

SCHWANDNERI,

AUSTRIACI STADELKIRCHENSIS

DISSERTATIO

EPISTOLARIS

DE

CALLIGRAPHIÆ

NOMENCLATIONE,

CULTU,

PRÆSTANTIA,

UTILITATE.

VIENNÆ AUSTRIÆ

EX TYPOGRAPHEO KALIWODIANO.

A. O. R. M. DCC. LVI.

PRIVILEGIUM
CÆSAREUM.

NOS FRANCISCUS
DIVINA FAVENTE
CLEMENTIA ELECTUS ROMA-
NORUM IMPERATOR, SEMPER AU-
GUSTUS, AC GERMANIÆ, ET HIERO-
SOLYMARUM REX, DUX LOTHARINGIÆ,
ET BARRI, MAGNUS HETRURIÆ DUX,
PRINCFPS CAROLOPOLIS, MARCHIO
NOMENEI, COMES FALCKEN-
STEINEI, &c. &c.

*Agnoscimus, & notum facimus tenore præsentium uni-
versis ; Quod, cum Nobis Auctor insignis cujuspiam Ope-
ris, cui Titulus:* **CALLIGRAPHIA LATINA,**
*humillime exponendum curarit, illius elaborationem solius
Publici amore liberaliter in se suscepisse, ejusdemque jam
plerasque æreas tabulas concinna Scalptoris manu magnis
sumptibus & labore absolutas prelo propediem commissurum
esse : vereri autem, ne alii quæstus cupiditate ducti laboris
sui liberalitate abuti, & præfatum Opus in ingens ejus de-
trimentum sive integrum, sive seorsim per quasdam partes
alicubi recudere conentur, ideoque Nobis præfatus Auctor
demississime supplicarit, ut ejus indemnitati* **PRIVILE-
GIO**

GIO NOSTRO CÆSAREO *clementiſſimè proſpicere dignaremur. Ne igitur impenſus labor & ſumptus invidia æmulorum hanc editionem imitantium fructu ſuo priventur ; Nos ſubmiſſæ pariter ac æquæ ejus petitioni annuendum cenſuimus ; Ac proinde authoritate Noſtra Cæſarea omnibus & ſingulis Bibliopolis, Bibliopegis, Typographis, Chalcographis & aliis quibuscunque rem ſive Librariam ſive Chalcographicam exercentibus firmiter inhibemus, vetamus, & interdicimus, ne quis ſupranominatum Opus ſub hoc aliove titulo, modo, formave ſive integrum, ſive per quasvis ejus partes citra præfati impetrantis, ejusque hæredum expreſſam voluntatem & aſſenſum in Scriptis obtentum, per* **DECEM ANNORUM SPATIUM** *ab hodierno die computandum intra Sacri Romani Imperii fines recudere, vel aliis recudendum dare, aliorſumve impreſſum apportare, vendere, vel diſtrahere auſit, vel præſumat ; Si quis vero ſecus faciendo* **PRIVILEGIUM** *hoc* **NOSTRUM,** *ſeu* **INTERDICTUM** *violare, contemnereque præſumpſerit, eum non ſolum ejusmodi exemplaribus, ubicunque locorum repertis, perperam quippe recuſis, ſeu apportatis (quæ dictus Auctor ſive propria authoritate, ſive Magiſtratus illius loci auxilio ſibi vindicare poterit) de facto privandum, ſed &* **SEX MARCARUM AURI PURI PŒNA** *Ærario ſeu Fiſco Noſtro Cæſareo, & parti læſæ, ex æquo pendenda, omni ſpe veniæ ſublata, mulctandum decernimus, dummodo te-*

tenor hujus NOSTRI PRIVILEGII *in fronte Operis vel Libri impreſſus reperiatur, & conſueta quinque Exemplaria ad arcanam Noſtram Cancellariam Imperialem Aulicam debite extradantur. Mandamus itaque omnibus & ſingulis Noſtris, Sacrique Romani Imperii ſubditis & fidelibus dilectis, tam Eccleſiaſticis, quam Sæcularibus, cujuscunque ſtatus, gradus, dignitatis, aut ordinis füerint, præfertim vero iis, qui in Magiſtratu exiſtentes, vel ſuo, vel Superiorum ſuorum loco, aut nomine jus, juſtitiamque adminiſtrant, ne quempiam* PRIVILEGIUM HOC NOSTRUM CÆSAREUM *impune violare, ſpernere, aut transgredi patiantur, ſed, ſi quos contumaces compererint, conſtituta a Nobis mulcta eos puniri, & quibuscunque modis idoneis coerceri curent, quatenus & ipſi graviſſimam Noſtram indignationem, prædictamque pœnam evitare voluerint. Harum teſtimonio literarum manu Noſtra ſubſcriptarum, & Sigilli Noſtri Cæſarei appreſſione munitarum, quæ dabantur Viennæ die undecima Menſis Aprilis Anno Domini Milleſimo Septingenteſimo Quinquageſimo Quinto, Regni Noſtri decimo.*

FRANCISCUS.

Vt. R. Comes Colloredo.

(L. S.)

Ad Mandatum Sac. Cæſ.
Majeſtatis proprium.

Paulus Antonius Gundel.

LECTORI BENEVOLO
JOANNES GEORGIUS SCHWANDNERUS
S. P.

I.

Siquis diverſa illa hominum ſtudia, quibus & generis ſui ſo- **Diverſa**
cietatem ſublevare, & boni civis partes, in hac ampla or- **homi-**
bis Republica, tueri quilibet Probus ſatagit, ſolertius per- **num ſtu-**
ſcrutetur, non ſeverioribus omnes diſciplinis alligatos repe- **dia.**
riet, ſed elegantiorum præterea artium cultura alios quamplurimos
occupatos conſpiciet : Cujus egregiæ contentionis licet neque idem
ſemper eventus, neque eadem præſtantia ſit, hoc tamen inter eos-
dem, utrinque convenit, ut liberalium ſuorum laborum fruƈtus in
alios potiſſimum redundare cupiant, quo inter illos demum viros
honorabile nomen ſortiantur, qui vitam non in deſidia contriverunt,
ſed pro virili quisque ſua, ſcientias & artes in bonum publicum lau-
dabiliter propagare conati ſunt.

II.

INter elegantiores has artes, quæ homini commendationem & or- **Calli-**
namentum impertiunt, CALLIGRAPHIAM haud infimo loco **graphiæ**
referendam eſſe, non vereor, quin ullus in controverſiam duxerit; **qualitas.**
attamen, cum ea vis eximiæ huic arti indita non ſit, ut animos
magis moveat, ac oculis præcipue deleƈtationem afferre conſue-
vit ; hinc, ne iniquius forſitan de ejus dignitate judicium mihi
tuum, Leƈtor benevole! mox animum præripiat, in limine Te po-
tius paucis quibusdam foliis morari & prius ad honorificam hujus
artis conditionem expendendam allicere conſtitui, quam oculos tuos
cupidos ad præproperum hujus amœniſſimi campi conſpeƈtum de-
fleƈtere patiar.

A 2 III.

III.

Anti-
quitas &
præro-
gativa
Artis
Scriben-
di apud
Roma-
nos.

SCRIBENDI ARTEM antiquiffimam effe & cum verborum fi-
gnis, quæ LITERAS vocamus, fimul ortam, plures fuere, qui
ex monimentis variis hoc dudum demonftrarunt : Neque demum
SCRIBÆ MUNUS, quod SCRIBATUS appellabatur, [1] præ-
fertim apud Romanos, fine honore fuiffe, ex Sigonio [2] colligi-
tur, qui SCRIBARUM ORDINEM Tribunorum ærarii ordini ho-
nore proximum fuiffe perhibet ; feu, quod eorum hominum fidei
tabulæ publicæ periculaque Magiftratuum committerentur, feu,
quod leges quodammodo in manibus haberent, & Magiftratibus
plerumque jus fuggererent. [3] Hi in varias tandem decurias de-
fcripti, tum a Magiftratibus, quibus apparebant, QUÆSTORII,
PRÆTORII, ÆDILITII &c. tum a muniis publicis, quæ fuftine-
bant, EPISTOLARES, SCRIPTURARII, LOGOGRAPHI, SUB-
ADJUVÆ, FORMULARII, CHARTULANI, ACTUARII, EX-
CEPTORES, SINGULARII, ac REGERENDARII dicti aliisque
nominibus fat multis diftinquebantur : Inter reliquos etiam MAXI-
MORUM PONTIFICUM SCRIBÆ, quos præterire nolumus,
PONTIFICUM MINORUM titulo eminebant, de quorum ordine
OPILIO MACRINO ad Pontificatum maximum aliasque præcel-
lentes dignitates eluctanti fuprema prorfus Imperii Romani poteftas
obtigit. [4] Pauca hæc de Romanorum inftituto delibaffe fufficiat,
nam plura requirenti HERMANNUS HUGO BRUXELLENSIS,
S. J. Presbyter [5] & celeberrimus illius Commentator C. H. Tro-
tzius JC^{tus} Batavus, qui omnem in hoc themate aliorum induftriam
fuperaverunt, abunde fatisfacient.

IV. Jam,

(1) L. 4. Cod. de Appellationibus &c. l. 1.
II. de Munerib. §. 2.

(2) De antiquo jure Civ. Roman. lib. 2. cap. 9.

(3) Hinc adhuc Theodorici Regis Oftrogo-
thorum tempore Caffiodorus Senator, Va-
riar. lib. XII. Ep. XXI. Deusdedit Scri-
bam Ravennatem commonefacit : *Scri-
barum Officium fecuritas folet effe cuncto-
rum - - - - - Apud cunctos Præfules de
tua cura litigatur, &, tu potius judicas,
qui caufarum vincula diffolvis. Hoc ho-
norabile decus, indifputabile teftimonium,*

*vox antiqua chartarum, cum de tuis ady-
tis incorrupta procefferit, cognitores reve-
renter excipiunt, litigantes, quamvis im-
probi, coacti tamen obediunt.* Edit. Parif.
in Fol. de Anno MDLXXXIX. pag. 276.

(4) Julius Capitolin. in Opilio Macrino.
§. m. VII.

(5) De prima Scribendi origine & univerfa
rei literariæ antiquitate, cui notas, opu-
fculum de fcribis & reliq. adjecit C. H.
Trotz JC^{tus} 8. Trajecti ad Rhen.
MDCCXXXVIII.

IV.

JAm, si aliarum gentium monimenta difcutiamus, illis æque, ac his, SCRIBÆ nomen ab omni tempore honorificum fuiffe comperimus. Canones Hiberniæ effufum fanguinem Epifcopi, vel excelfi Principis, vel SCRIBÆ eodem pretio metiuntur : Et, omnem, qui ea, quæ funt Regis, vel Epifcopi, vel SCRIBÆ furari, aut rapere, aut aliquid in eos committere aufus fuerit, æquali pœnæ addicunt : (¹) SCRIBANIAM, quæ fuit Officium SCRIBANI, alias SCRIBÆ, AD OFFICIA PALATII pertinere in Annalibus Genuenfibus Nicolai Guercii legimus : (²) Apud Francos CANCELLARIUS, vir fummæ dignitatis & cum Græcorum Logothetis comparandus, (³) SCRIBÆ ADJURATI nomine appellabatur. Talem Scribam adjuratum Carolus Magnus Imperator in Eginharto fuo habuit, (⁴) quem revera tamen Cancellarii munere funðtum fuiffe, graviffimorum virorum teftimonio conftat. (⁵) A Francis mos ifte ad noftros quoque Principes & terras dimanavit : Seculo quippe XIII. elabente, cum Albertus I. Auftriæ Dux antiqua Senatus Civitatisque Viennenfis privilegia tum fua auctoritate muniret, tum amplioribus gratiis exornaret, Magifter Otto de Metlich (⁶) Cancellarius Principis (per cujus manus hæ literæ publicæ datæ funt) non fibi alium, quam SUPREMI SCRIBÆ titulum arrogaverat. (⁷) Et perftant hodiedum tam in Regno Bohemiæ, quam Marchionatu Moraviæ, nec non in Archiducatu Auftriæ honorabiliora quædam

B

mu-

(1) Martene Tom. IV. Anecdotor. Col. 6.

(2) Inter Muratorii Rer. Italicar. Scriptor. Tom. VI. Col. 541.

(3) Nicetas lib. VII. Rer. a Manuel. Comneno geftar.

(4) Hunc enim plerique Codd. MSS. titulum præferunt : *Vita & gefta Caroli cognomento Magni - - - - Per Eginhardum illius quandoque alumnum atque SCRIBAM ADJURATUM, Germanum, confcripta.*

(5) Joan. Weinckens Eginhartus illuftratus & vindicatus. Fol. Francofurti. MDCCXIV. Cap. I. §. 3. & 4.

(6) De Mellico, hodie Melck, celebri illo Benedictinorum Monafterio & Oppido Auftriæ natus.

(7) Hujus diplomatis Ducalis, idiomate germanico exarati (cujus avtographum in tabulario civico Viennenfi adhuc diligenter affervatur) tenorem ad affertum noftrum pertinentem addimus : *Diefer Brieff ift gegeben ze VVienn mit Maifter Otten handt von Metlich unfers Obriften Schreiber, da von Chriftus Geburt waren taufend Jahr in den fechs und neuntzigften Jahr. An den erften Sonntag in der Faften, als man fingt das Ambt Invocavit.* Vid. Memorabilia de Templo ac Turri ad S. Stephanum Viennæ Auftriæ. 8. ibidem 1721. Titul. VIII. pag. 55. & feqq. Item, Confpectus Hiftoriæ Univerfitat. Viennenf. 8. Viennæ 1722. Part. I. pag. 3.

munia, equeftris plerumque Ordinis viris & nonnifi jurium rerumque patriæ cumprimis peritis, conferri folita, quæ antiquum a SCRIBA- TU titulum ad noftra usque tempora retinuerunt. [1] Quemadmodum nempe ipforum CANCELLARIORUM, olim a CANCELLIS dictorum, conditio primum fat humilis fuerat, & paullatim deinde in excellentem dignitatem affurrexit; ita & SCRIBARUM nomen nullo tempore tam vile fuit, quin eo, Franci cumprimis, etiam fuprema infignirent officia, quorum utpote SCRIBÆ ADJURATI, fi inter Confiliarios non principem, primo faltem proximum, inter illos fibi eminentiæ locum vendicaverant. [2] Plura de SCRIBIS in genere jam miffa facimus, &, a Scopo paulifper longius digreffi, ad CALLIGRAPHIAM noftram revertimur.

V.

Calligraphiæ nomenclatio Tachygraphiæ contraria & utriusque character.

CALLIGRAPHIA græcæ Originis vocabulum, a ΚΑΛΟΣ PULCHER, VENUSTUS [3] & ΓΡΑΦΩ SCRIBO, PINGO derivatum, nihil aliud, quam ARTEM illam modumve ELEGANTIUS SCRIBENDI indicat, de quo librarii veteres, qui codicibus ornate & fplendide exarandis ftudebant, nonnunquam ΚΑΛΛΙΓΡΑΦΟΙ, latine CALLIGRAPHI, illorum denique ars ΚΑΛΛΙΓΡΑΦΙΑ dicta eft. Diverforum quippe Scribarum opera tam Græci, quam Romani utebantur, fed relictis aliis, folos CALLIGRAPHOS & his quodammodo contrarios TACHYGRAPHOS ad noftrum propofitum accerfimus: Hi, feu a velocitate Scribendi ΤΑΧΥΓΡΑΦΟΙ, feu interdum etiam ΑΠΟ ΤΩΝ ΣΗΜΕΙΩΝ a NOTIS, Latinis NOTARII; illi, ab elegantia Scribendi pingendique CALLIGRA- PHI appellabantur, unde CALLIGRAPHIÆ proprium characterem haud difficulter conjicimus, quod ejus videlicet cultores, literas grandiufculas, fe nusquam contingentes, fingillatim effingerent, e con-

(1) In Bohemia & Moravia *Der Obrifte Land- fchreiber*: In Archiducatu Auftriæ infra Anafum *Der Landfchreiber*.

(2) J. Weinckens loc. cit. §. 3, in fin.

(3) Hoc autem a Καλέω, voco, quia pul- chritudo omnium ad fe oculos vocat, de- fcendit

e contrario TACHYGRAPHIA, quæ plerumque judiciorum actis celeriter excipiendis inserviebat, literas fortuitas, graciles, oblongas, invicem potissimum connexas ad suos usus deligeret.

VI.

UTriusque hujus artis exempla ad manifestum captum exoptantium desiderio velificaturi, horum paucula quædam ex plurimis in compendio lubenter suggerimus: De GRÆCORUM itaque Calligraphia monimentum vere Augustum in vetustissimo illo DIOSCORIDIS, medici Cilicis, Anazarbensis, Manuscripto Codice Bibliotheca Augusta Vindobonensis [1] hodieque conservat, qui Christi nati Seculo circiter sexto JULIANÆ ANICIÆ, Flavii Anicii Imper. Filiæ, auspicio & liberalitate, LITERIS MAJUSCULIS græcis, SINE ULLO ACCENTU, absque VERBORUM et TEXTUS DISTINCTIONE elegantissime exaratus, figuris plantarum ad naturam depictis, aliisque variis imaginibus, quin & ipsius JULIANÆ effigie splendidissime exornatus, circa An. Chr. MDLXII. sagaci demum Augerii Busbeckii, Legati Cæsarei, indagatione in cujusdam Hebræi manibus Constantinopoli repertus, munificentia dein, aut FERDINANDI I. certius MAXIMILIANI II. Imp. centum aureis redemptus, huc tandem in Austriam feliciter translatus est. [2] Alia hujus generis specimina, ex variis Germaniæ, Franciæ, Angliæ, Hollandiæ &c. manuscriptis græcis codicibus, eruditissimi duo Anonymi, ex Congregatione S. Mauri Religiosi Benedictini, in suo novo artis diplomaticæ Tractatu annis hisce Parisiis evulgato largiter exhibuerunt, [3] quæ commodo quisque suo perspicere poterit.

Exempla Calligraphiæ græcæ.

VII.

A GRÆCIS ad quasdam LATINÆ CALLIGRAPHIÆ antiquas reliquias procedimus: Primatu inter has propemodum dignas æstimamus celeberrimas illas JURISPRUDENTIÆ ROMANÆ

Exempla Calligraphiæ latinæ in Italia.

B 2

(1) Inter Manuscriptos Codices græcos Medicos No III.

(2) Pet. Lambecius Commantar. de Bibliothec. Cæsar. Vindobon. lib. II. cap. 6. pag. 489. & integro cap. 7. pag. 519. seqq.

(3) Nouveau Traité de Diplomatique par deux Religieux Benedictins de la Congregat. de S. Maur. Tom. I. 4. à Paris. MDCC - - - Chap. XVI. pag. 686.

MANÆ PANDECTAS, quarům codex antiquiffimus ancipiti primum fato, Amalphi An. Chr. MCXXXV. a Pifanis direpta, [1] his in prædam cefferat; eorum pofthac Republica Anno MCCCCVI. a Florentinis itidem fubacta, illuftre tanquam victoriæ trophæum, ac præcipuum fubditi nexus fymbolum in Hetruriæ metropolim tranfiit. [2] Ubi noftris his temporibus in CURIA, feu publico REIPUBLICÆ PALATIO, quod hodie PALATIUM VETUS dicitur, inter alias gazas diligentius cuftoditur. [3] Ne ab hoc cimelio longius divertamus, mox alterum ei fimile, ac ætate ferme fuppar antiquitatis calligraphicæ latinæ exemplum, videlicet eximium illum OROSII CODICEM ex Bibliotheca Medicea producimus, alicubi jam Mabillonio [4] laudatum: Ex quo folertiffimus Sigebertus Havercampus, procurante D. Alberto Mazzoleno, elegantiffimam fuam Pauli Orofii editionem [5] præcipue adornavit.

VIII.

Exempla Calligraphiæ latinæ in Germania.

GERMANIÆ nunc noftræ etiam meminiffe juvat, cujus literati viri non fegnius, quam exteræ nationes, Calligraphiæ latinæ jam olim fuam præclaram operam navarunt. Scatent hujus Studii veftigiis Bibliothecæ & Tabularia: Augufta Vindobonenfis, Ducales Guelpherbytana & Saxo-Gothana ampliffimum mihi præ reliquis teftimonium afferunt, immo eruditiffimus Beffelius nofter [6] ex facrario ac Bibliotheca Ecclefiæ Cathedralis Herbipolenfis, Monafteriorum denique San-Emmeramenfis, Gotwicenfis, S. Petri Salisburgenfis, Tegernfeenfis, Werdinenfis, quin & ab Arctoæ

(1) Vid. H. Brencmanni Differtatio de Amalphi a Pifanis direpta. §. 23. & 24. Item, ejus Tabula chronologica huic Differtationi fubnexa.

(2) Francifcus Taurellus in Dedicatoria Pandectar. ad Cofmum Medicem.

(3) Pretiofam arculam feu thecam, in qua Florentini has Pandectas reconditas habent, una cum fplendido ipfius codicis amictu, fedulo defcripfit cit. Brencmannus in Hiftoria Pandectar. 4. Trajecti ad Rhen. MDCCXXII. lib. I. cap. X. pag. 64. feqq. ubi characteris fimul Calligraphici

fpecimina ex eodem typis excufa dedit lib. II. Cap. II. pag. 109. feqq. Item, Cap. V. per integrum.

(4) De Re Diplomat. lib. V. pag. 354.

(5) Pauli Orofii Hiftoriarum lib. VII. cura Sigebert. Havercampi. 4. Lugd. Bat. MDCCXXXVIII. circa finem Præfat. & pag. 70.

(6) Godefridus Beffelius Abbas Gotwicenfis in Chronici Gotwicenfis. Fol. Typ. Monaft. Tegernfeenf. MDCCXXXII. Tom. I. pagg. 1. 34. 36. 37. 39. 43. 46. 47. 50. 52. 61. 63.

&ctoæ prorſus Germaniæ plaga, tot conſpicua Calligraphiæ latinæ apud noſtrates Schemata a Seculo Chriſti quarto usque ad decimum tertium, univerſo jam Orbi Literario in tabulis typicis propoſuit, ut, niſi de luce quis ſoli litem movere cogitaverit, in hoc argumento non habeat, quod poſthac a Germanis deſideret. Rariores Calligraphicis ſunt chartæ & volumina Tachygraphica nobis ſuperius memorata, ne tamen & hoc Scripturæ genus ſine exemplo relinquamus, ad duas illas particulas inſtrumenti venditionis fundorum & ædificii in agro Ariminenſi, ſub Juſtino II. Imp. An. Dom. DLXXII. Ravennæ ſcripti, quos Philippus a Turre, Epiſcopus Adriæ diſſertationi ſuæ apologeticæ ad nummum Anniæ Fauſtinæ (1) inſeruit, paucis provocaſſe ſufficiat.

Inſtrumentum Scripturæ Tachygraphicæ.

IX.

ARTIS CALLIGRAPHICÆ cultum quod attinet, ſolerti eruditiſſimorum virorum indagatione jam pridem conteſtatum habemus, & ſupervacanea noſtra disquiſitione non indiget, tam Hebræos, quam Græcos, Romanos, ac Germanos noſtros, ab omnibus usque Seculis, immo a prima ſtatim Scribendi origine Calligraphiam impendio coluiſſe, ejusque cultores peculiari ſemper in pretio habuiſſe; hoc tamen oblivioni traditum nolumus, quin gratiſſima potius memoria recolendum duximus, optimos pleroque codices manuſcriptos tam ſacros, quam profanos, nos ſedulis diverſorum ordinum, de D. Benedicti potiſſimum inſtituto, Monachis omnino in acceptis referre : non deſunt nobis copioſa prædicabilis hujus induſtriæ teſtimonia. S. Gregorius Turonenſis (2) de Aulico quondam Palatino Theodoberti Francorum Regis, humili dein Abbate, S. Aridio refert: ILLUM NUNQUAM OTIO INDULSISSE, QUO NON AUT LECTIONI VACARET, AUT OPUS CHRISTI PERFICERET, AUT CERTE MANIBUS OPUS ALIQUOD AGERET, AUT DENIQUE SACROS CODICES SCRIBERET; MAXIME AUTEM DECREVISSE, UT

Cultus artis Calligraphicæ olim apud ſolos ferme Clericos & Monachos.

<div style="text-align:center">C</div>

IN

(1) Philip. a Turre de annis Imperii M. Aur. Ant. Elogabali Diſſertatio Apologetica ad Num. An. Fauſtinæ. 4. Patavii. 1 7 1 3. Cap. VIII.

(2) Inter opera a P. Theodorico Ruinart Fol. Pariſiis edita MDCXCIX. in vita hujus Sancti §. VI. circa fin. pag. 1287. Et Hiſt. Francorum Lib. X. §. 29.

IN VICINAS DIOECESES SACRI CODICES, QUOS IPSE MANIBUS SUIS SCRIPSERAT, DISTRIBUERENTUR. Ekkehardus junior [1] Ottonum tempore, fub Burckhardo S. Galli in Alamannia Abbate, Monachorum hujus Monafterii Scriptorum digitos præ gemmis & auro elatos celebrat. S. Berwardus eodem pene ævo SCRIPTORIÆ non in Monafterio tantum, fed in diverfis locis ftudebat, unde & copiofam Bibliothecam tam divinorum, quam philofophicorum codicum comparavit. [2] Acta Fundationis Monafterii Murenfis [3] recenfionem hujus Cœnobii librariæ fuppellectilis hoc cum memorabili epiphonemate abfolvunt : LIBROS AUTEM OPORTET SEMPER DESCRIBERE, ET AUGERE, ET MELIORARE, ET ORNARE, ET ANNOTARE CUM ISTIS, QUIA HIC VITA OMNIUM SPIRITUALIUM HOMINUM SINE LIBRIS NICHIL EST. Commendatam porro Monachis ab omni tempore elegantem & emendatam librorum Scriptionem fuiffe, teftes funt innumeri paffim illorum codices, auctorum plurium fide confirmat Haëftenius [4] &, ne patriæ noftræ oblivifcamur, præ aliis vel unicum antiquiffimum MELLICENSE MONASTERIUM appellemus, cujus SCRIPTORES BENEDICTINOS illorumque a fexcentis & amplius annis exarata opera fat multa egregius P. Martinus Kropf [5] eximia cum folertia in lucem revocavit, ac luftro proxime præterito, in fuorum gloriam, pofteritati transfcripfit.

X.

Artis dignitati inde nihil derogatum.

PArum fortaffe dignitatis ARTI CALLIGRAPHICÆ a præcipuis fuis cultoribus Monachis acceffiffe aliquis exiftimaverit, æquius attamen mox in judicium quemlibet nobifcum defcenfurum confidimus, fi eandem, quam huic, reliquis pariter

ar-

(1) De cafibus Monafter. S. Galli Cap. XI. in Goldafti Scriptor. Rer. Alamannic. Edit. Senckenberg. Fol. Francof. MDCCXXX. pag. 52.

(2) Vita S. Berwardi cap. 5. apud Mafcov. Commentar. de Reb. Imper. a Conrado I. usque ad obitum Henrici III. 4. Lipfiæ 1741. pag. 106.

(3) Apud Clariff. P. Marquard. Herrgott in Genealogia Diplomat. Aug. Gent. Habsburg. Fol. Viennæ Auftr. Tom. I. pag. 317.

(4) Disquifition. Monafticarum Lib. IX. Tractat. II. Disquif. 4.

(5) In Bibliothec. Mellicenf. 4. MDCCXLVII.

artibus & fcientiis fortunam contigiffe, eas longo tempore in fo-
lis quafi Monafteriis delituiffe, adeoque horum per vigilan-
tes inquilinos fævæ adhuc ignorantiæ feliciter ereptas fuiffe, au-
dacter affeveraverimus. Plus apud Germanos femper armorum
exercitium; quam literarum ftudium valuiffe, diu notum eft: Cum
porro flagrantibus, inter Ludovici Pii præfertim filios, funeftis
bellis civilibus, Normannis infuper univerfam regionem depopu-
lantibus, latina lingua conticuiffet, omnes prope cum illa difcipli-
næ fimul evanuiffent, nifi Clerici ac Monachi, quos ad excolen-
da fcientiarum & artium ftudia fui Ordinis adftringebat profeffio,
mifere laborantibus literis tam ftrenue opitulati fuiffent.

XI.

AQuibus non fola Calligraphia, fed omnes propemodum fcien-
tiæ & artes excultæ, confervatæ ac paulatim ad nos aufpi-
cato transmiffæ fuerint, perftrinximus; ut veram tandem ac fo-
lidam Calligraphico ftudio gloriam afferamus, unus præ multis aliis
nobis fuppetit, quo majorem fplendidioremve cultorem ars ulla
nancifci haud potuit, MAGNUS ille Imperii Germanici auctor
CAROLUS, PIUS, FELIX, AUGUSTUS. Hic, uti
diverfarum in linguarum peritia & artium liberalium doctrina fedu-
lum a juventute ftudium collocare affueverat, [1] tanta fibi hujus
artis comparandæ delectatione tenebatur & defiderio, ut, quam-
vis fero inchoaffet, fubfecivis tamen horis victricem manum il-
lam, qua tot hoftium phalanges fortiter proftraverat, effingendis
etiam calligraphicis literis aptam reddere pertentaret. [2]

Carolus Magnus Calligraphiæ cultor.

XII.

IGnarum me nemo opinetur, tortuofum hunc Eginharti locum
neque omnibus æqualiter legi, neque eandem pluribus inter-
pretationem probari; At, vetuftiffimi codicis Vindobonenfis [3]

Eginharti locus explanatus.

C 2 lu-

[1] Eginhart. in vita Caroli M. edit. Schminck. 4. Traject. ad Rhen. MDCCXI. Cap. XXV. pag. 116. feqq.

[2] Idem Eginhart. loc. cit. pag. 118. & 119. *Tentabat, & fcribere tabulasque, & codicillos ad hoc in lectulo fub cervicalibus circumferre folebat, ut, cum vacuum tempus effet, manum effingendis literis affuefaceret.*

[3] Eginharti Vita Caroli M. in Biblioth. Aug. Vindobonenf. inter Codd. MSS. hiftoricos latinos Num. CXLVIII.

luculentus tenor, excellentiſſimi Lambecii [1] & eruditiſſimi Schminckii [2] auctoritas, graviſſimo explanationem noſtram ſuffragio ſuo firmiſſime fulciunt, & ſanæ omnino rationi conſentaneum eſt, Eginhartum non ſcripturam quamlibet, ſed elegantiores illas majuſculas literas, quæ ad ornamentum potius pinguntur, quam ſcribuntur, ac, citra dubium, ad Calligraphiam pertinent, intelligi voluiſſe, cujus utpote ſcientiæ affectu Carolus etiam, quamvis ſibi rebelli, egregio tamen Calligrapho Paulo Diacono vitam conceſſerat & in communi ſcribendi genere illum jam prius ſatis exercitatum fuiſſe vel ex ipſo Eginharto facile eruitur, dum ſubſequente mox capite XXIX. antiquiſſima, quibus veterum Regum actus & bella canebantur, carmina CAROLUM SCRIPSISSE, & memoriæ mandaſſe perhibet.

XIII.

Utilitas literaria ex arte Calligraphica.

SUpereſt, ut de utilitate, non quidem illa œconomica, ſed, quam CALLIGRAPHIA rei literariæ attulit, non incongrua diſſeramus: CALLIGRAPHORUM opera Bibliothecas elegantiſſimis ſimul ac emendatiſſimis Codicibus in hodiernum diem reſplendere, eosque vulgaria manuſcripta volumina ſuo pretio longe antecellere, æqui dudum æſtimatores comprobavere & lugubrem magis antiquorum codicum jacturam, hercle, paſſi fuiſſemus, niſi eximia CALLIGRAPHIÆ venuſtas amatores ſibi ſolicitosque cuſtodes allectaſſet, ſpes demum lucri ex præclariore præda captandi ſæpe barbaras etiam gentes ad ejusmodi Membranarum conſervationem permoviſſet. Quid? ſi divinum quodammodo Typographiæ Inventum a CALLIGRAPHIS primum decorem & ſubſidium acquiſiviſſe ſtatuamus; neque anxia probatione res indiget, nam, & Majuſculas illas, luculentas ac ſingulares literas, quibus illuſtre de Maximiliano I. Imperatore poema epicum [3] a Joanne Schoenspergero anno MDXVII. Norimbergæ primum excuſum

(1) Commentar. de Bibliotheca Cæſ. Vindobonenſ. lib. II. cap. V. pag. 263. & 264. in notis.

(2) Schminckius in notis ad Eginhart. Vit. Car. M. pag. 119. & 120.

(3) Vulgo *Theuerdanck*, alias: Die Geverlichkeiten und ein Theils der Geſchichten des löblichen ſtreitbaren und hochberumbten Helds und Ritters Tewrdanckhs. Fol. Nürnberg im Jahr MDXVII.

ſum fuit, peculiari inſignis cujusdam Calligraphi ſtudio, ad nito-
rem libro conciliandum, inventas, ad harum formam deinceps ſimi-
les alias effictas, & novam ſibi exinde typothetarum loculamenta
acceſſionem feciſſe, decantatum eſt.

XIV.

OSmannica Gens, artium ad culturam alias minus propenſa, li-
cet typographos hactenus reſpuerit, CALLIGRAPHOS
tamen ſuos ſub largis præmiis retinuit; ac diſperſæ per orbem He-
bræorum reliquiæ hujus artis ſtudioſos mirifice extollunt. Quæ
cum omnia probe perpenſa & explorata habeamus, non mirum
adeo poſthac ulli, ſpero, videbitur, quod in noſtris regionibus,
ubi Muſis jam pridem felicius renaſci datum, viri gravioribus etiam
curis detenti ac honorificentioribus in muniis conſtituti reperian-
tur, qui, ab officio quantum vacat temporis, arti tam decoræ,
tam præſtabili, tam amœnæ liberaliter impendere, nequaquam
conditione ſua indignum reputavere.

Calligra-phiæ ſtu-dium omnibus ſuis cul-toribus honori-ficum.

XV.

ALbertus III. Auſtriæ Archidux, cum trica dictus, tornum,
animi relaxandi gratia, fertur crebrius exercuiſſe [1] eidem
pariter arti Leopoldum Imperatorem, auguſtiſſimæ MARIÆ
THERESIÆ, noſtri temporis MINERVAE, mag-
num Progenitorem, non mediocrem operam locaſſe, Muſicam ad-
hæc impenſius coluiſſe, ejus biographi tradiderunt, [2] quis modo
tam vecors ſit, ut Principibus pacis bellique ſtudiis inclytiſſimis
liberalem hunc otii fructum, immortali gloria digniſſimum, expro-
brare aut calligraphicum Magni Caroli conatum reprehendere non
erubeſcat? & fuere nihilominus (in cujus fortuitam lectionem quon-
dam apud Leodium [3] incidimus) olim Hiſpani quidam, Aulæ

Artium quarum-libet vi-tupera-tores ca-ſtigati.

D Mi-

(1) Fuggerus in Spiegel der Ehren. Fol.
 Nürnberg. 1668. Lib. IV. pag. 389.

(2) P. Franc. Wagner HiſtoriaLeopoldi M. Cæſ
 Fol. Partes II. Auguſt. Vind. MDCCXIX.
 & XXXI. Parte II. pag. 791. E. G. Rinck
 Leben und Thaten Leopolds des Groſſen

IV. Theile. 8. Leipzig. MDCCXIII. Part. I.
 pag. 126.

(3) Hub. Leodius Annal. de vita & reb. geſt.
 Friderici II. Elect. Palat. 4. Francofurt.
 MDCXXIV. Lib. III. pag. 51. & 52.

Miniftri, qui, cum Fridericum II. Electorem Palatinum , Joannem Marchionem Brandeburgicum, aliosque ab arte Mufica commendari audirent , illam effœminare homines fortesque viros minimum decere criminarentur; pedeftri quidem militari ludo hanc caufam dirimendam decreverat Carolus Hifpaniarum infans, [1] fed finiftre adeo Munckevallio & auctoribus fociis certamen cefferat, ut multa cum ignominia, liventibus oculis, tumentibus labiis ac genis, ex inaufpicata arena difcederent & animi fortitudinem ftudio Mufico neutiquam enervari fuo damno intelligerent. Nos equidem, qui mites & manfuetas Mufas amamus, procaces Calligraphiæ arrofores in eandem arenam provocare non intendimus, ne tamen centuriato, forfitan, judicio a tot Auguftis, tot illuftribus omnium fcientiarum & ingenuarum artium cultoribus ad Lapithas & Centauros relegentur, fpondere, profecto, non poffumus. TANTUM! Vale, Lector benevole! & me atque omnes egregiæ CALLIGRA-PHIÆ propugnatores favore perenni complectere. Scribebam Viennæ in Auftria VI. Idus Septembr. A. O. R.

<div align="center">MDCCLV.</div>

[1] Dein quintus hujus nominis Imperator.

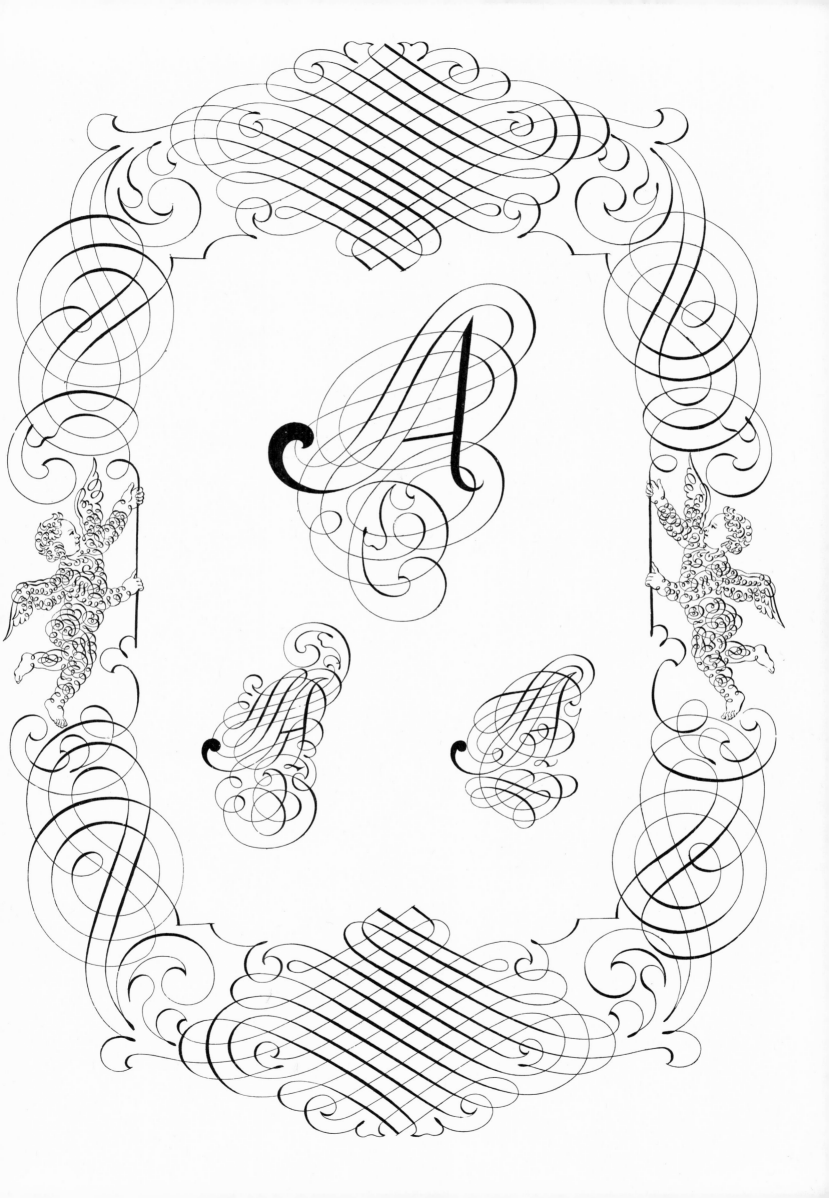

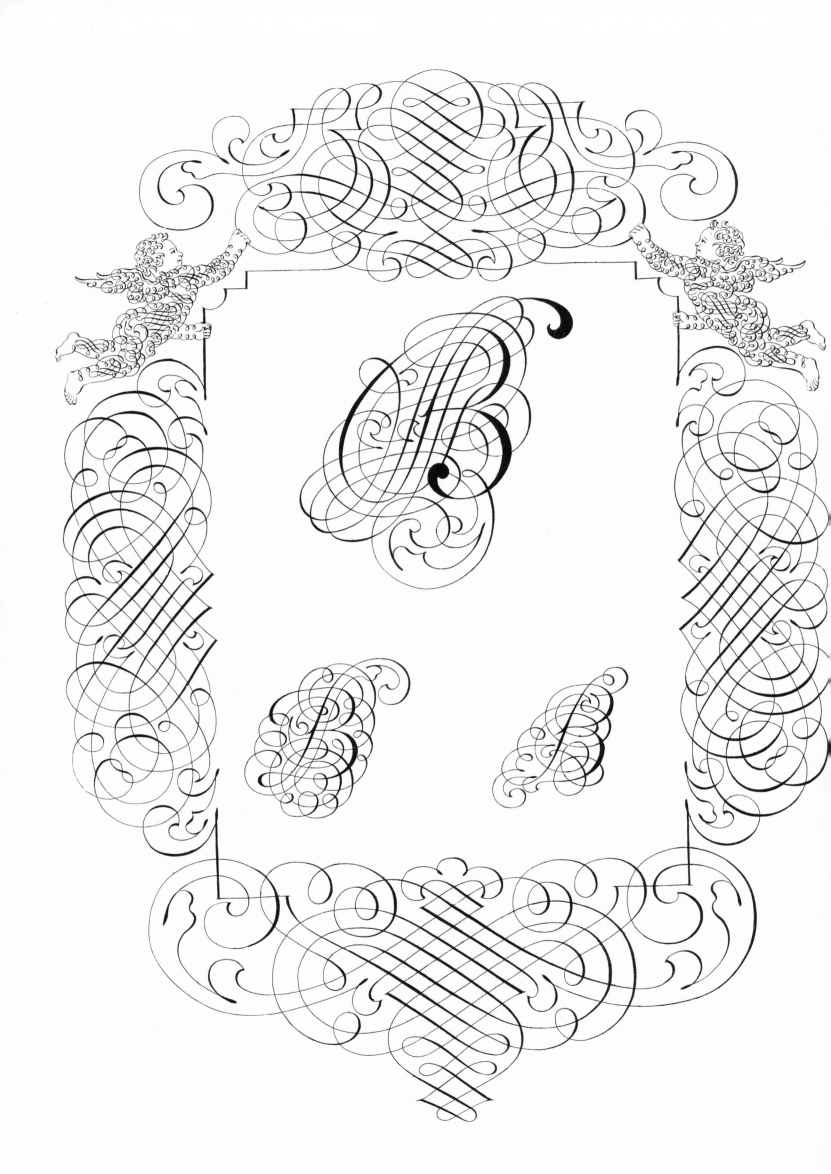

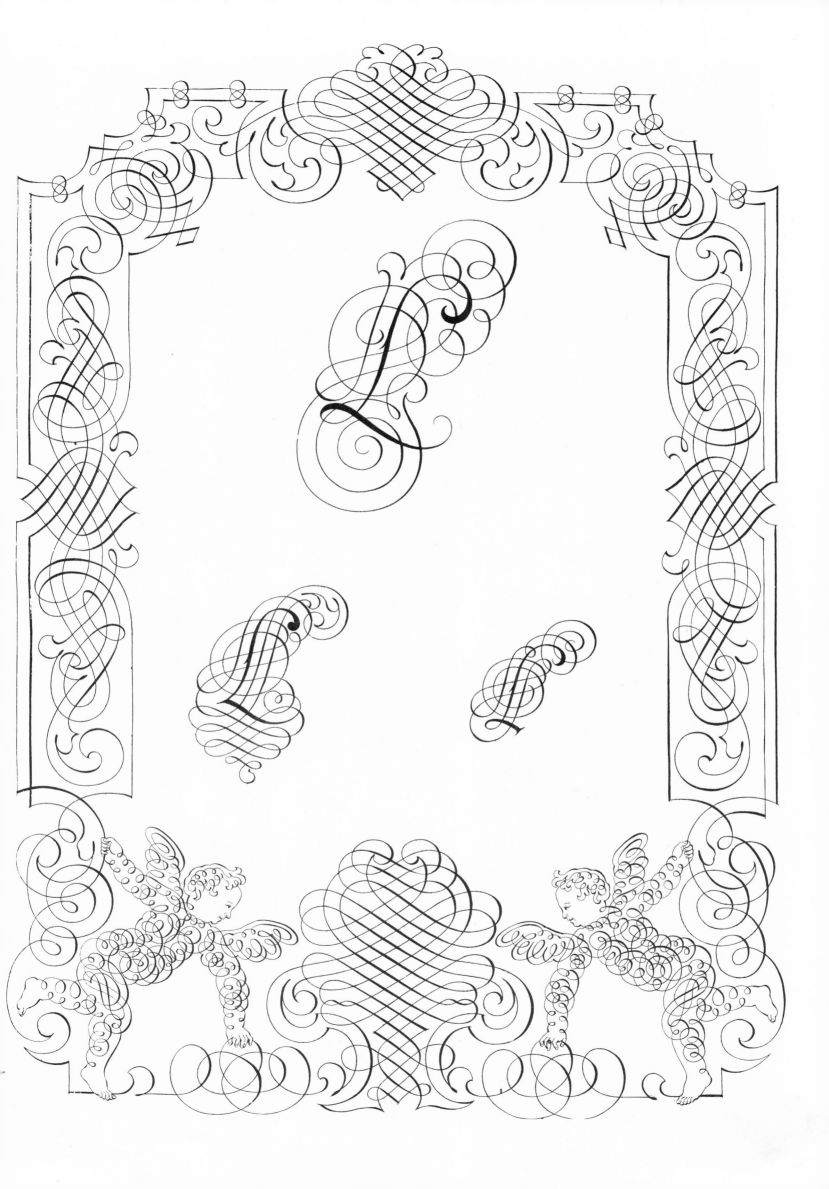

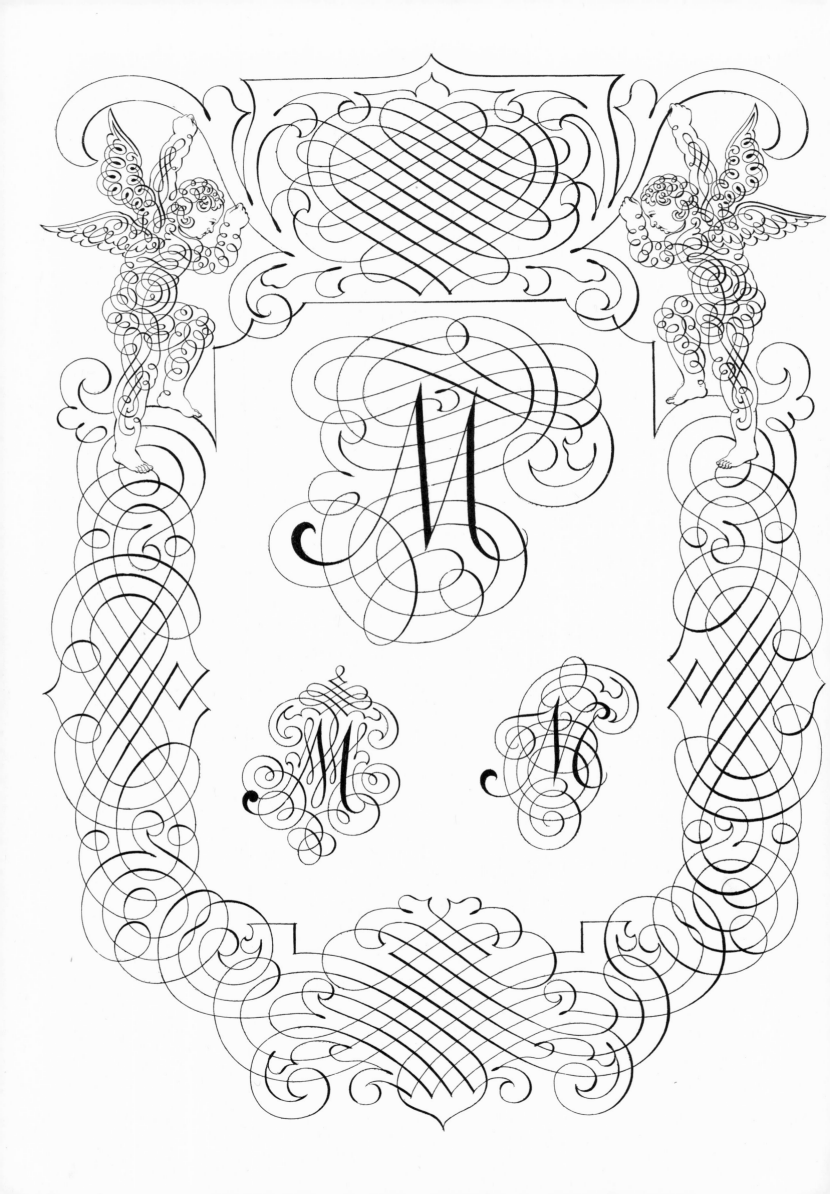

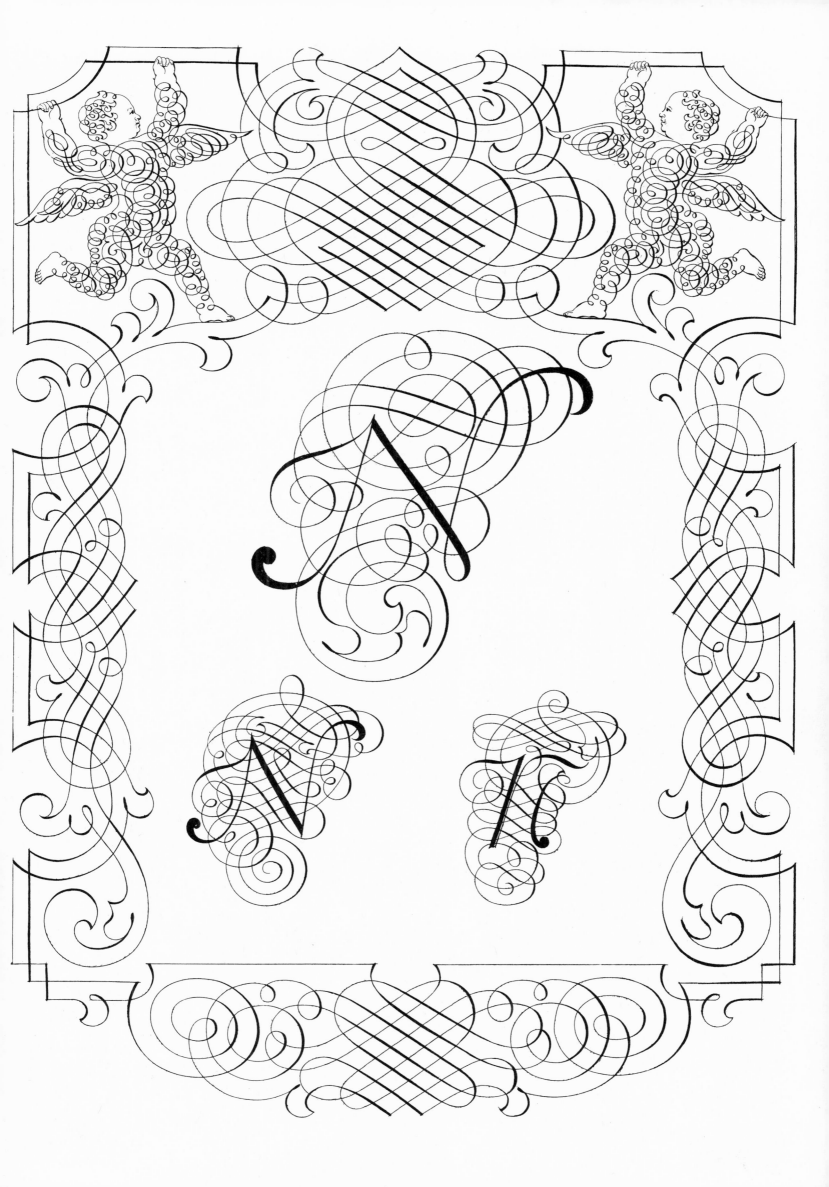

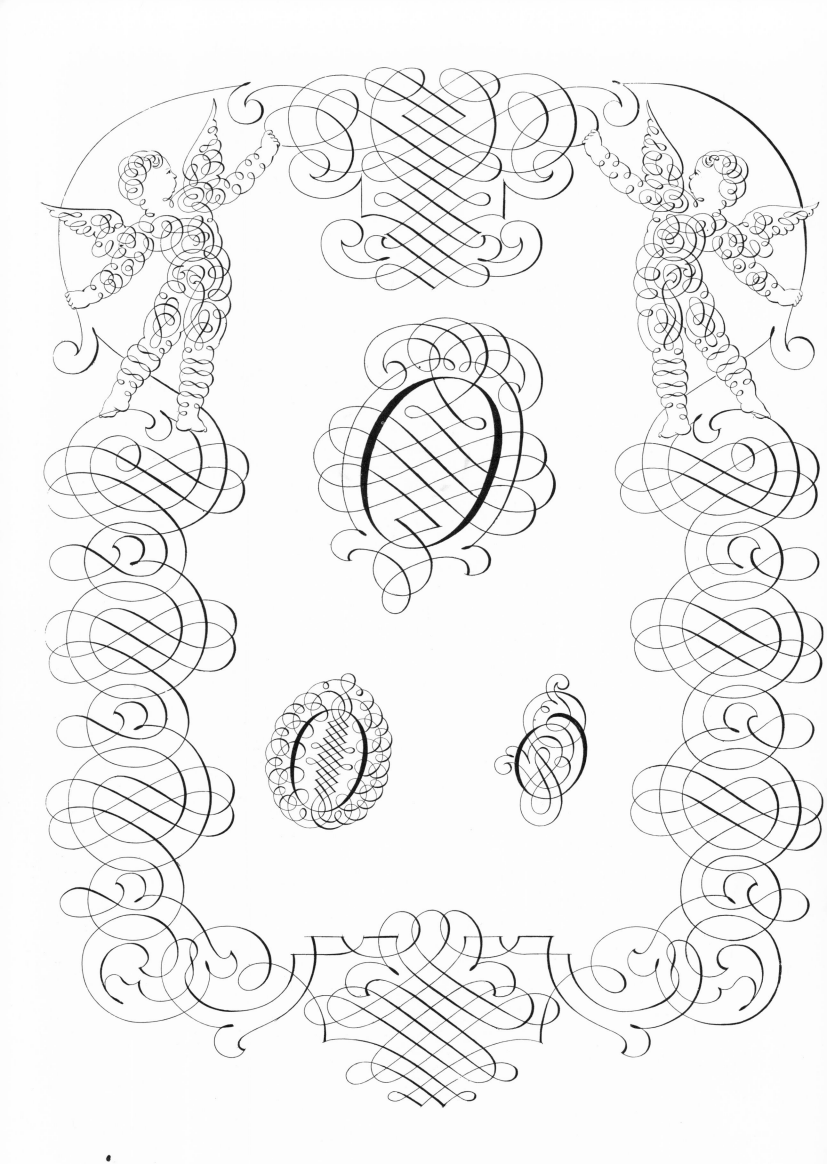

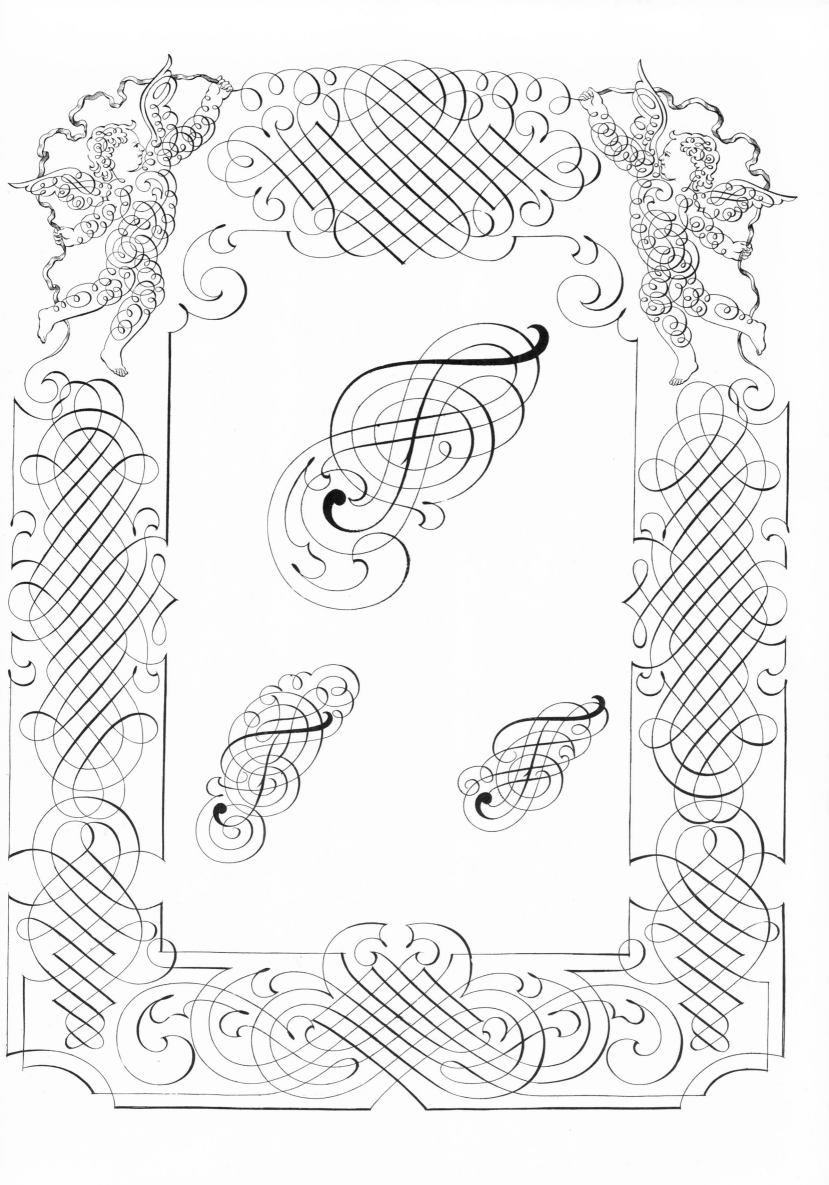

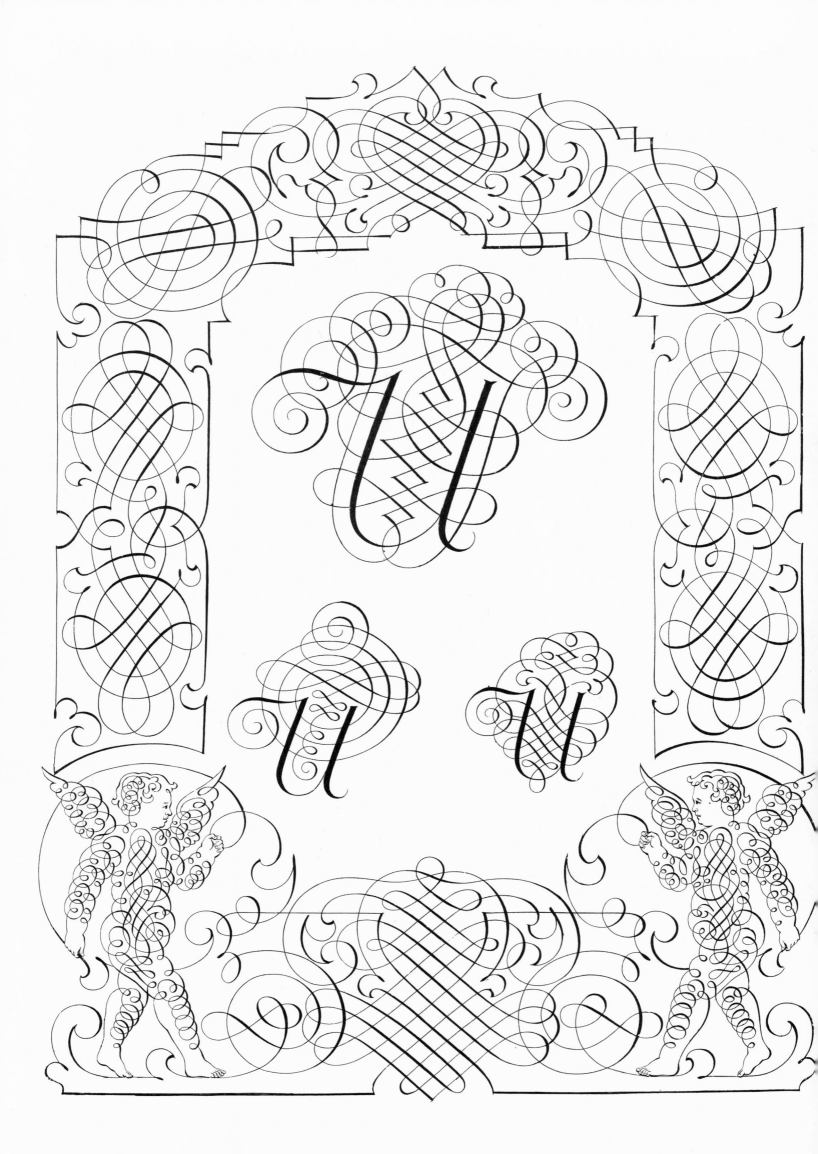

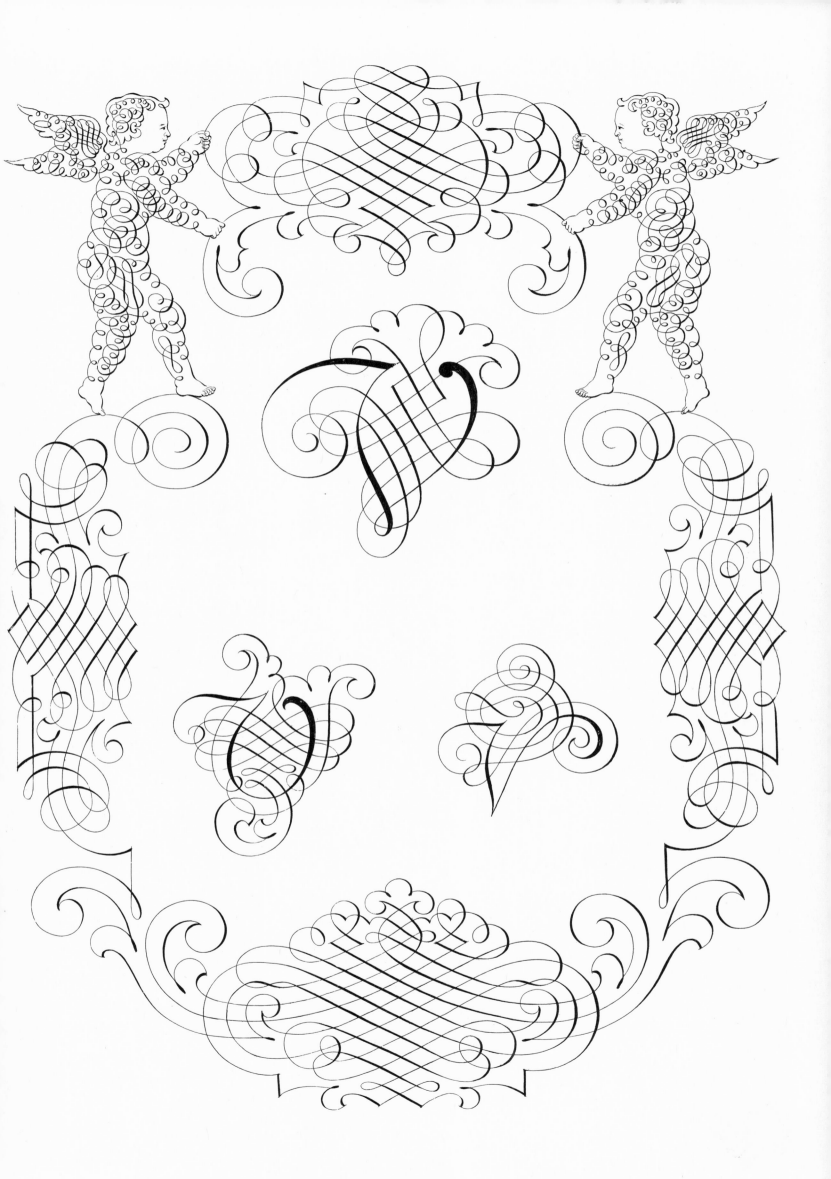

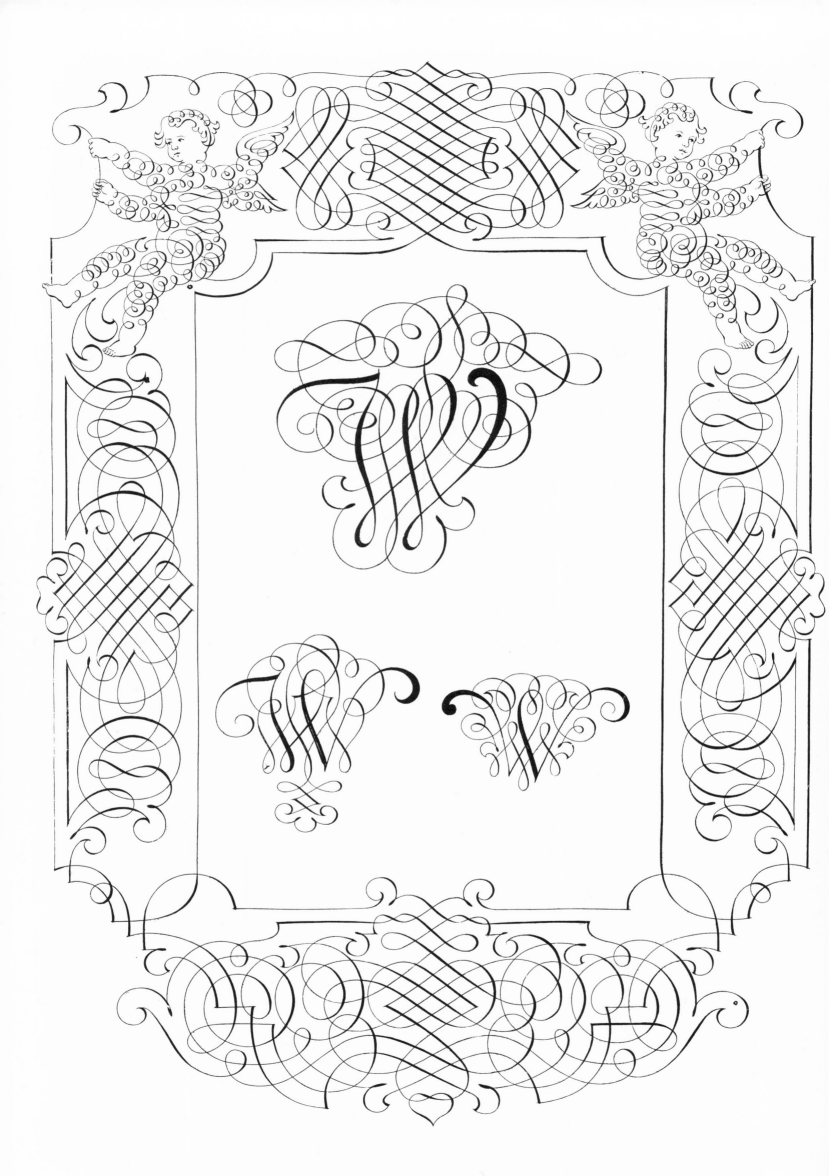

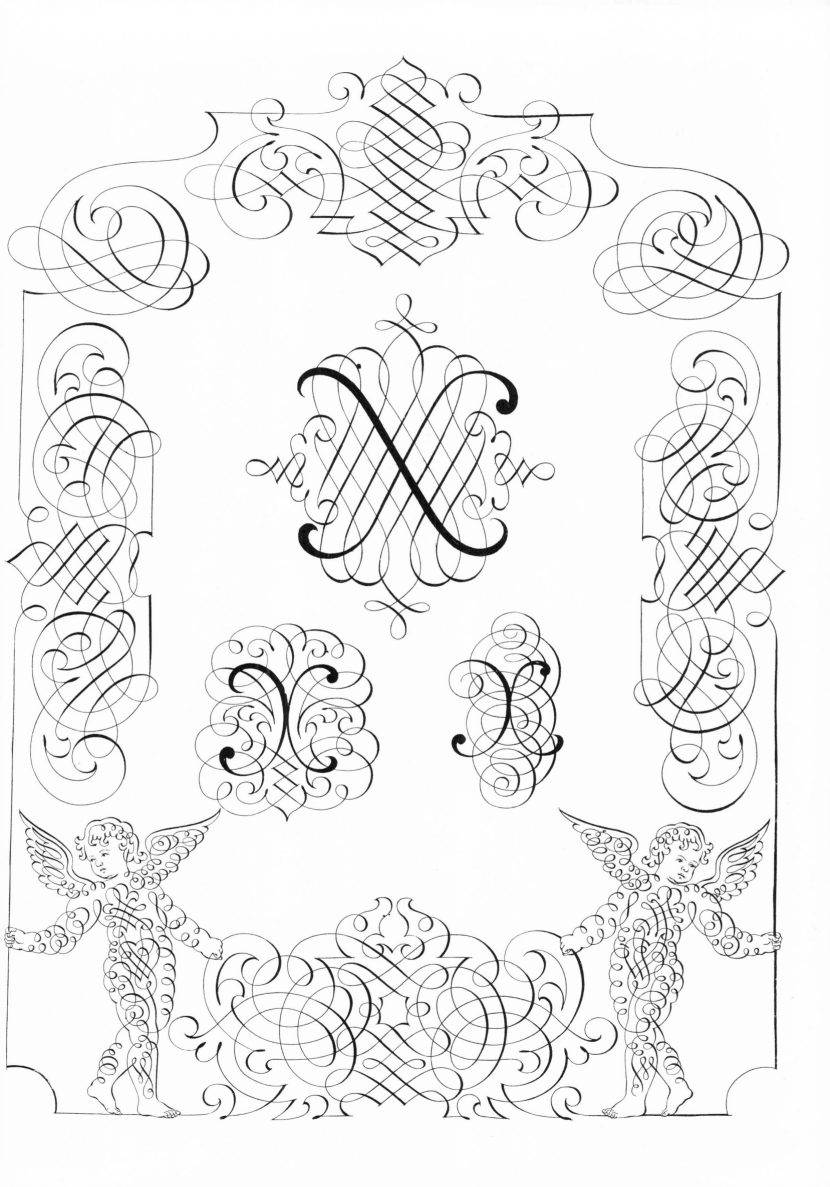

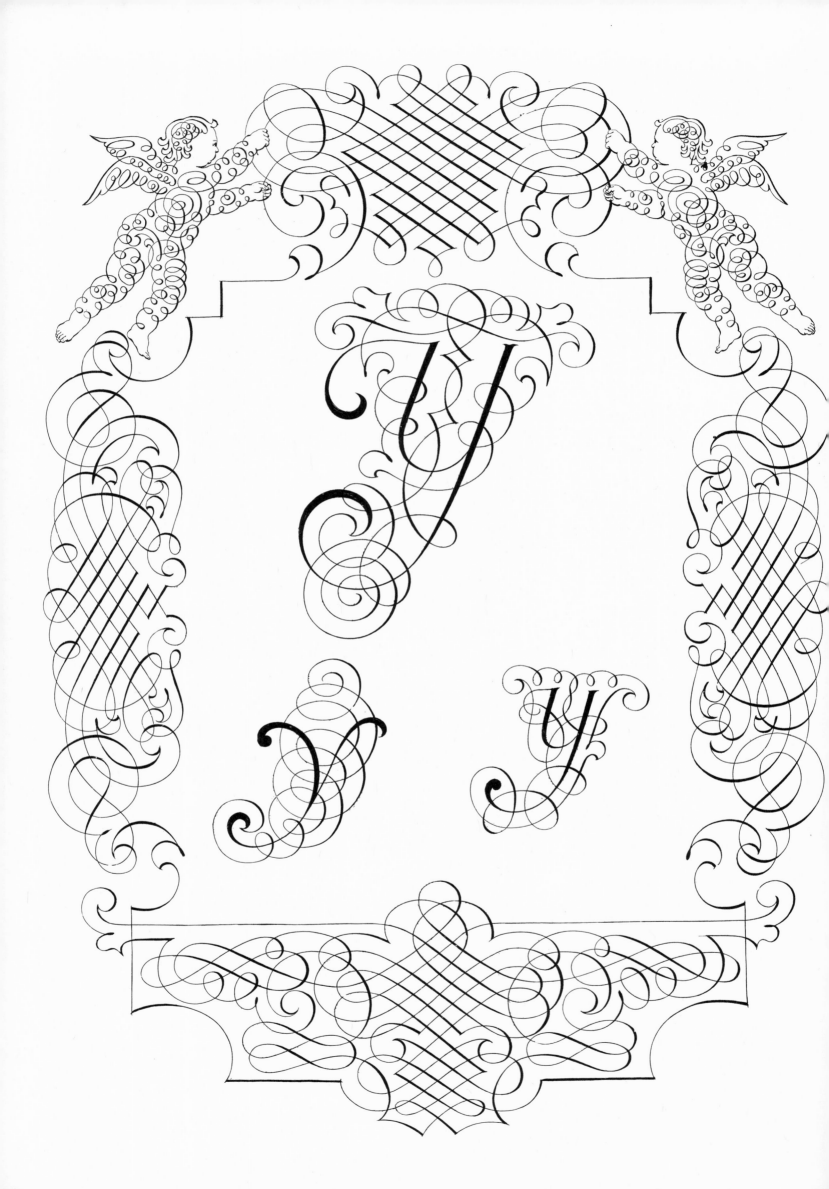

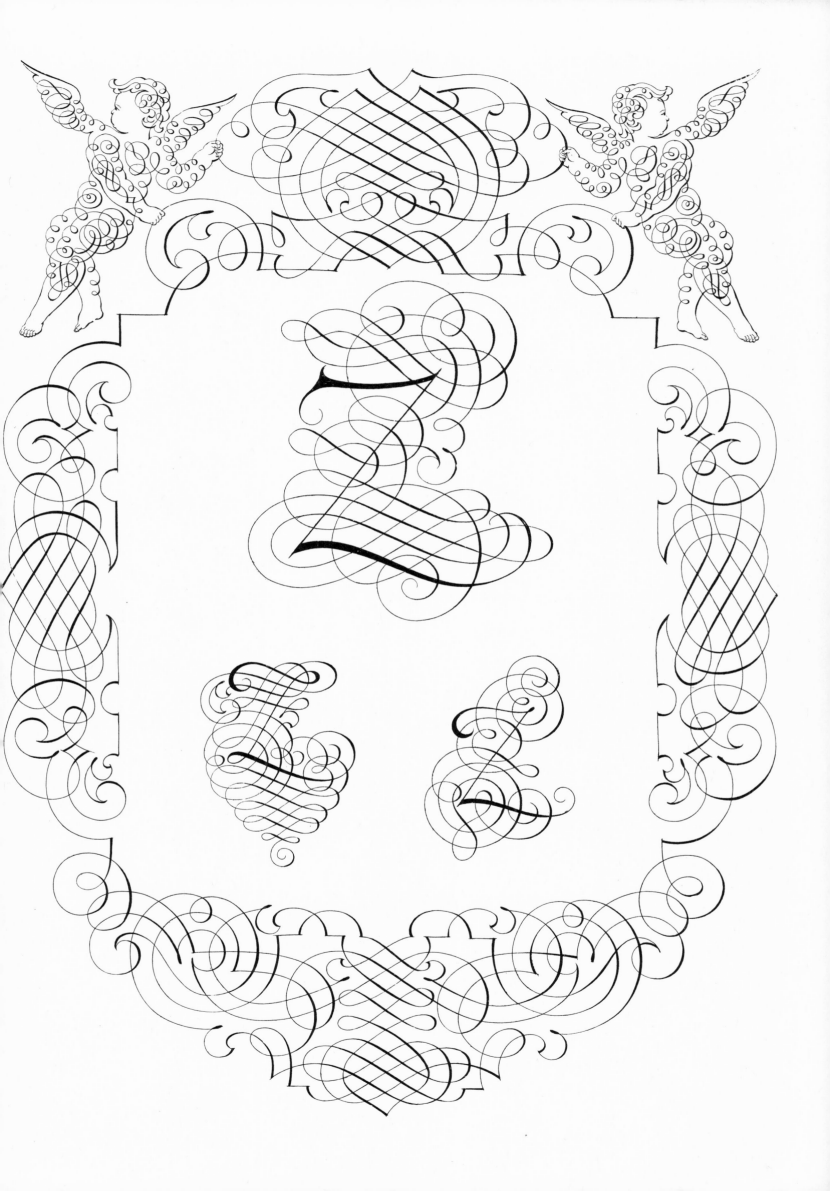

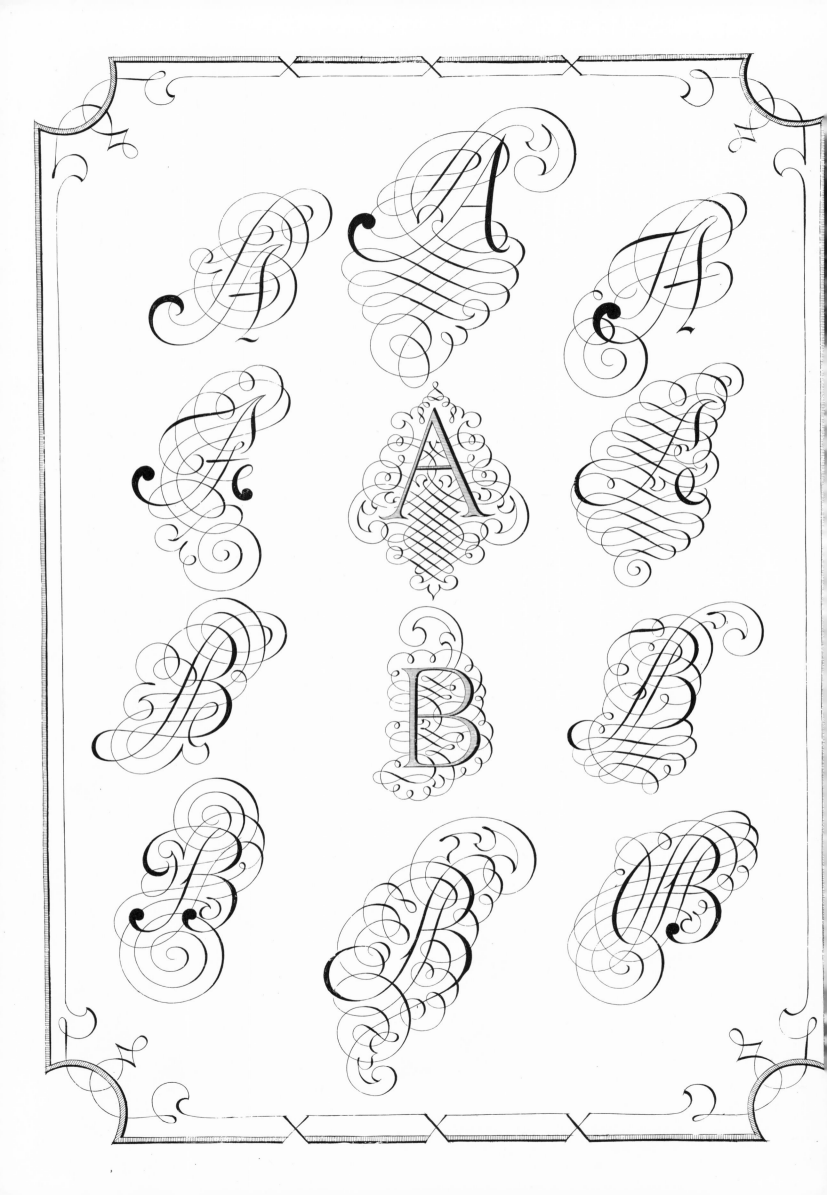

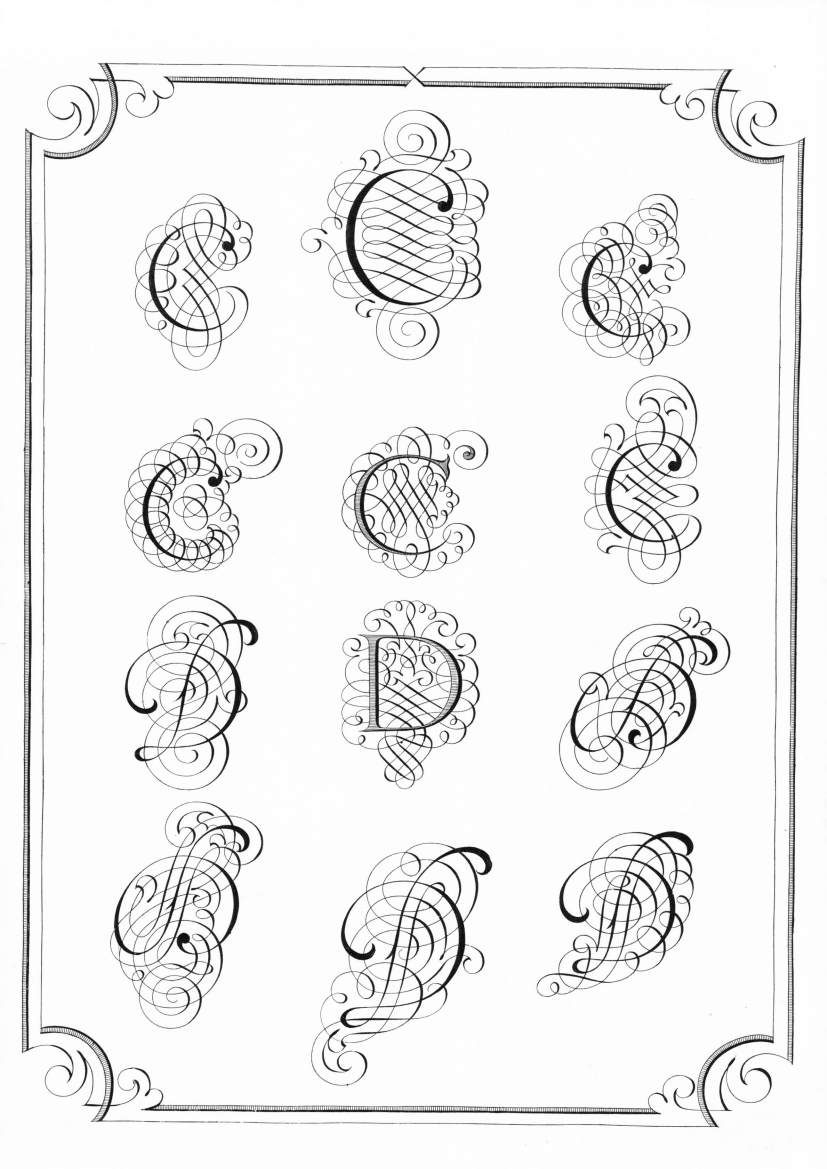

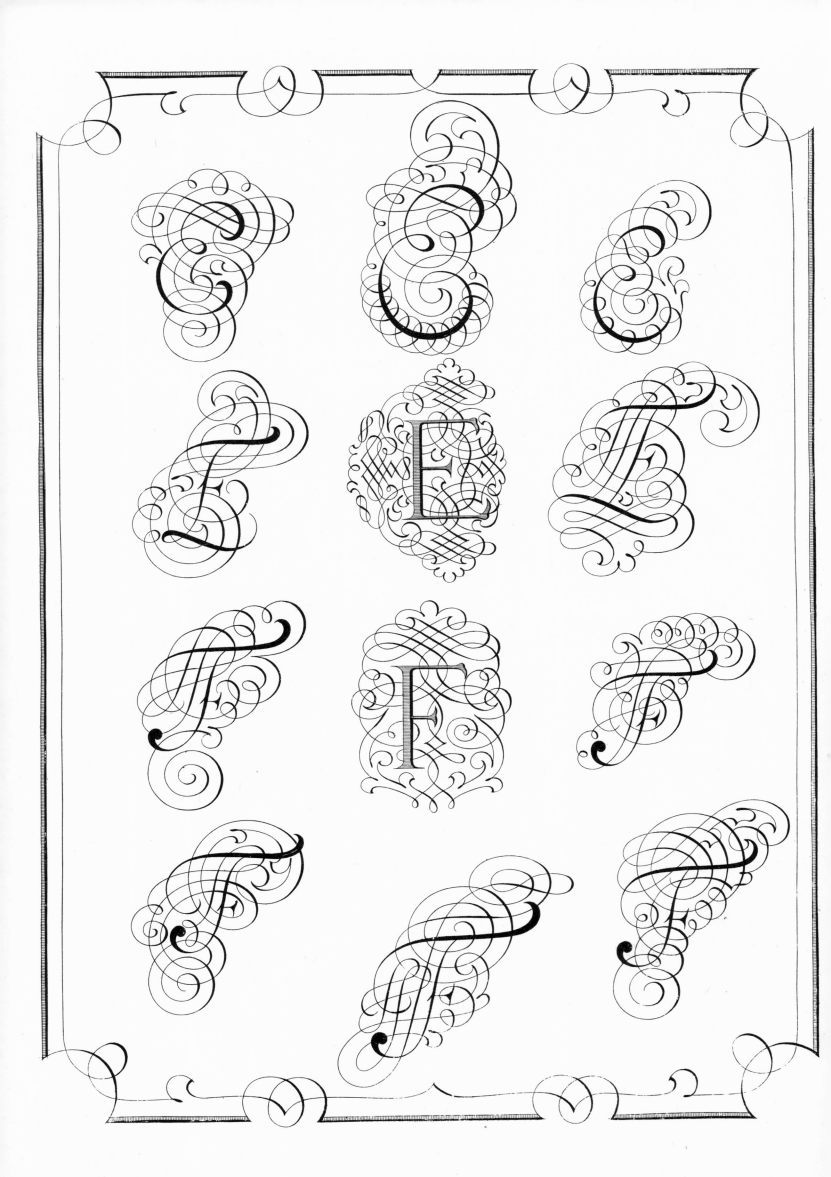

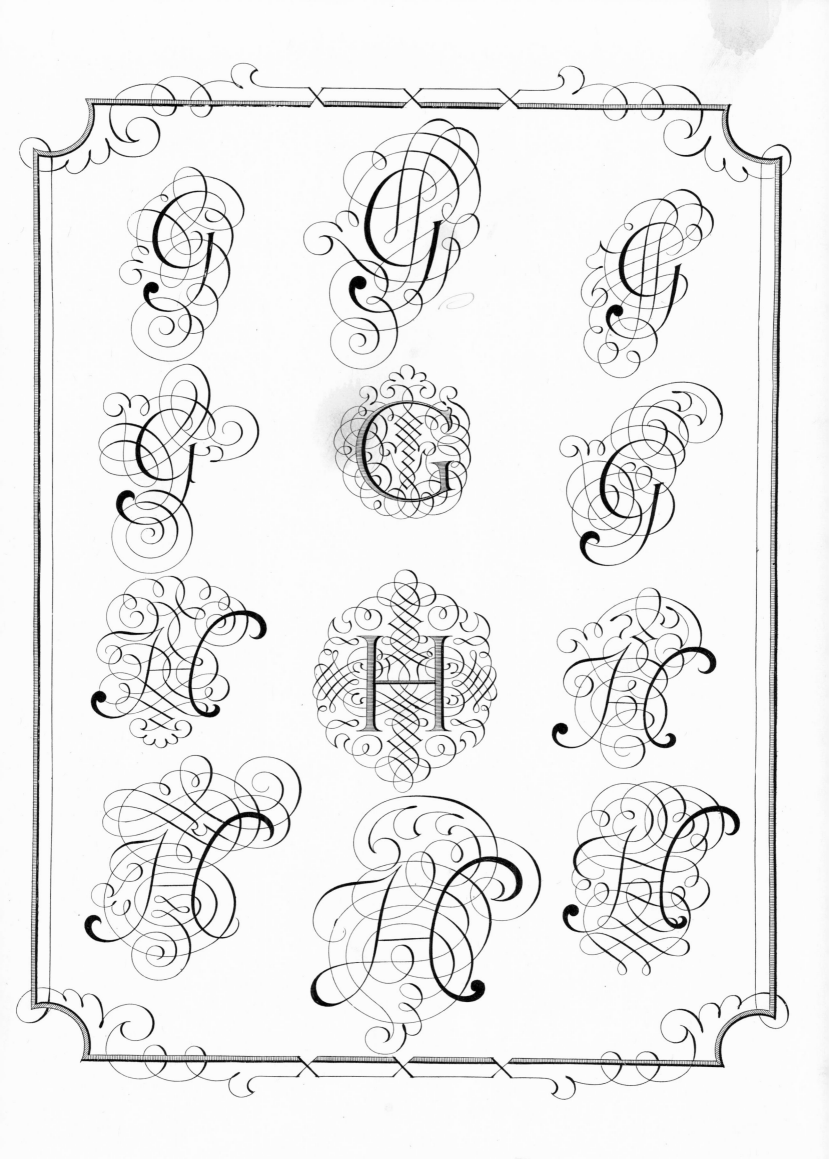

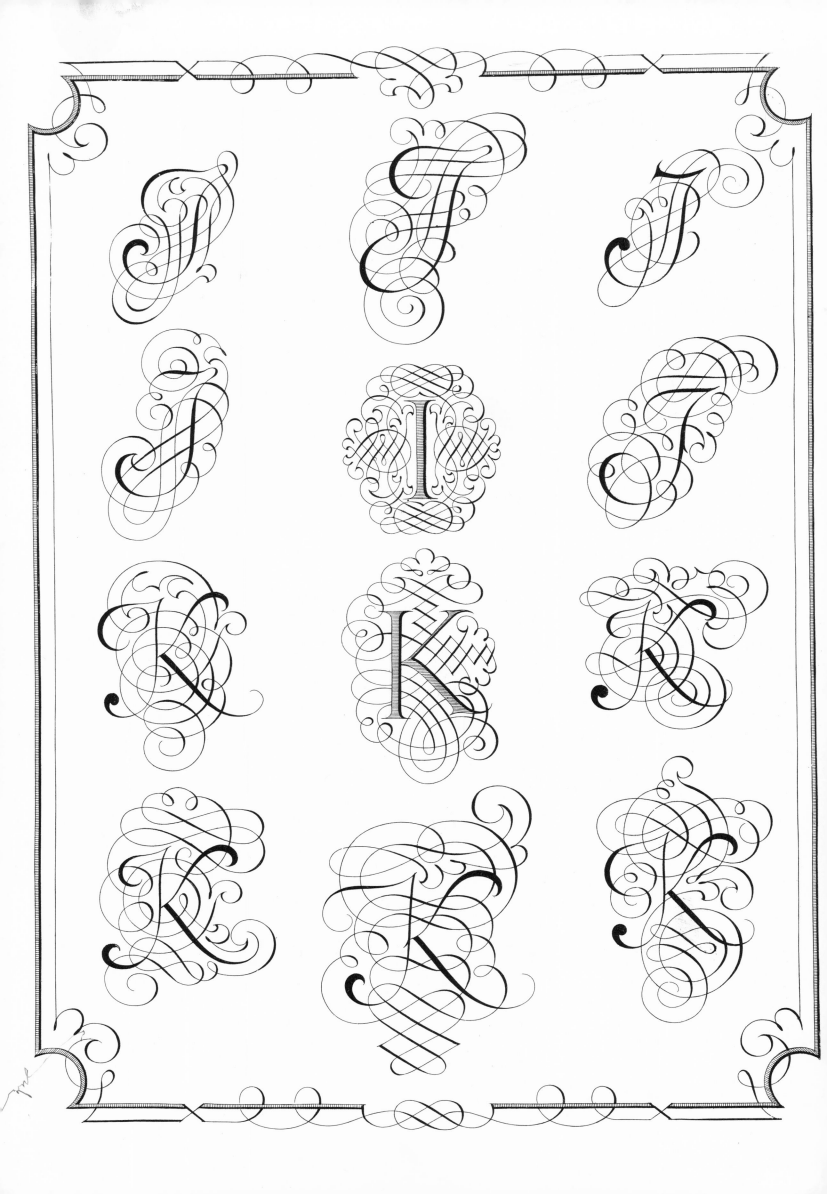

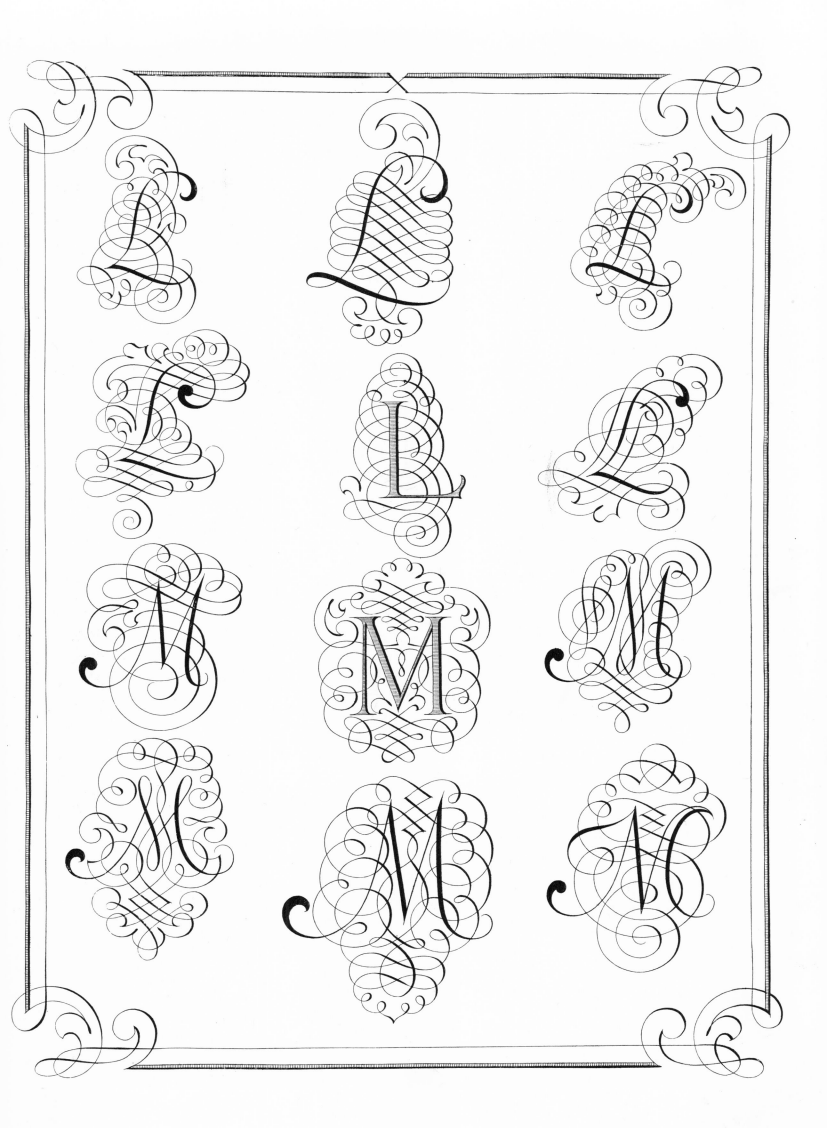

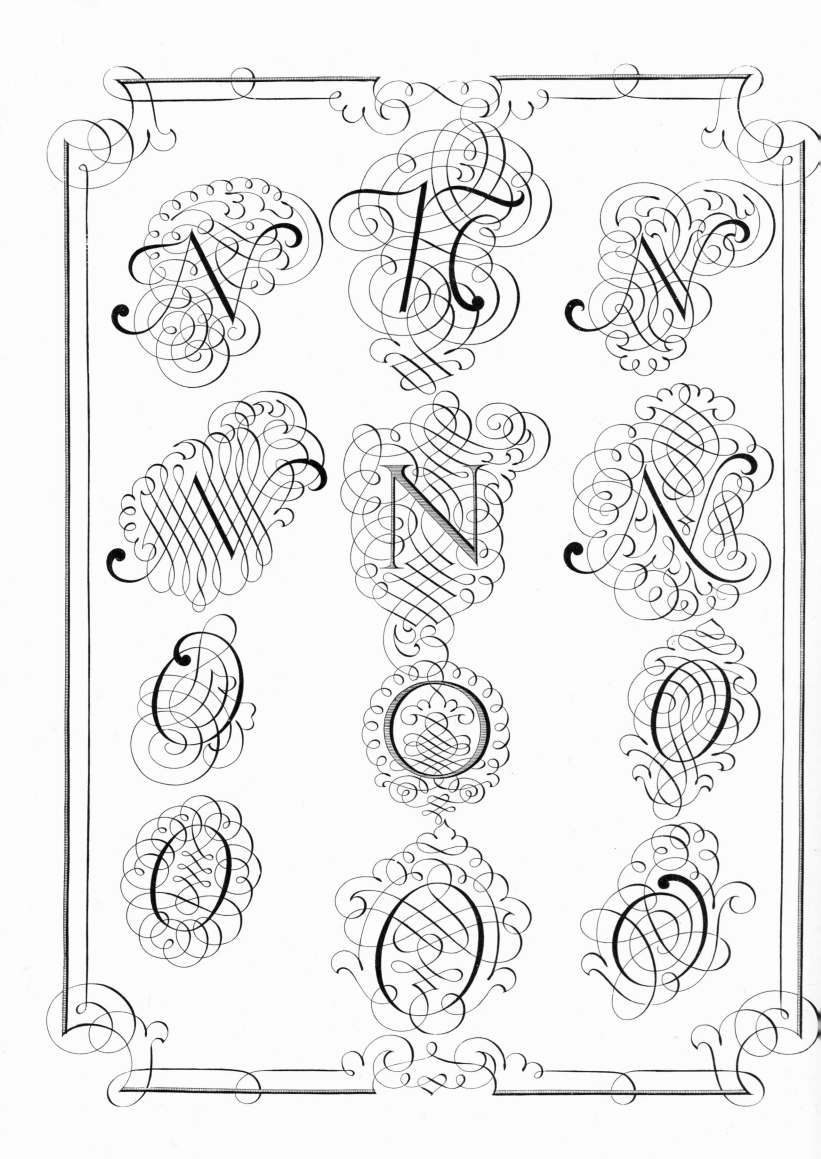

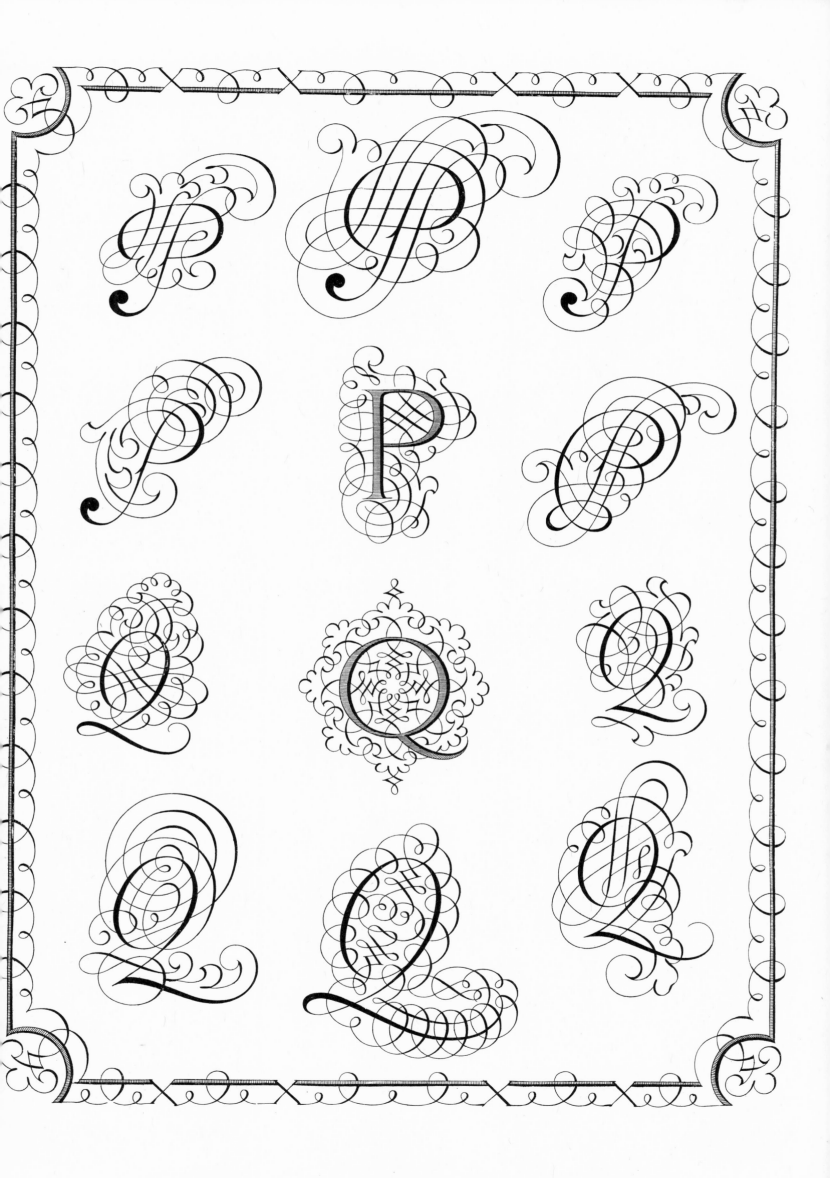

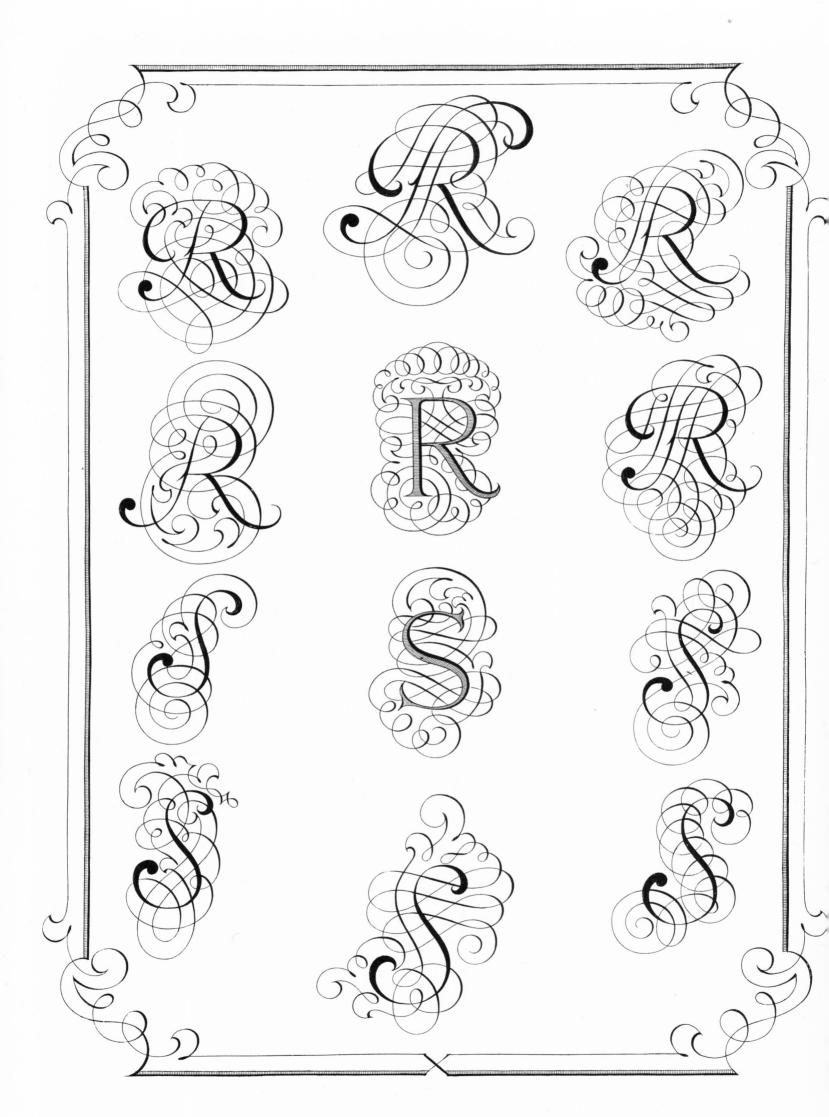

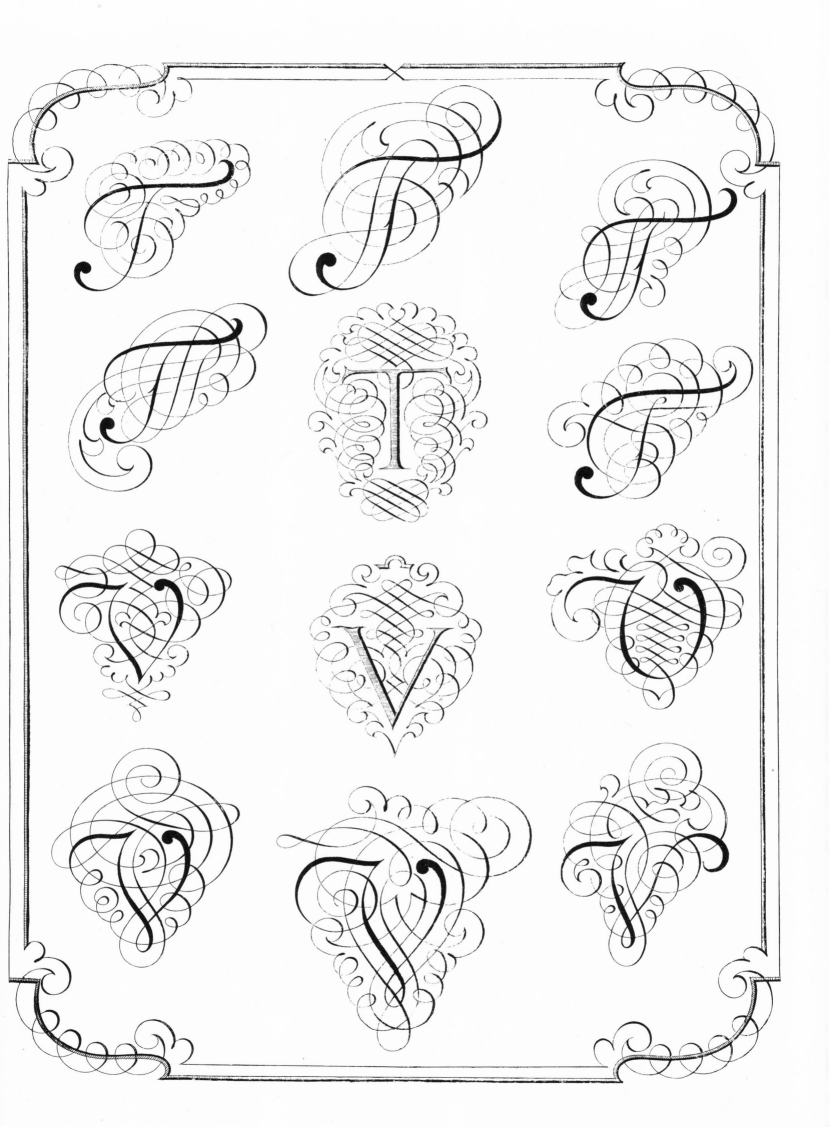

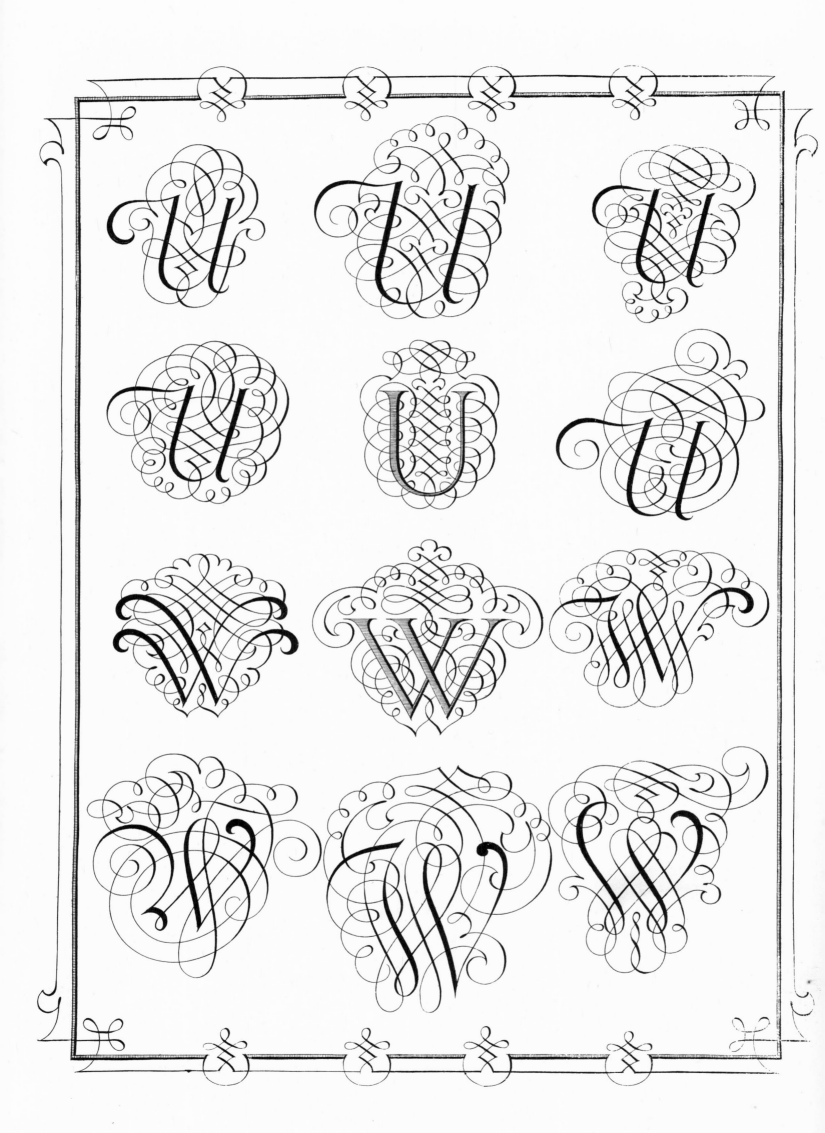

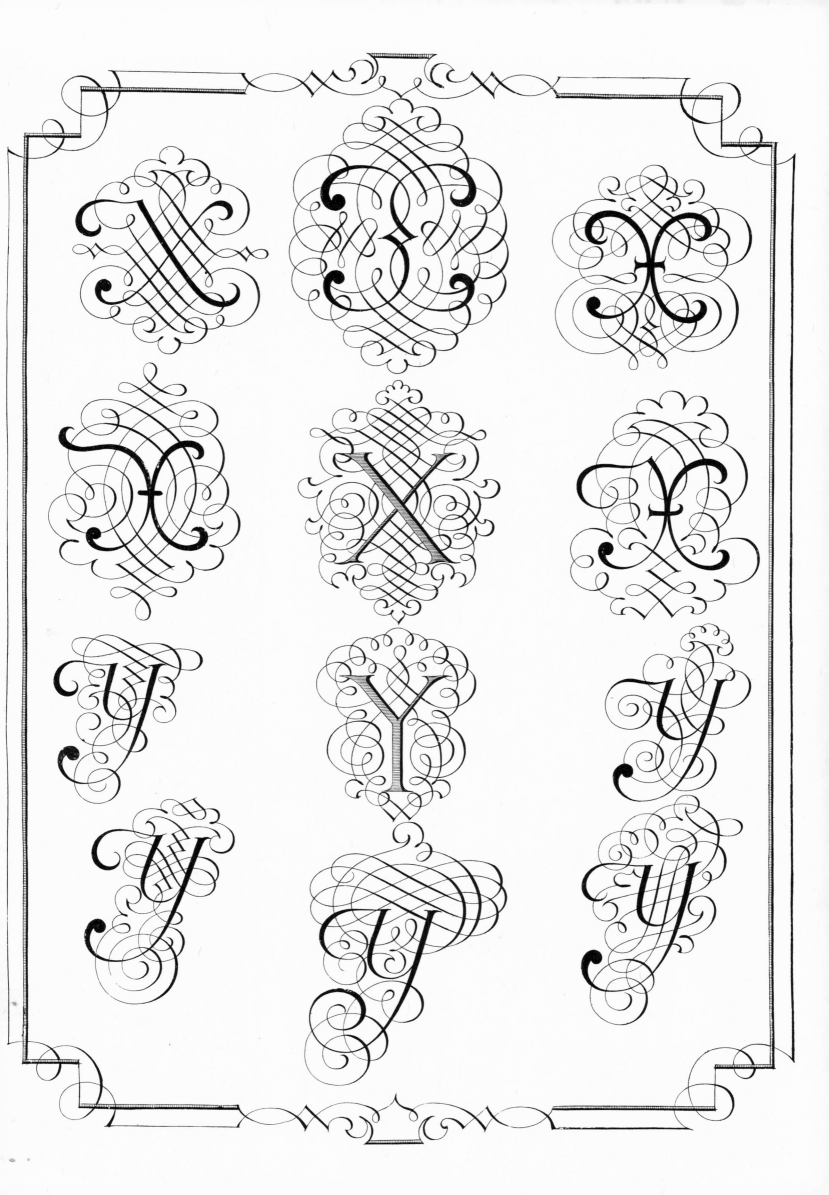

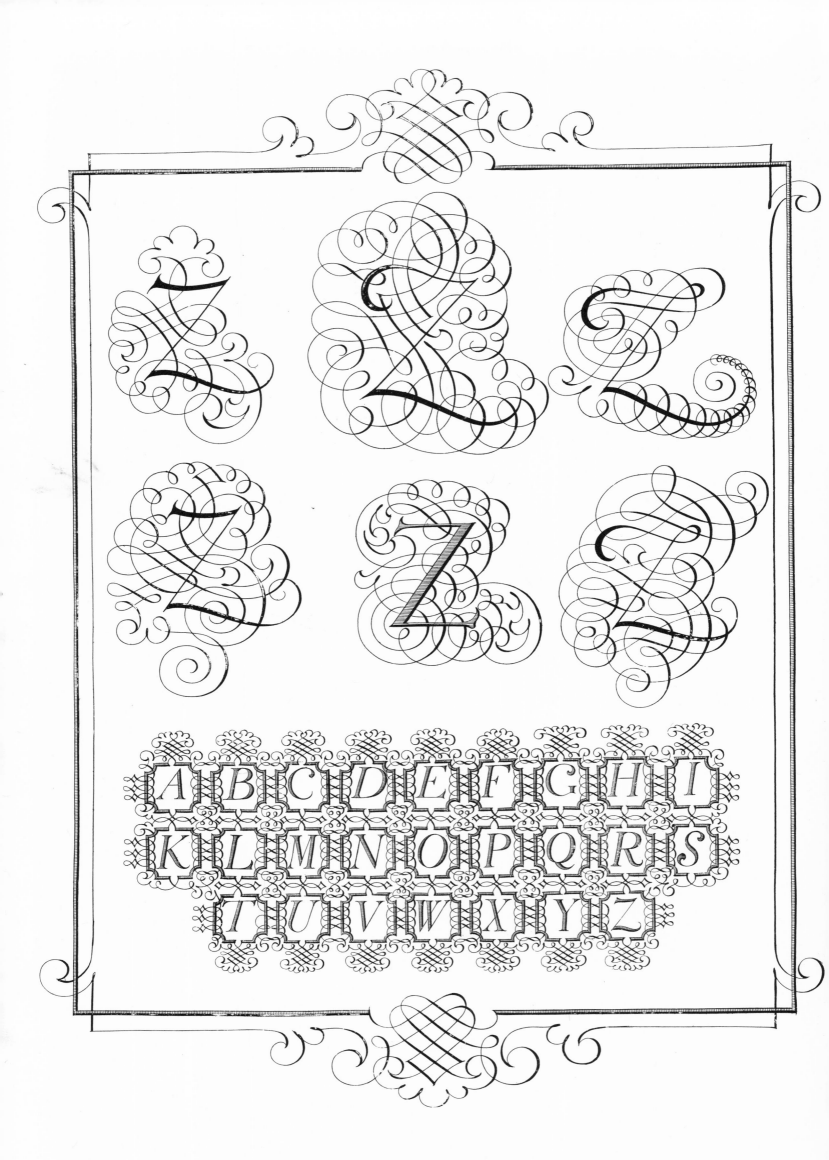

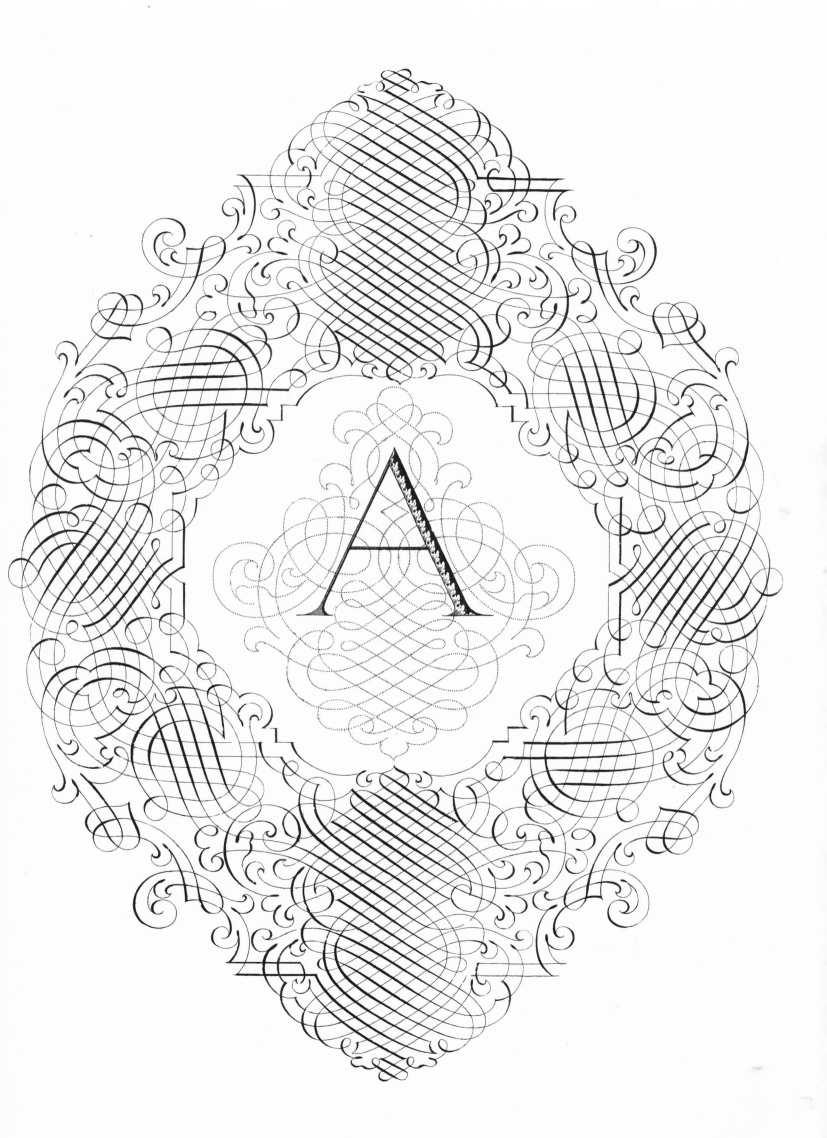

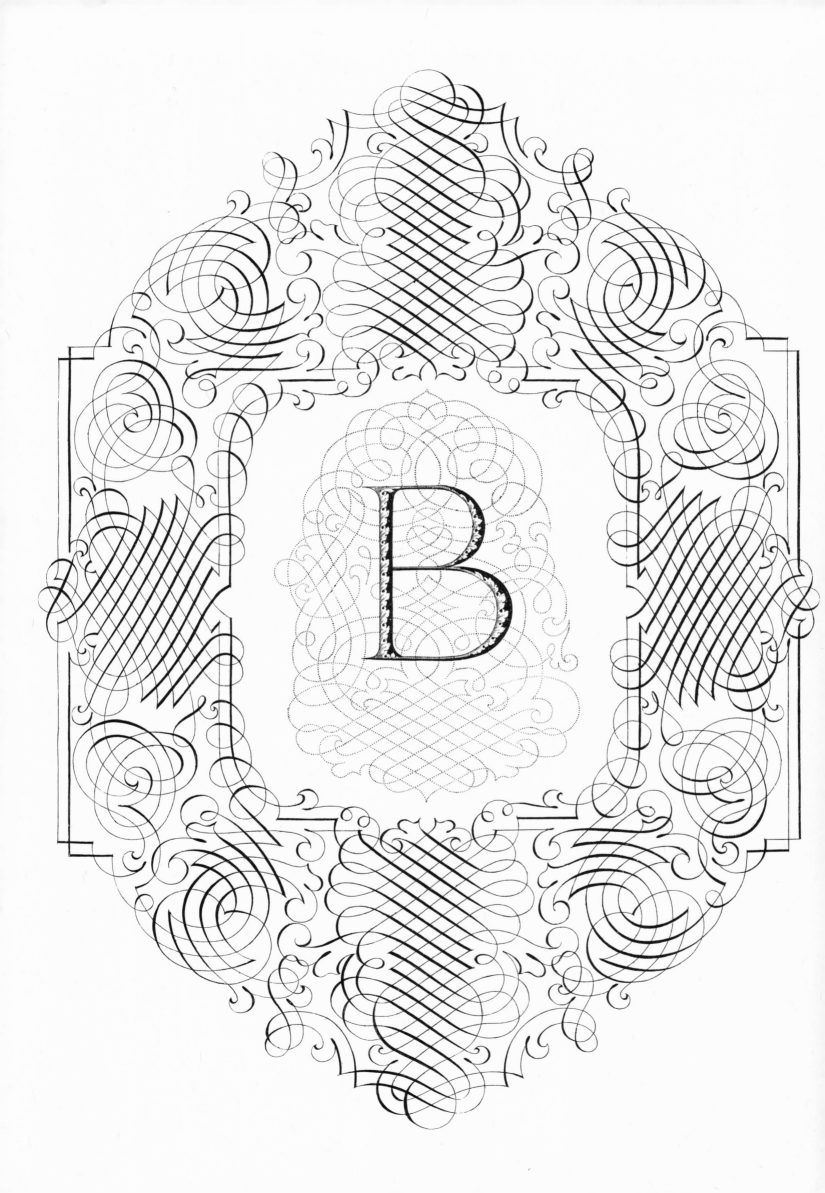

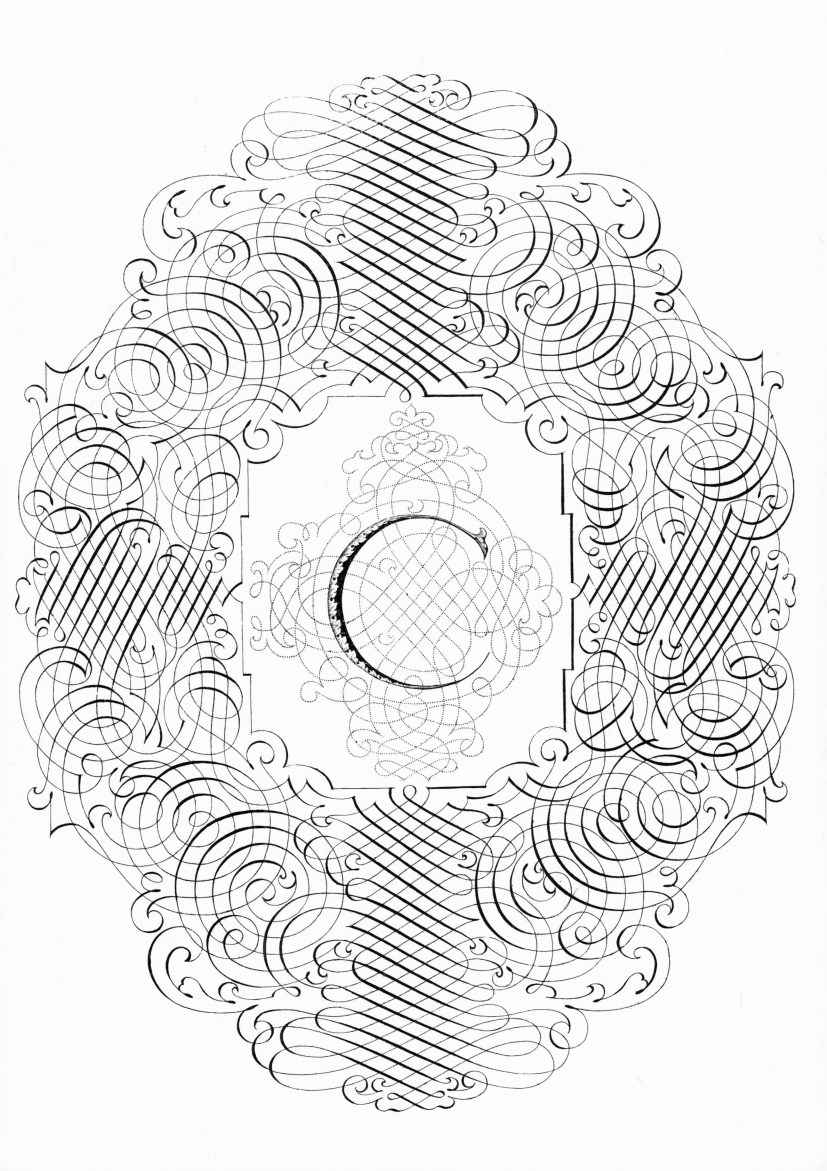

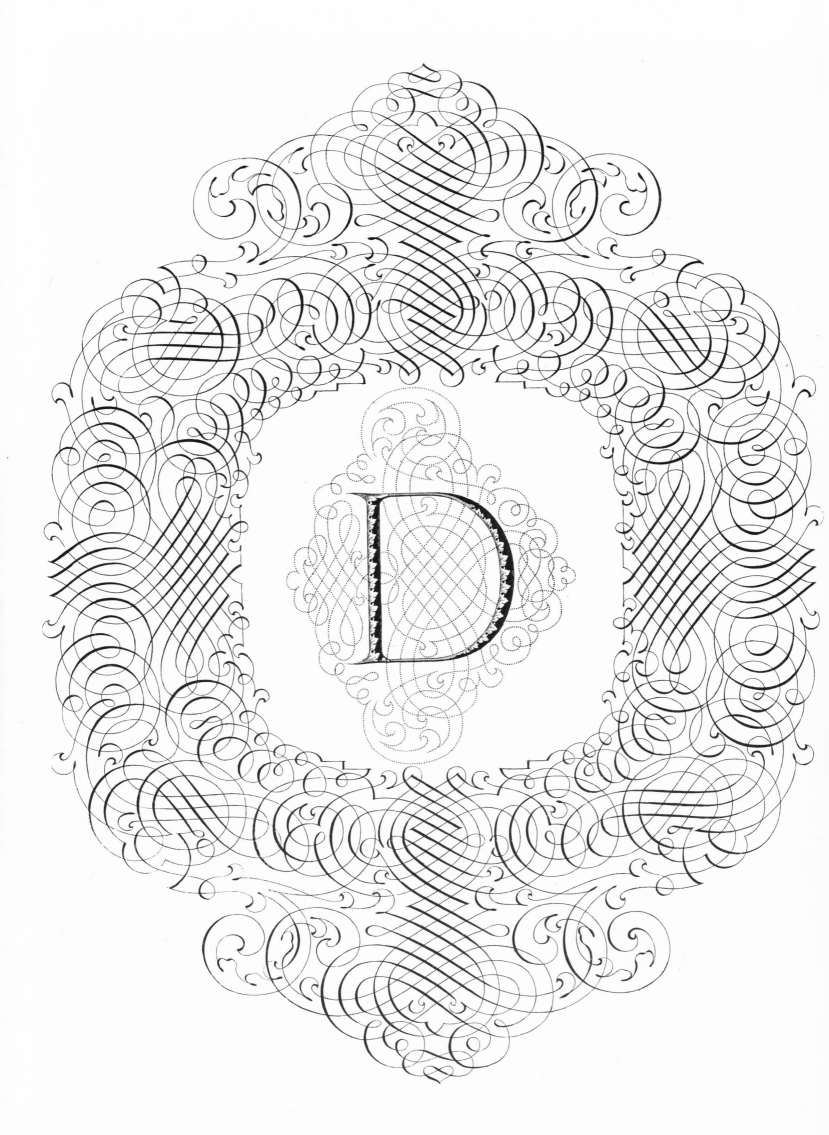

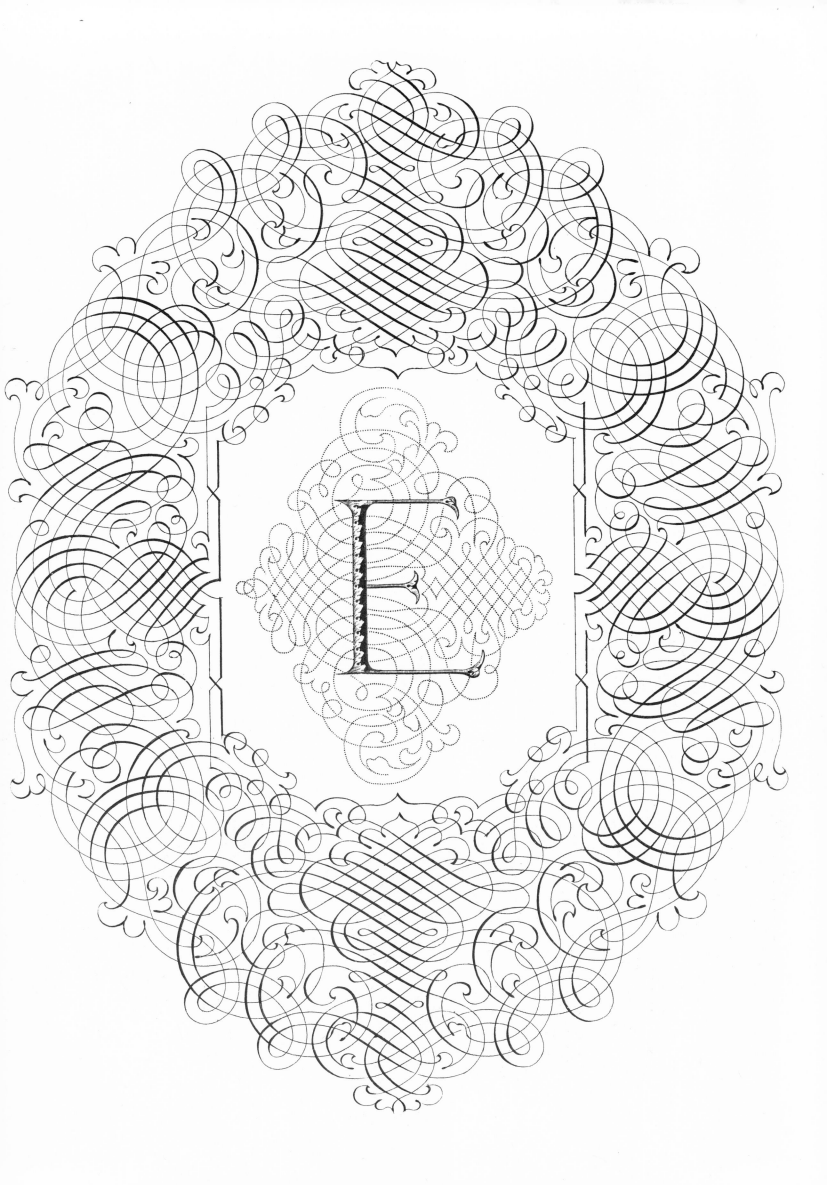

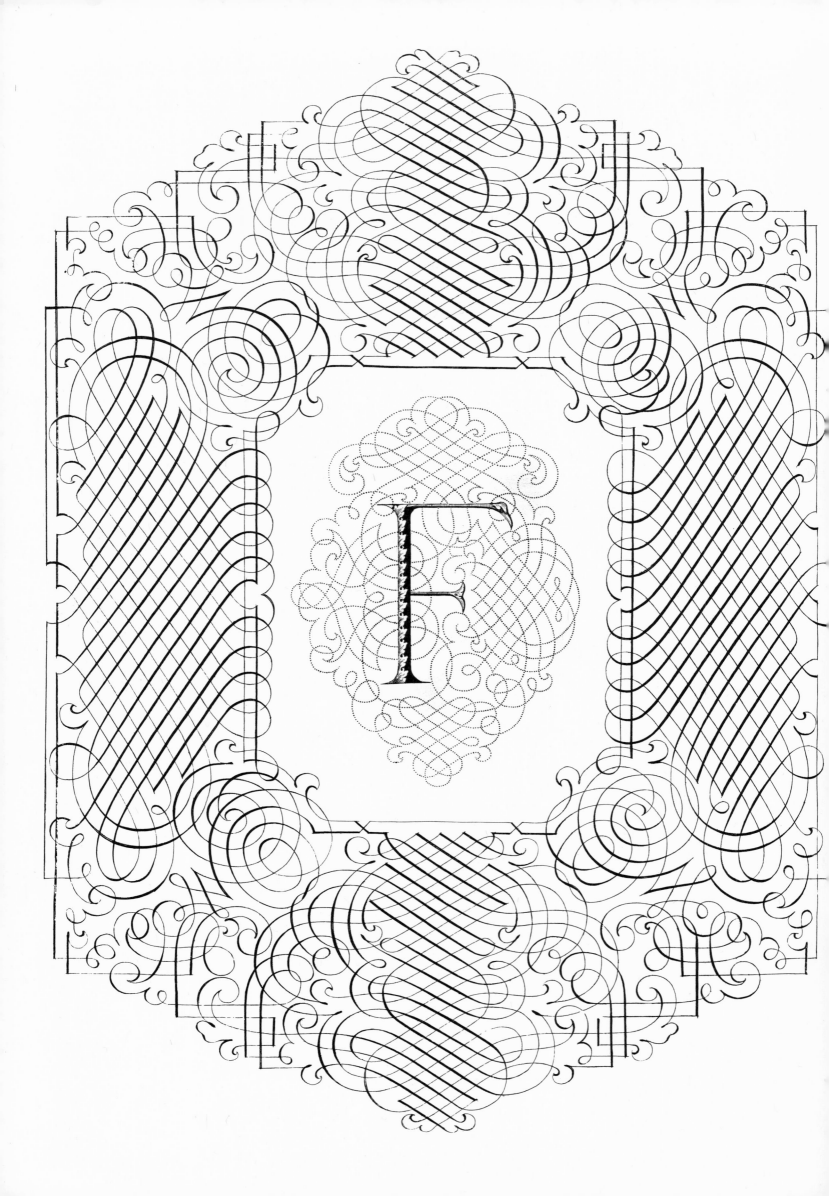

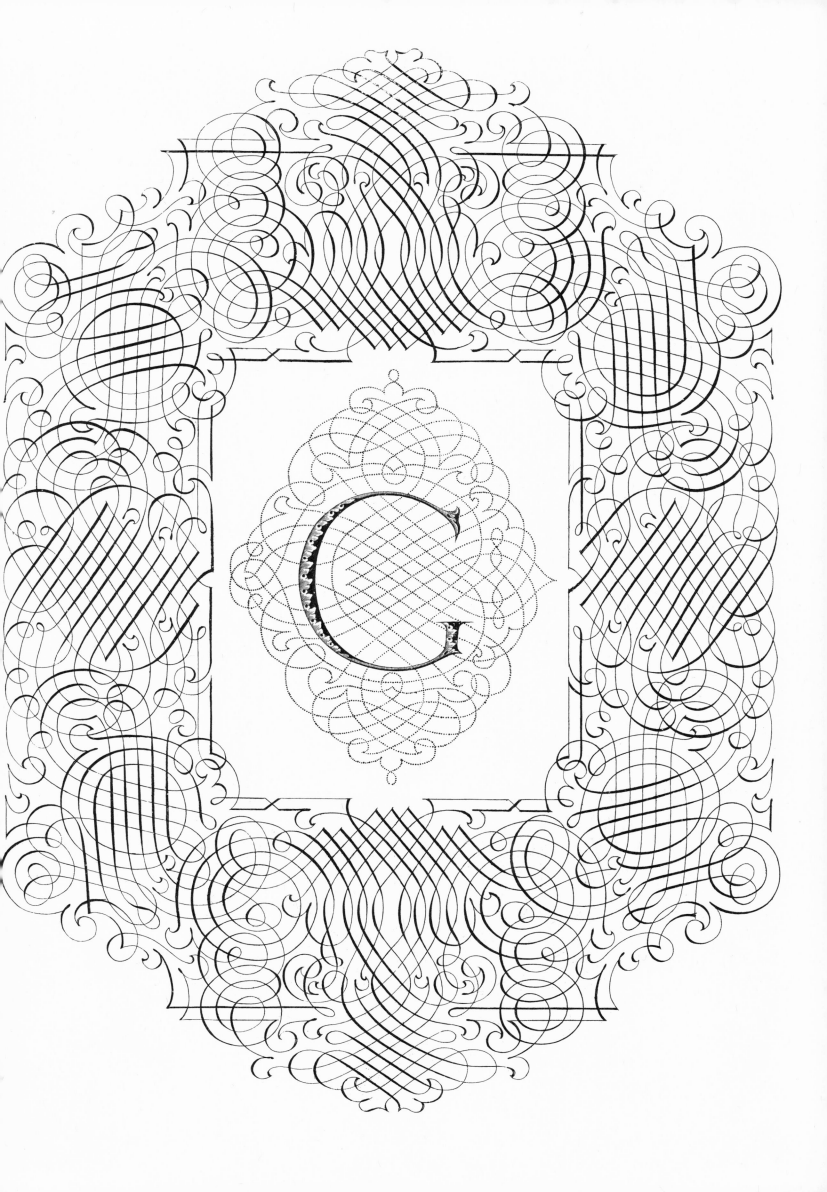

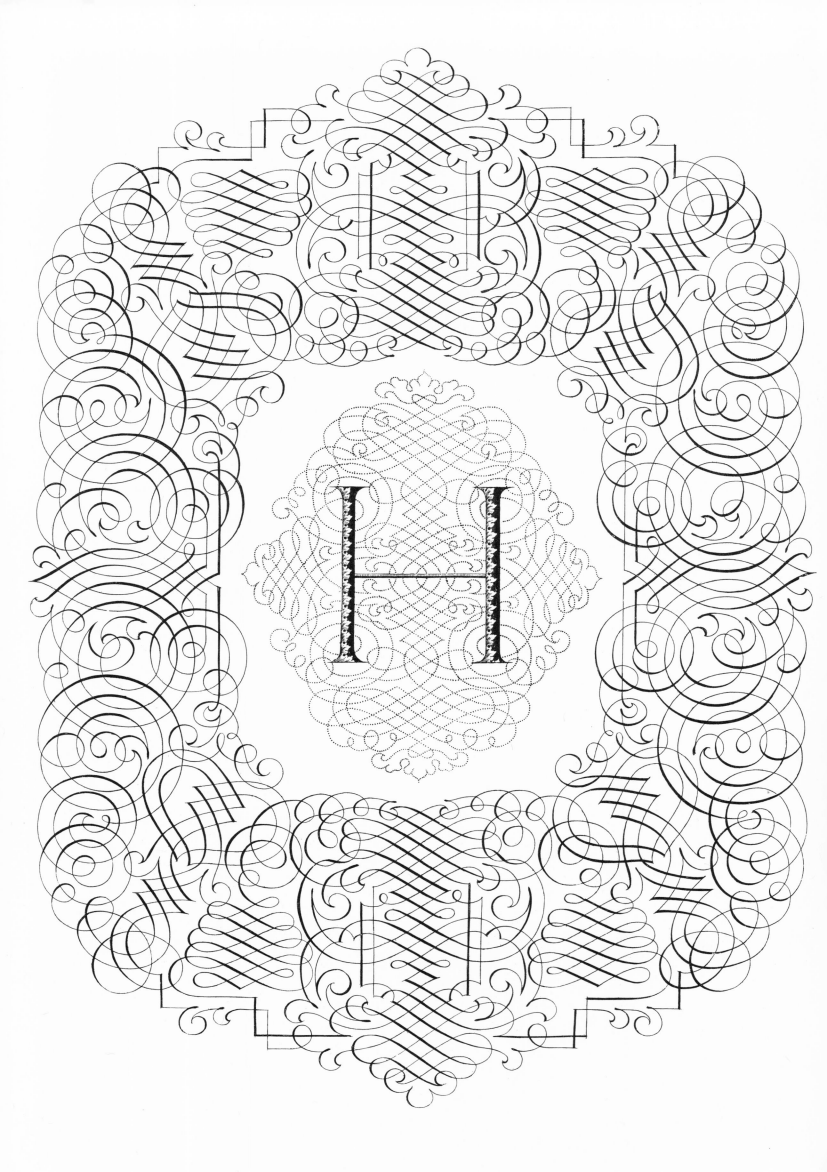

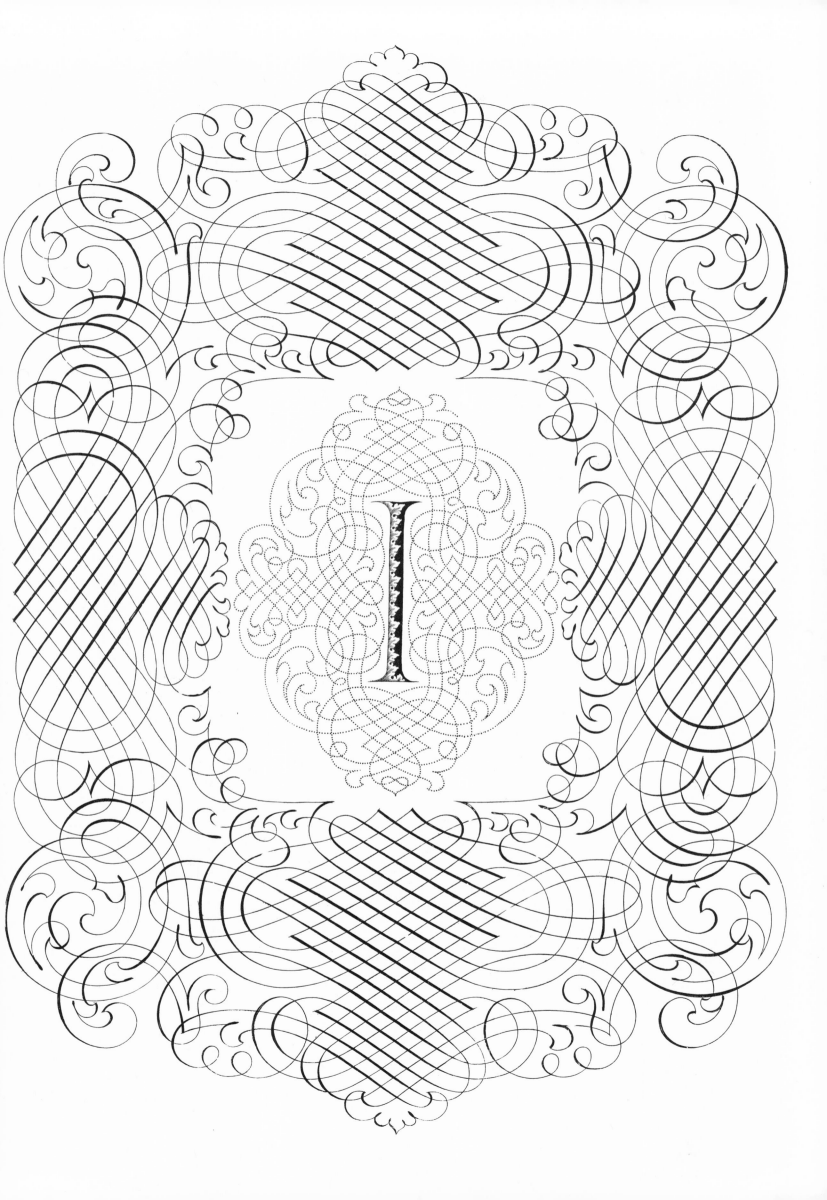

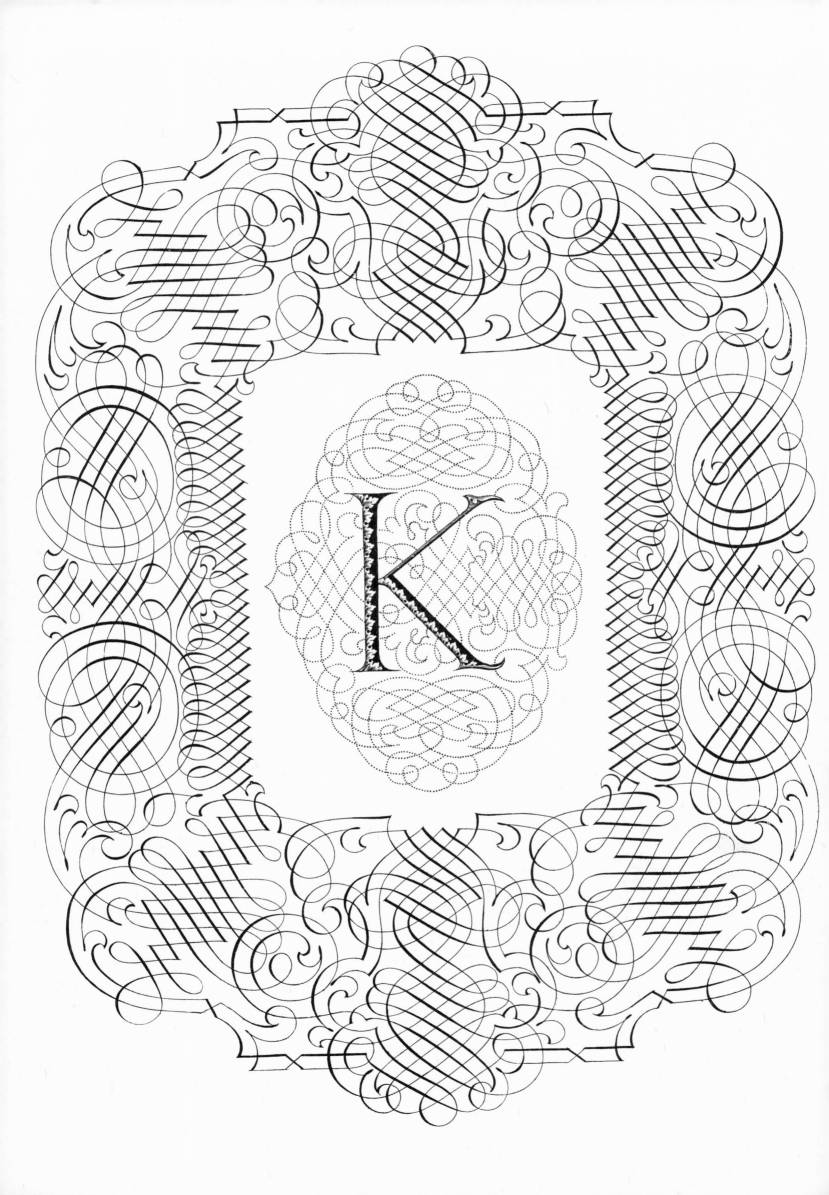

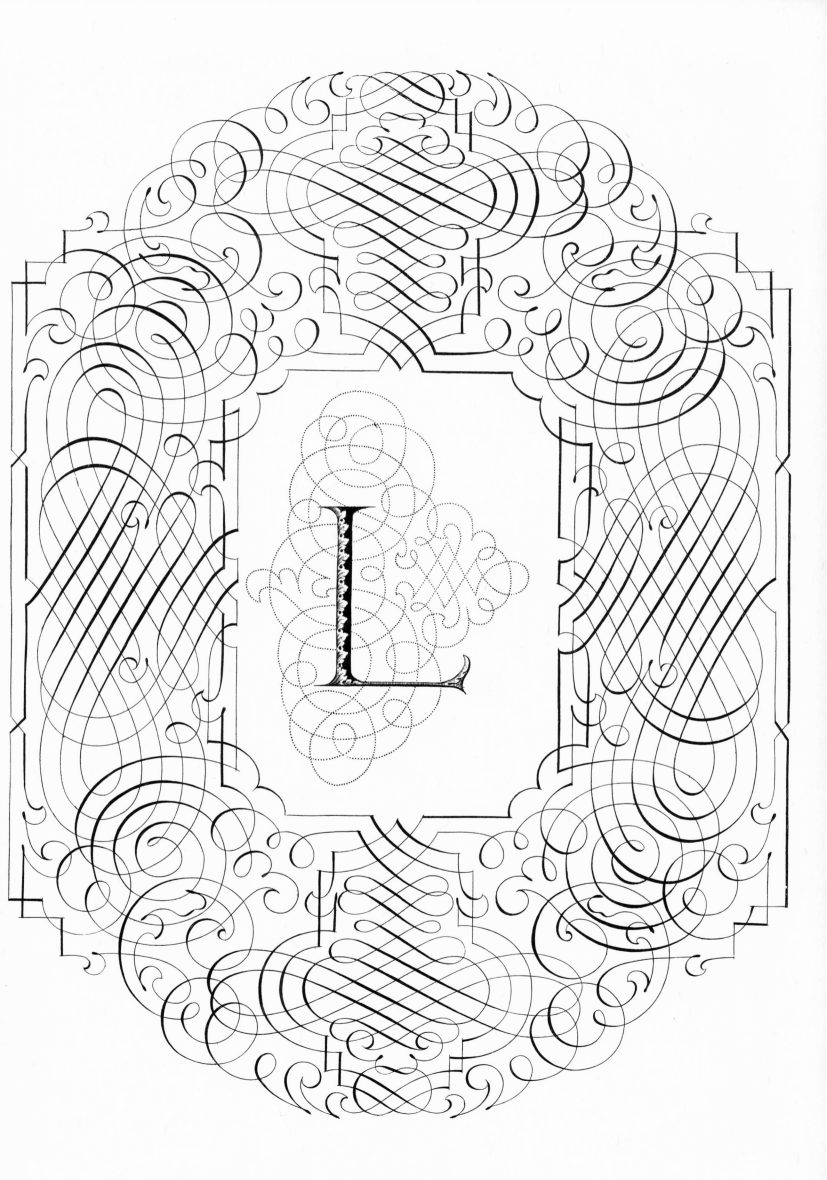

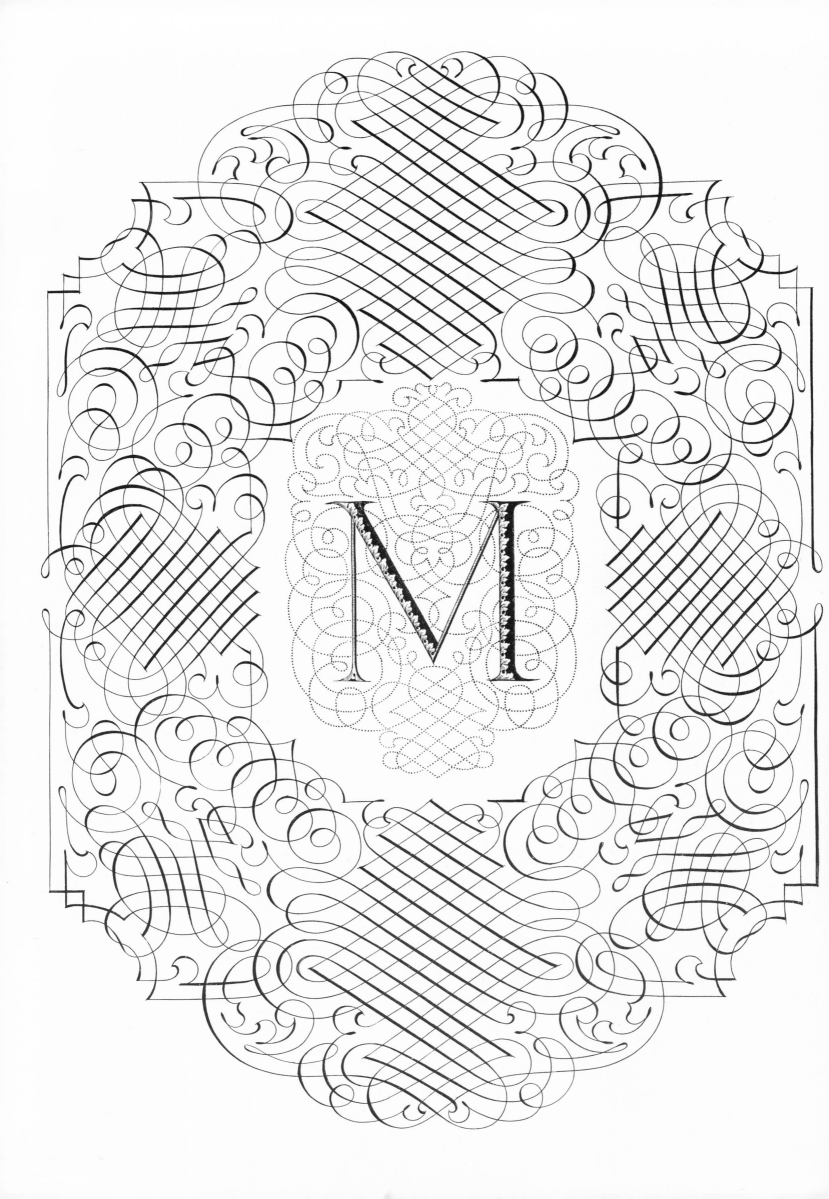

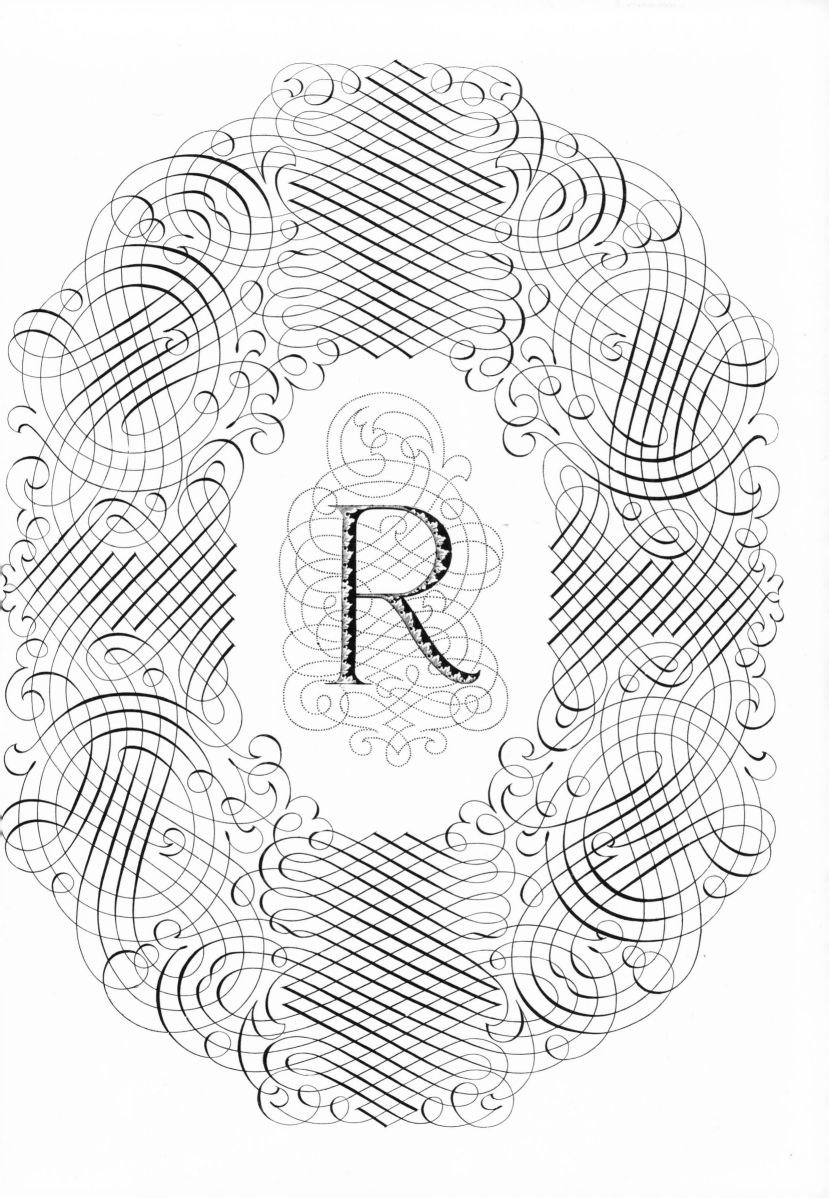

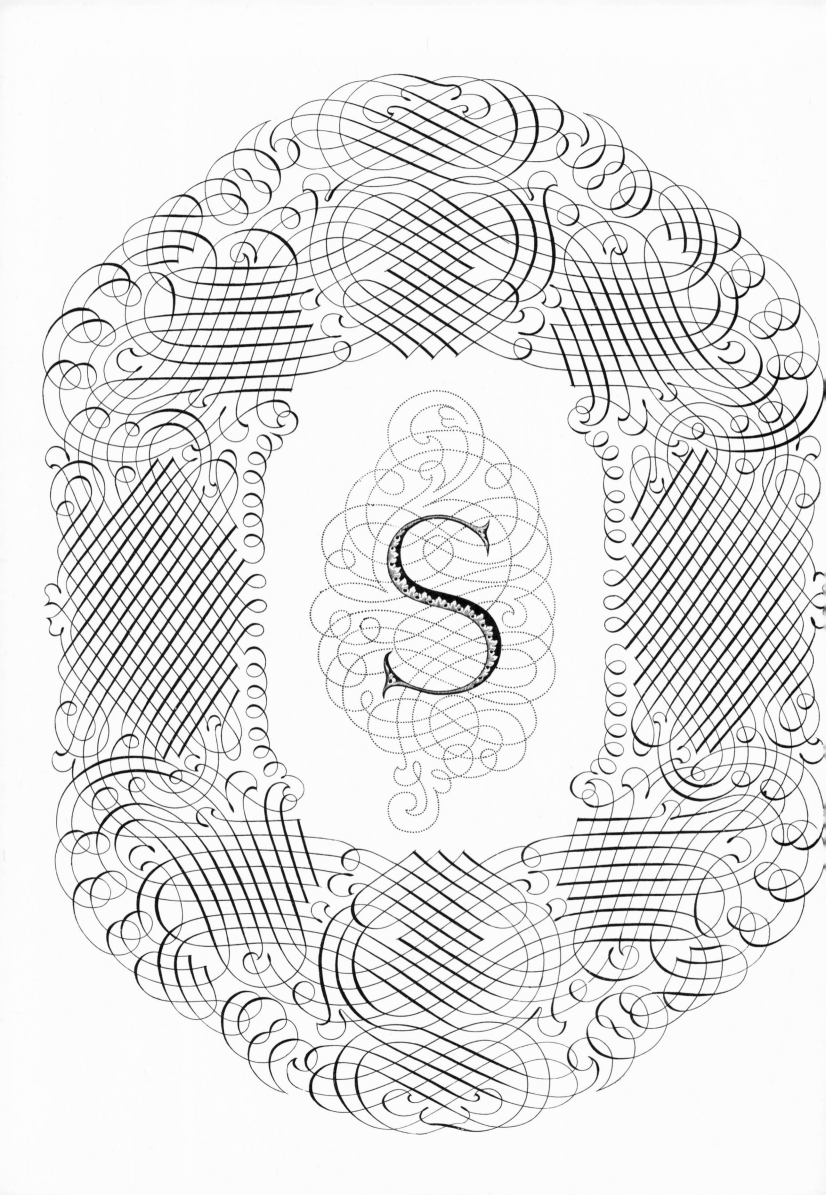

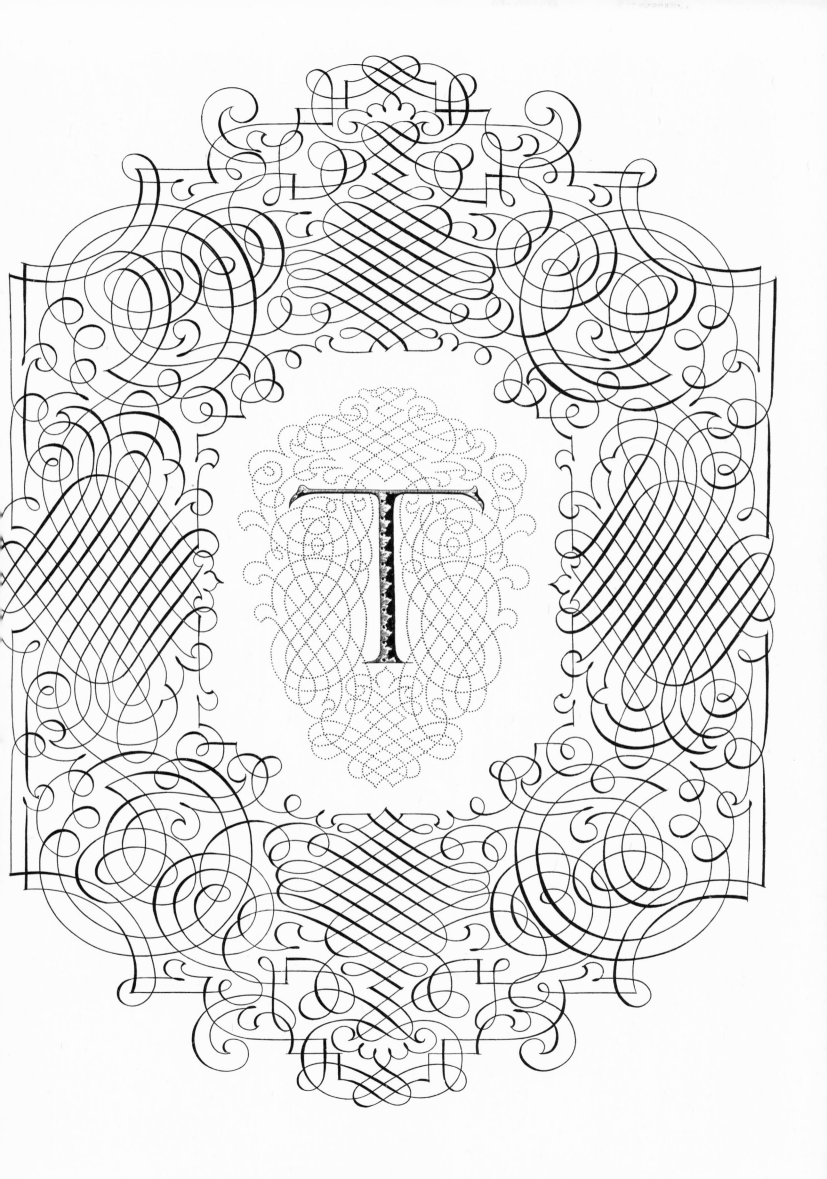

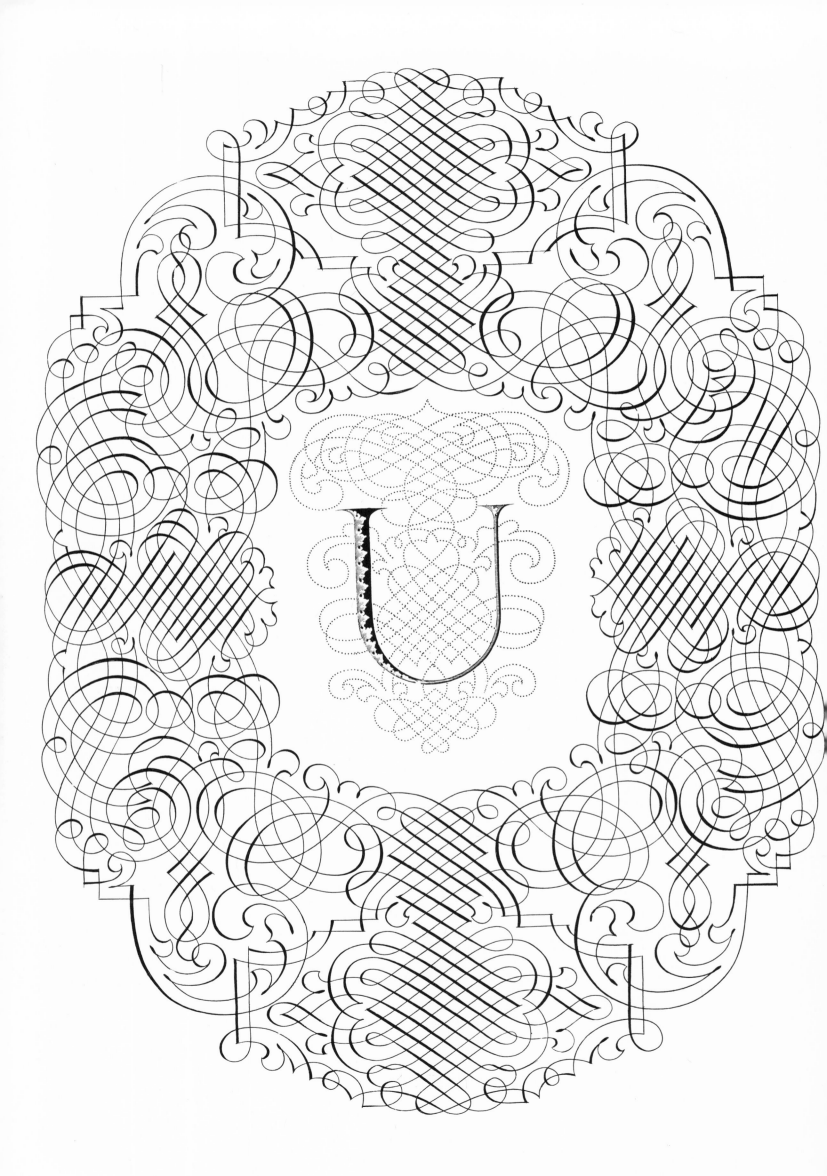

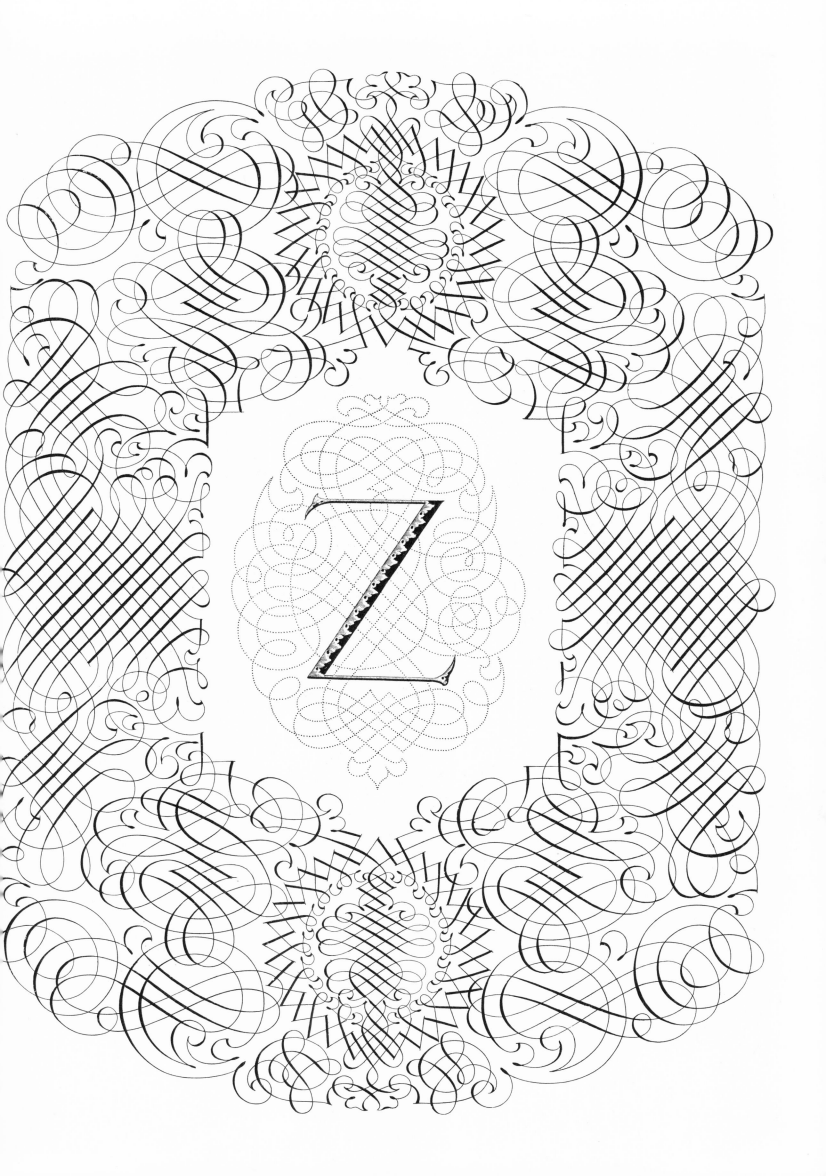

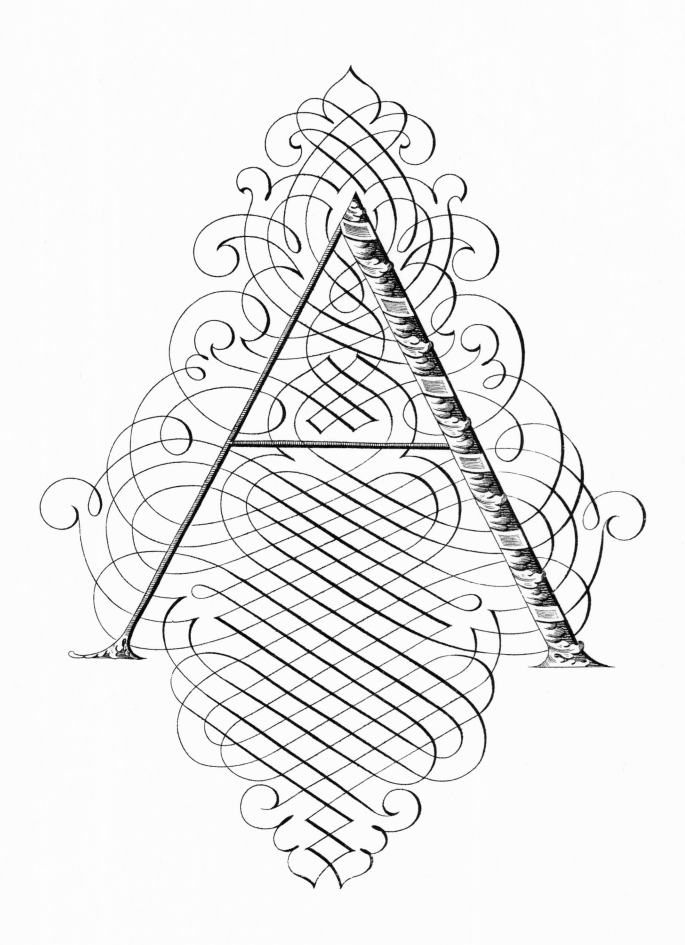

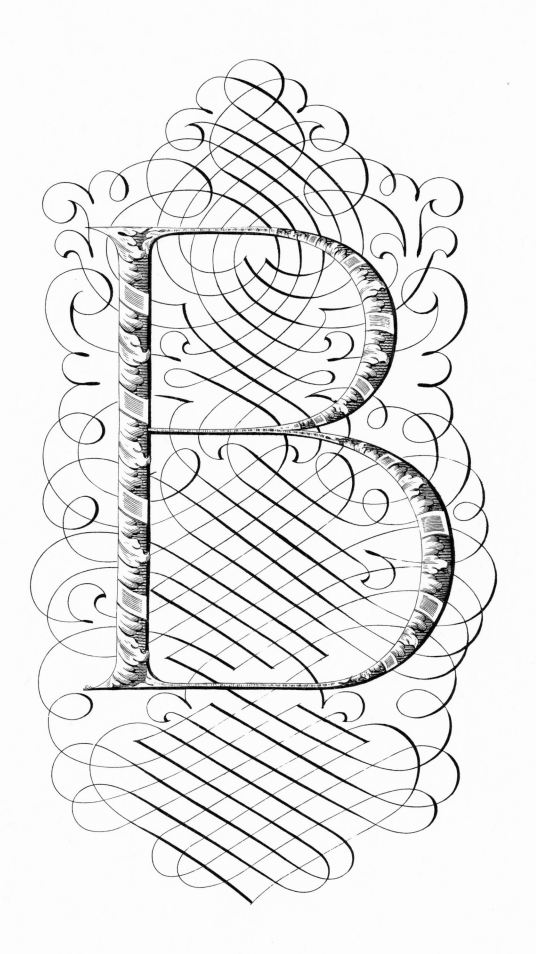

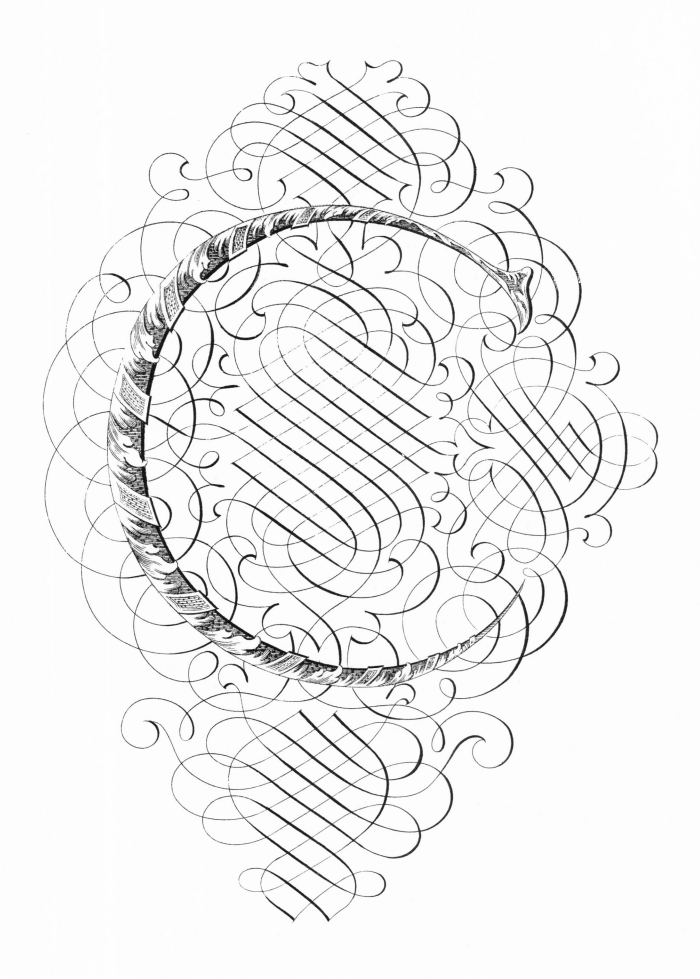

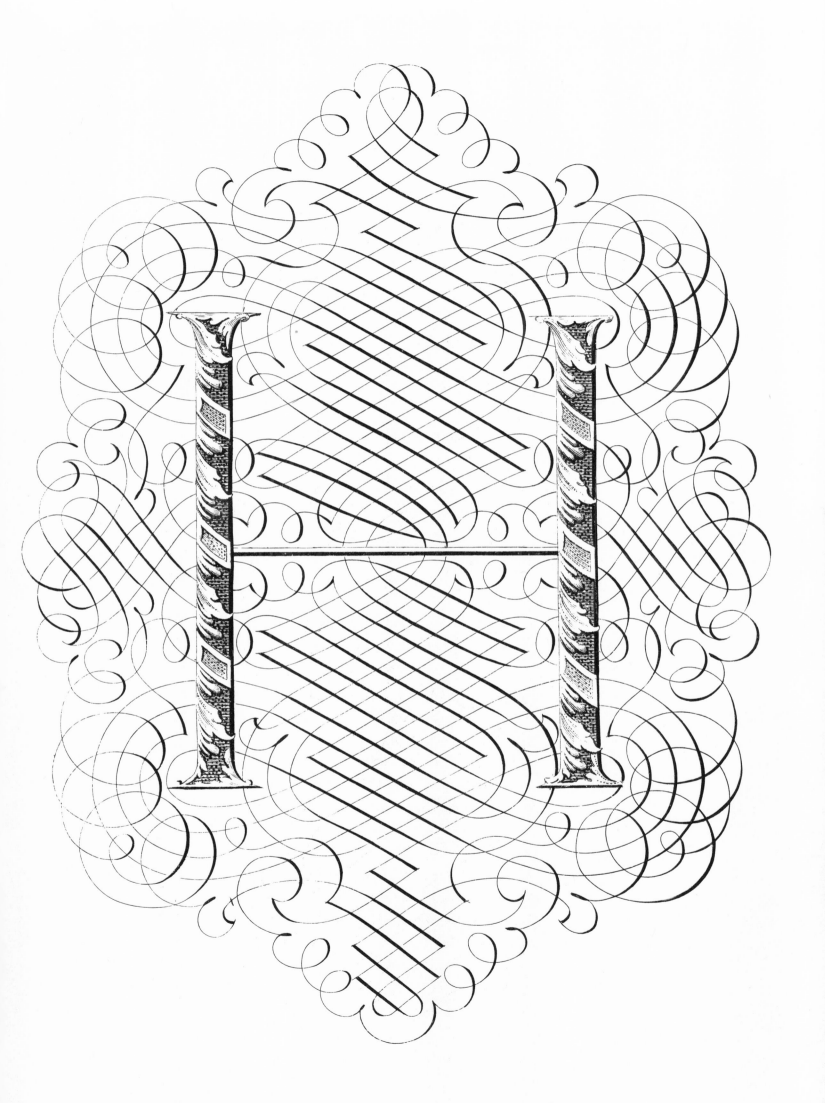

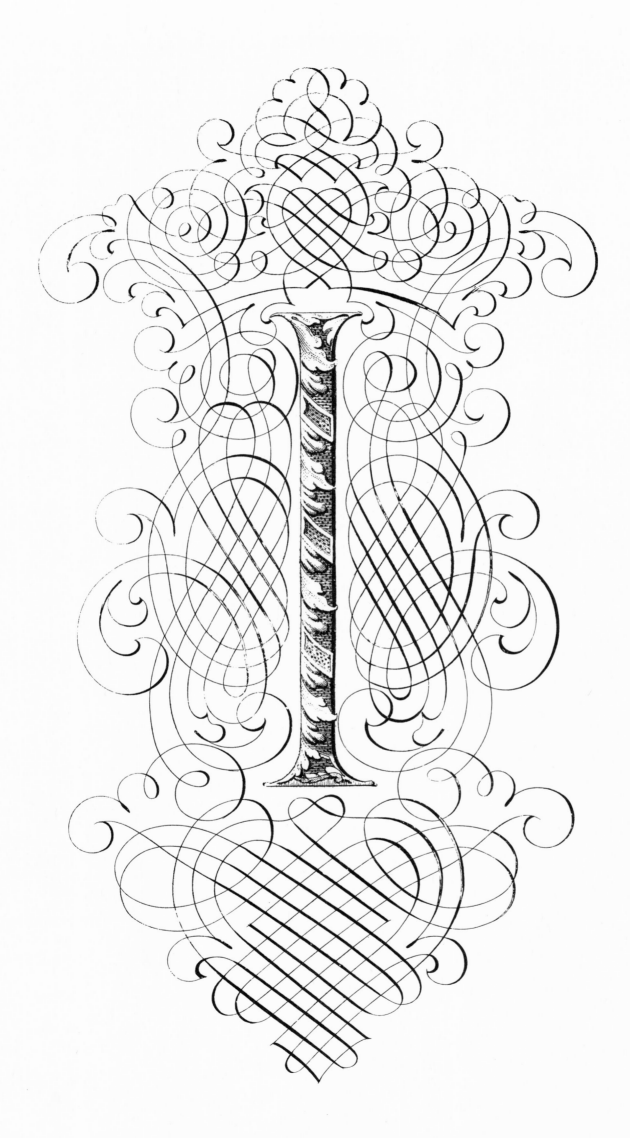

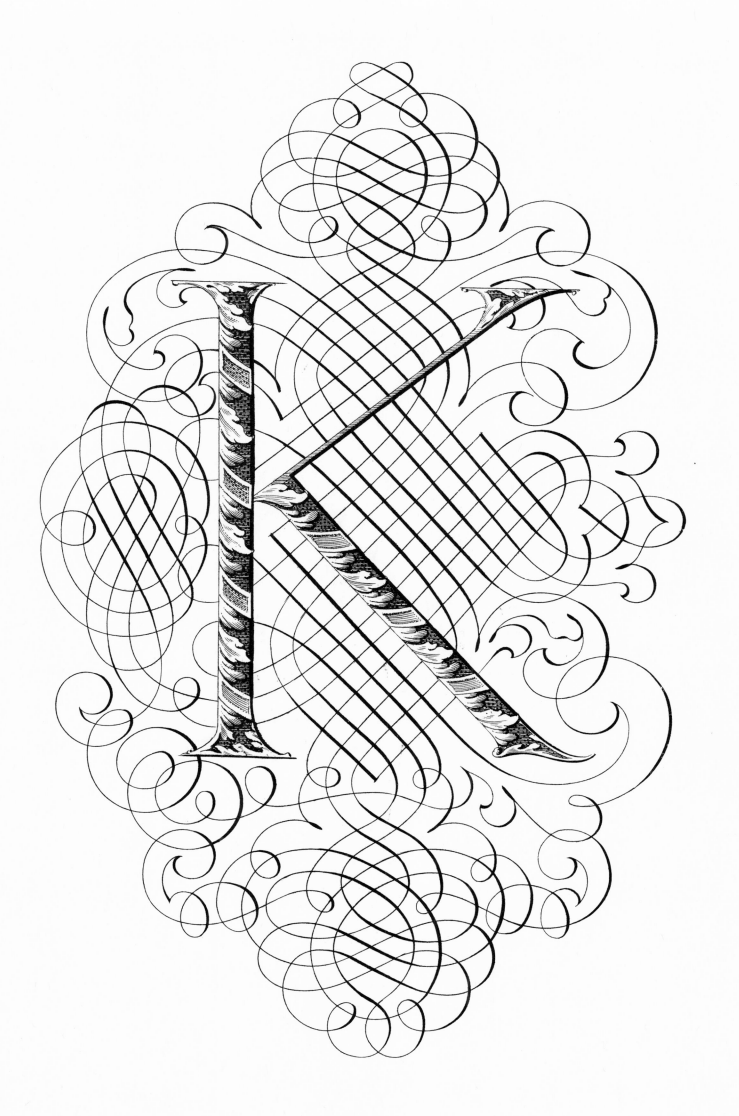

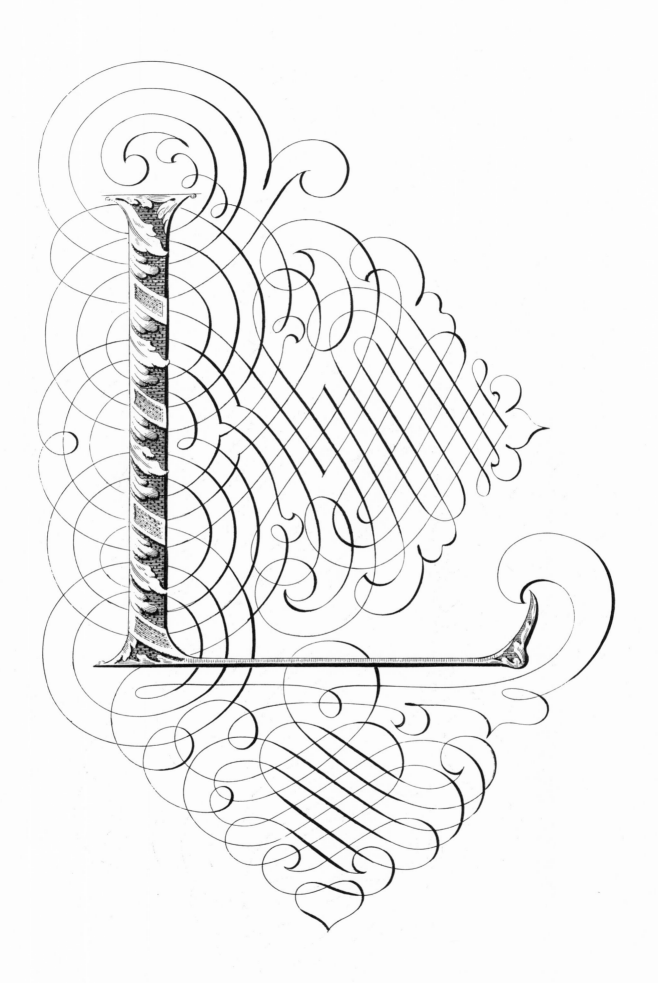

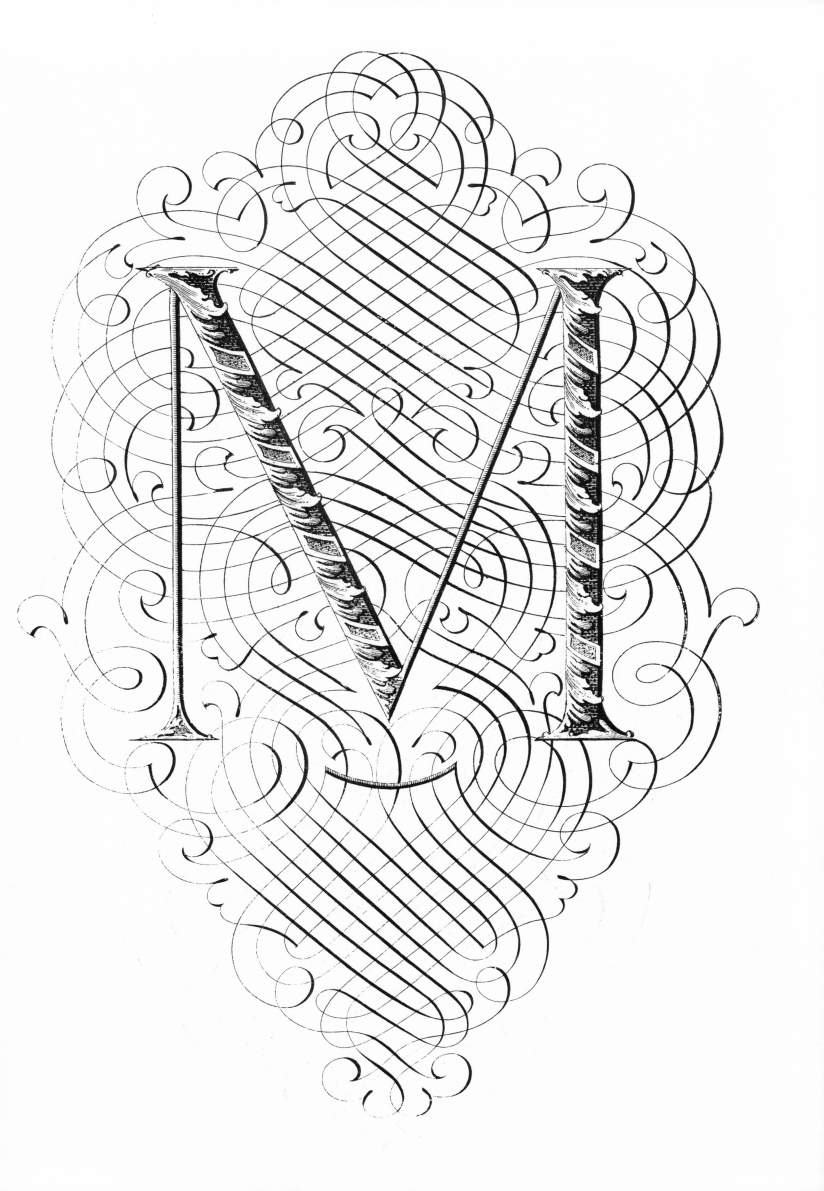

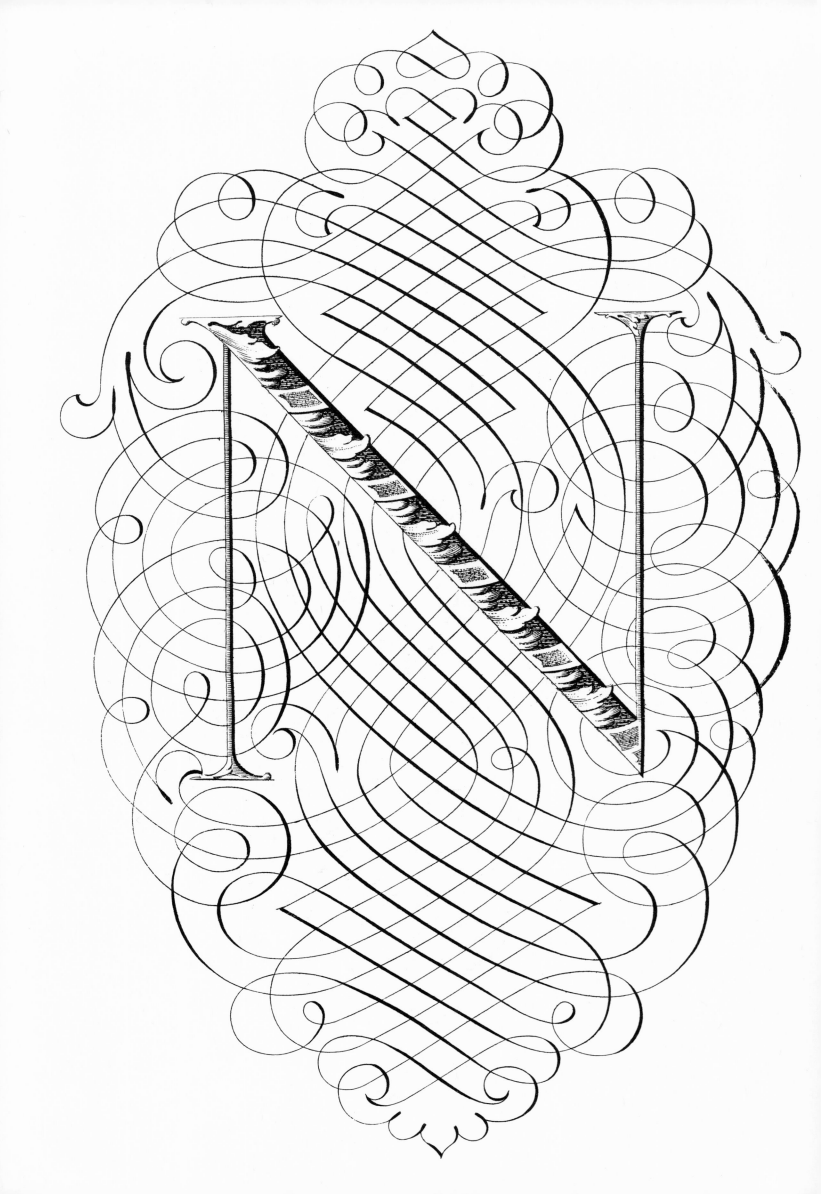

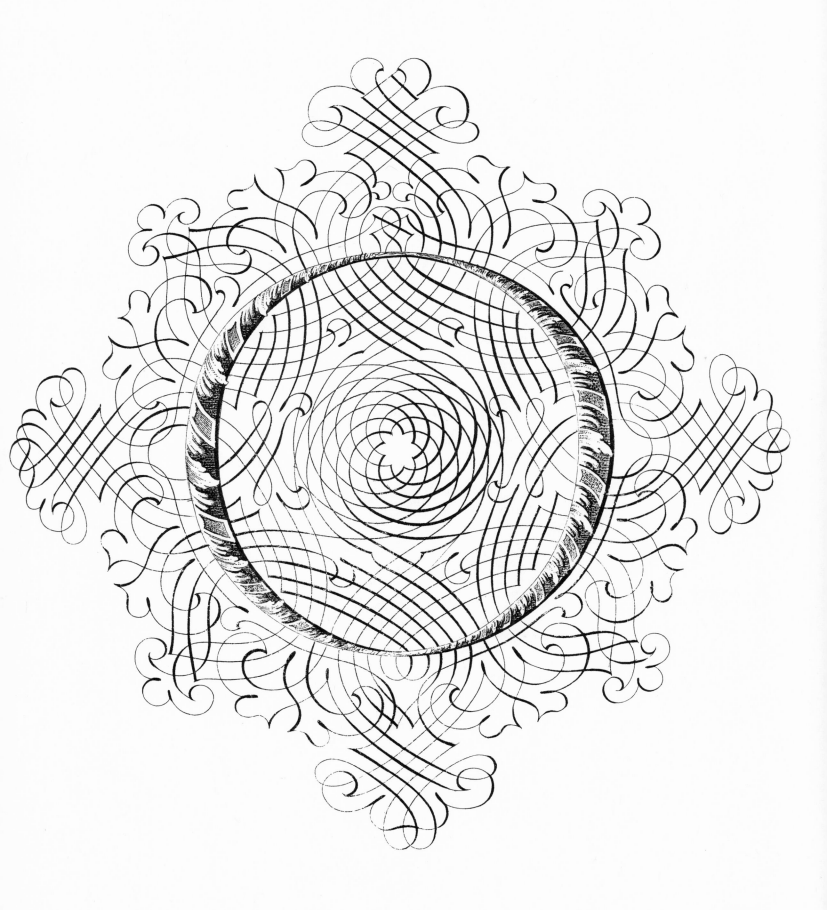

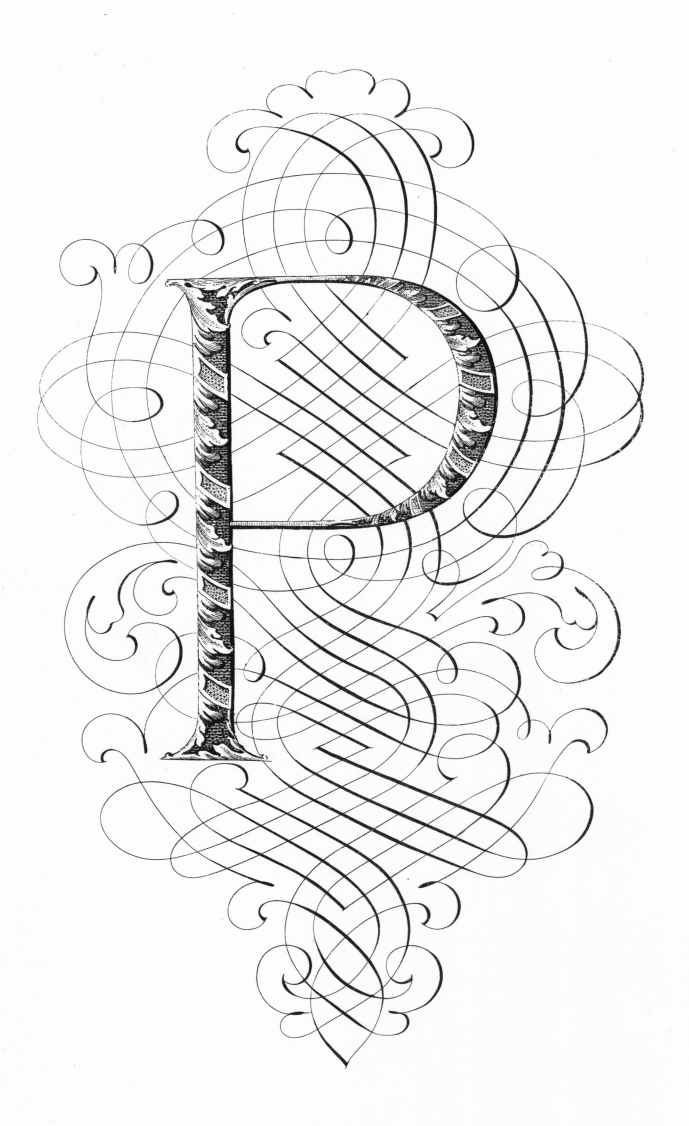

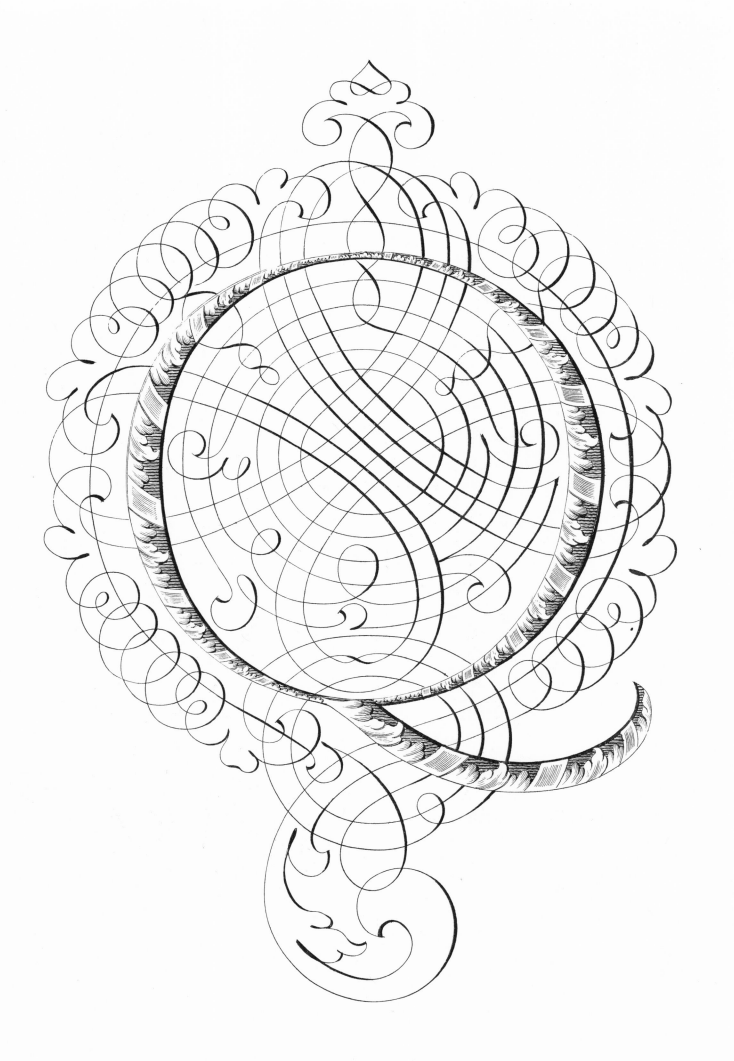

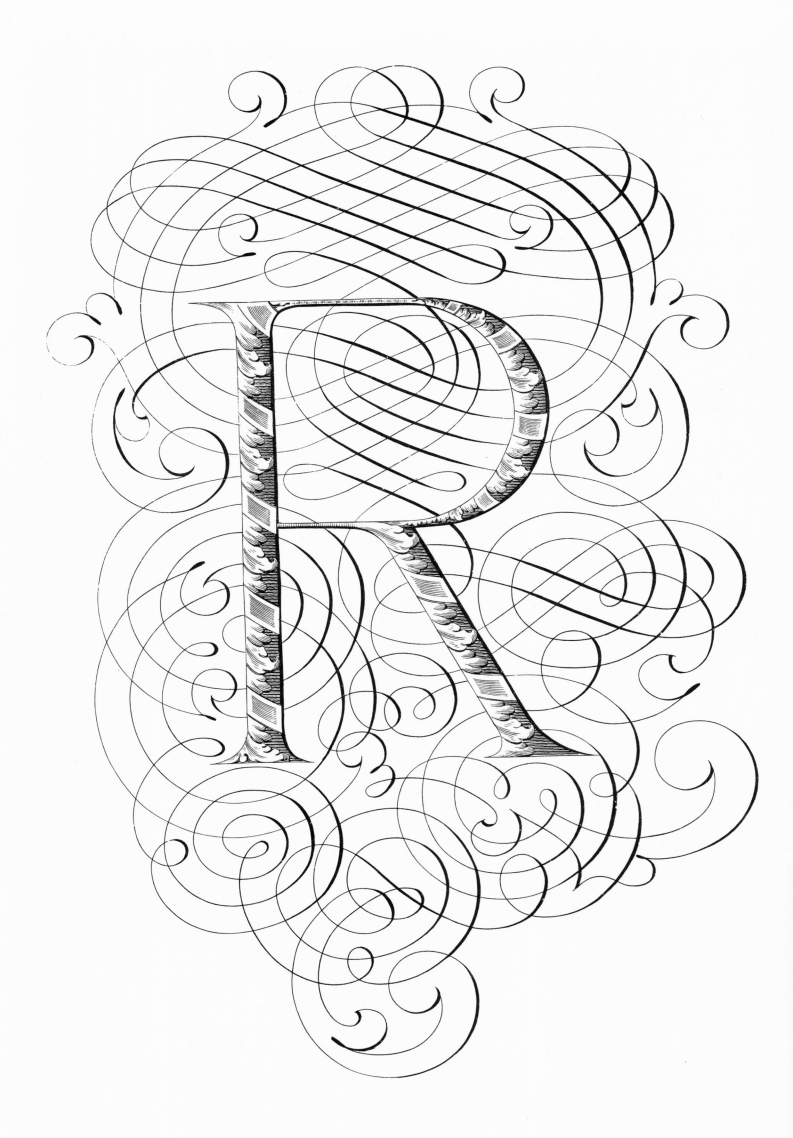

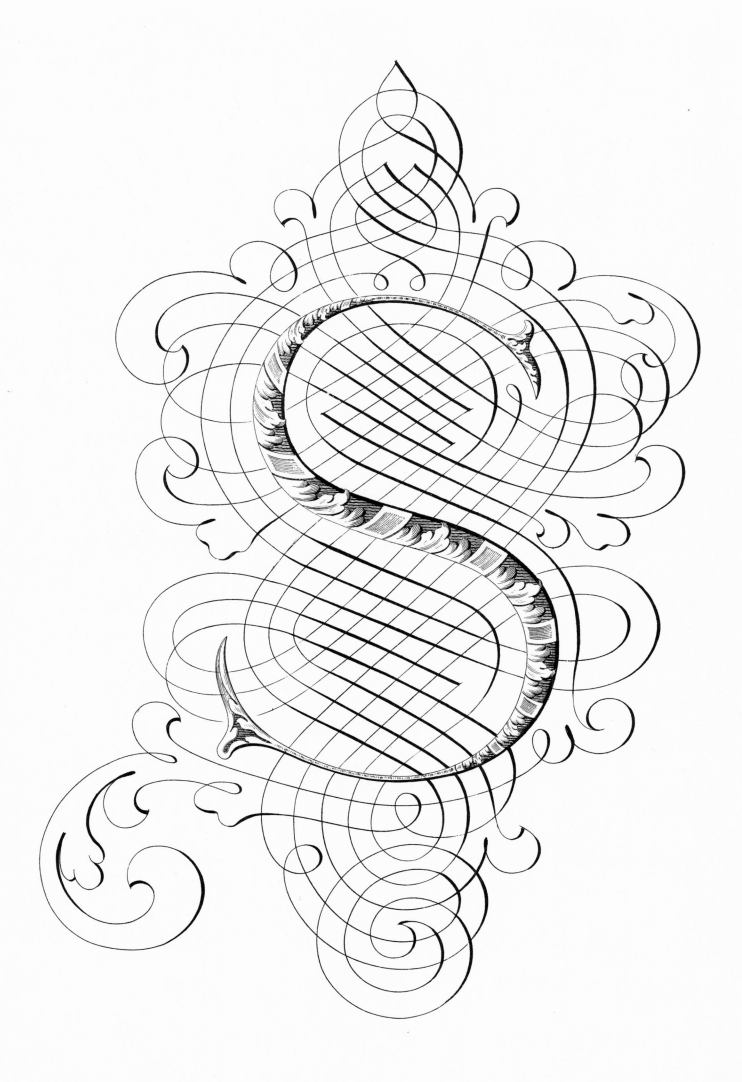

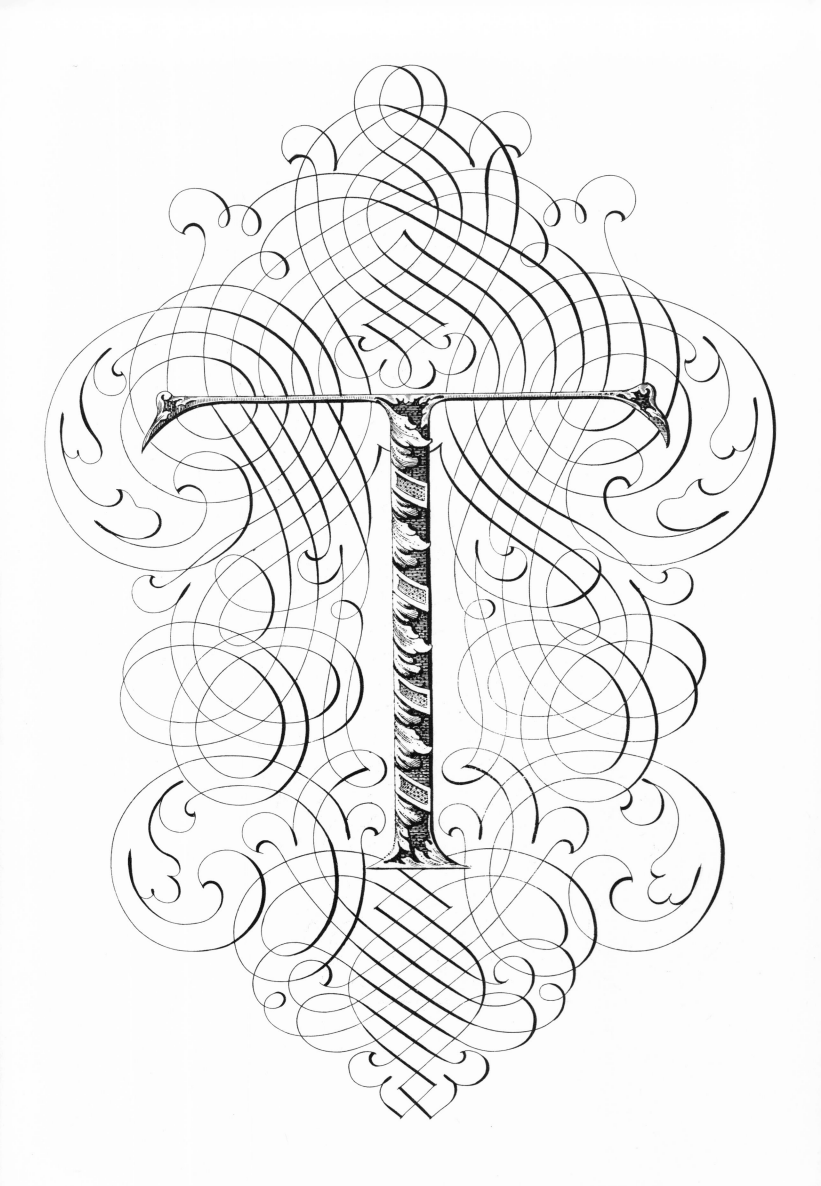

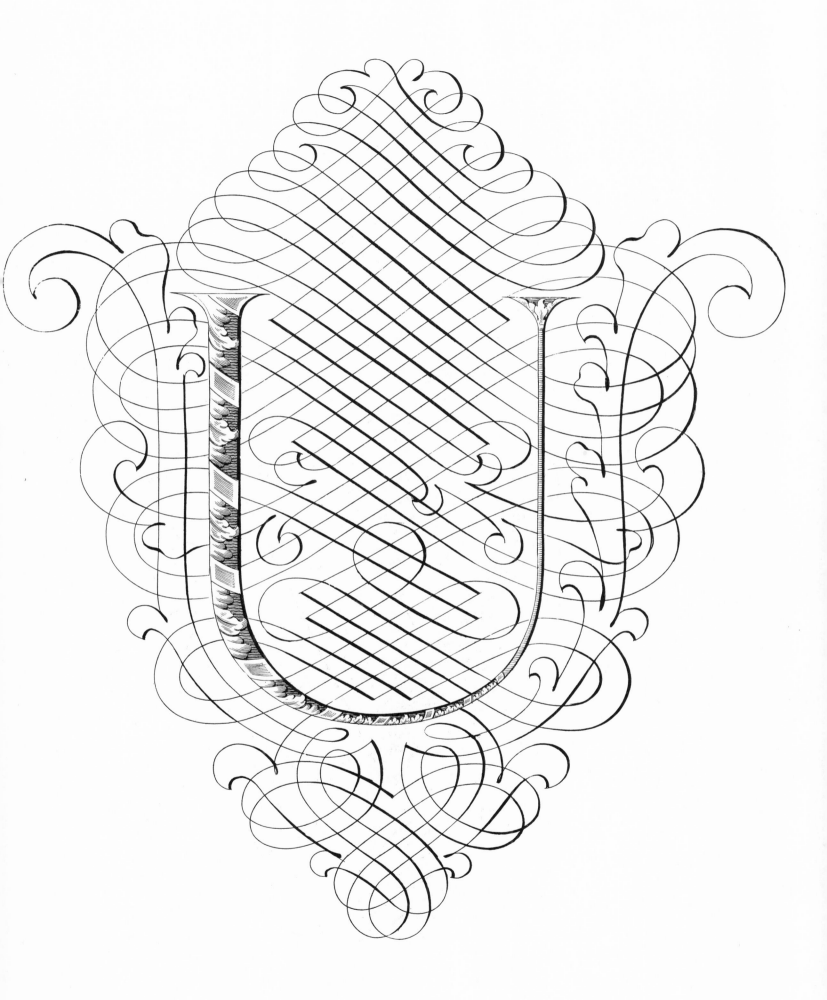

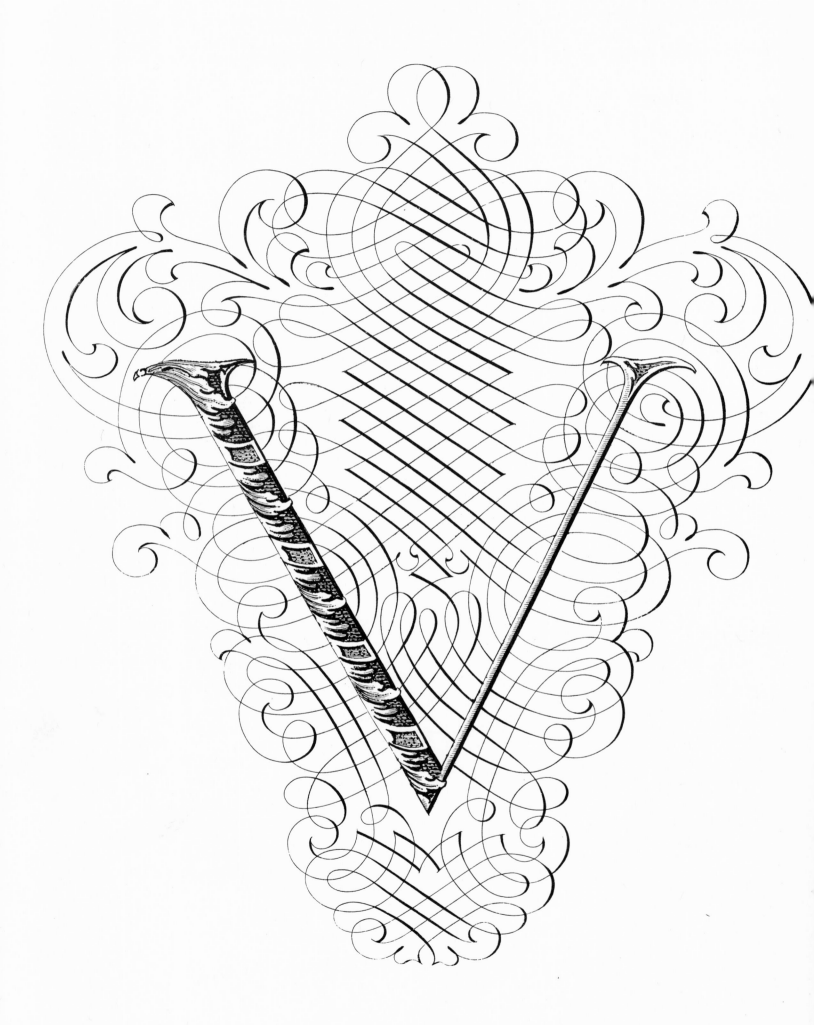

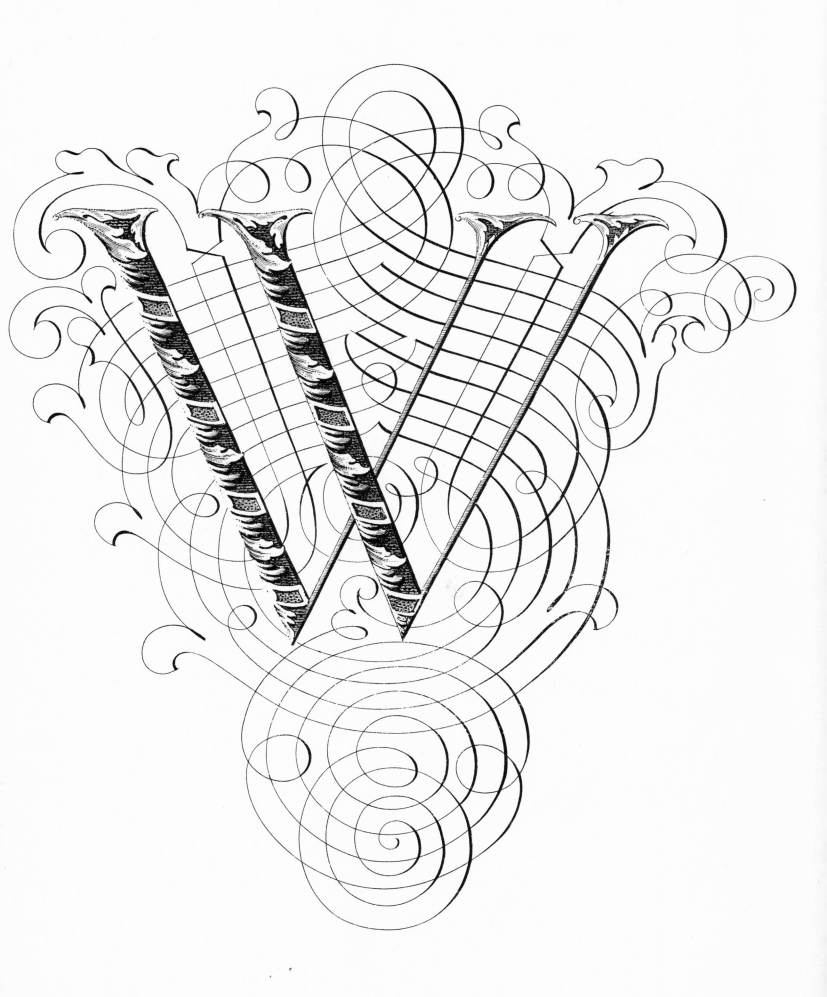

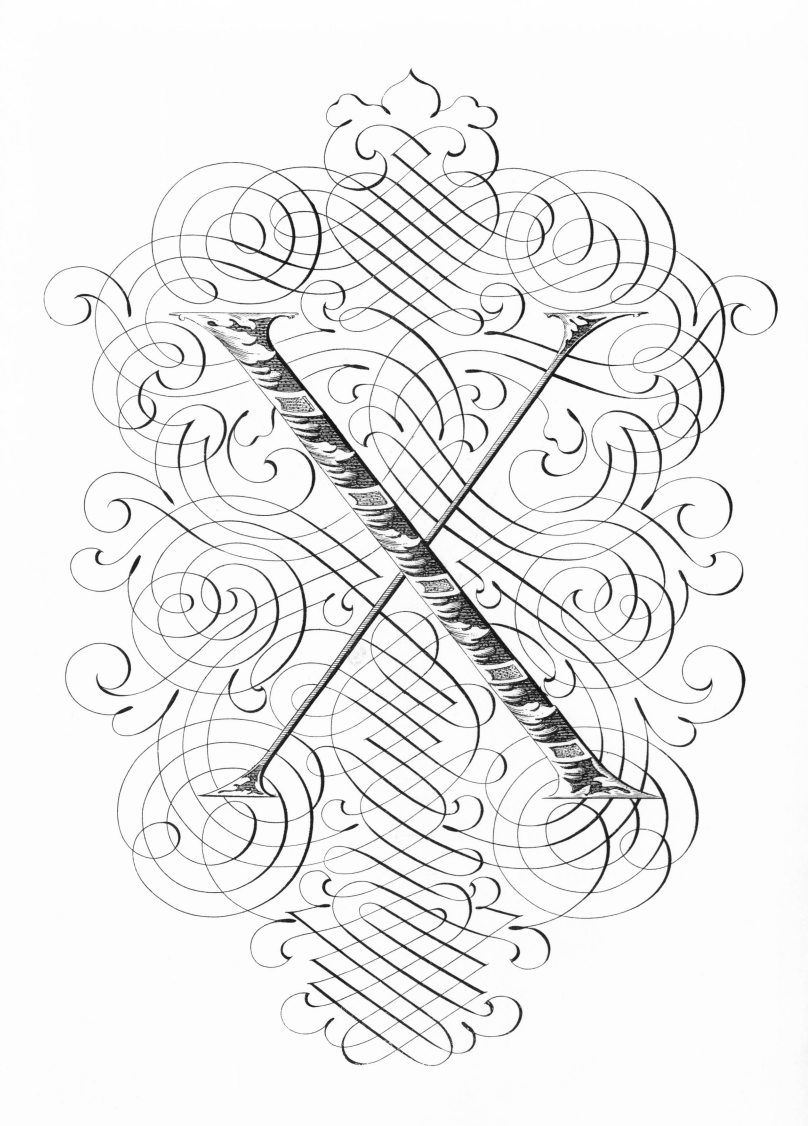

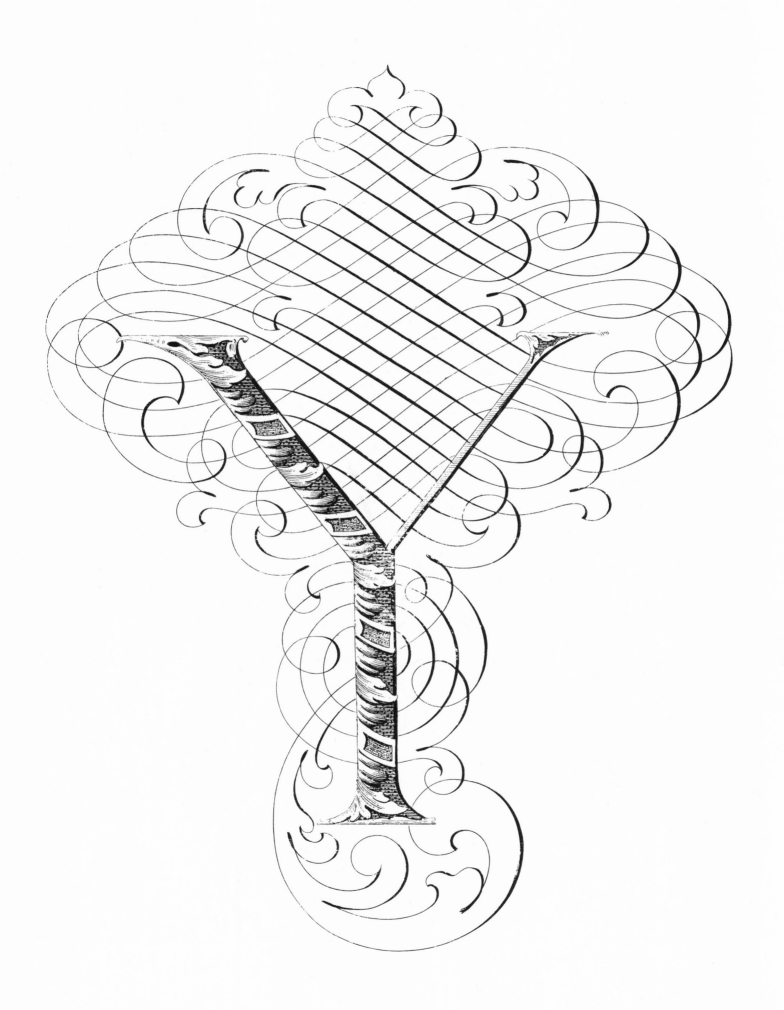

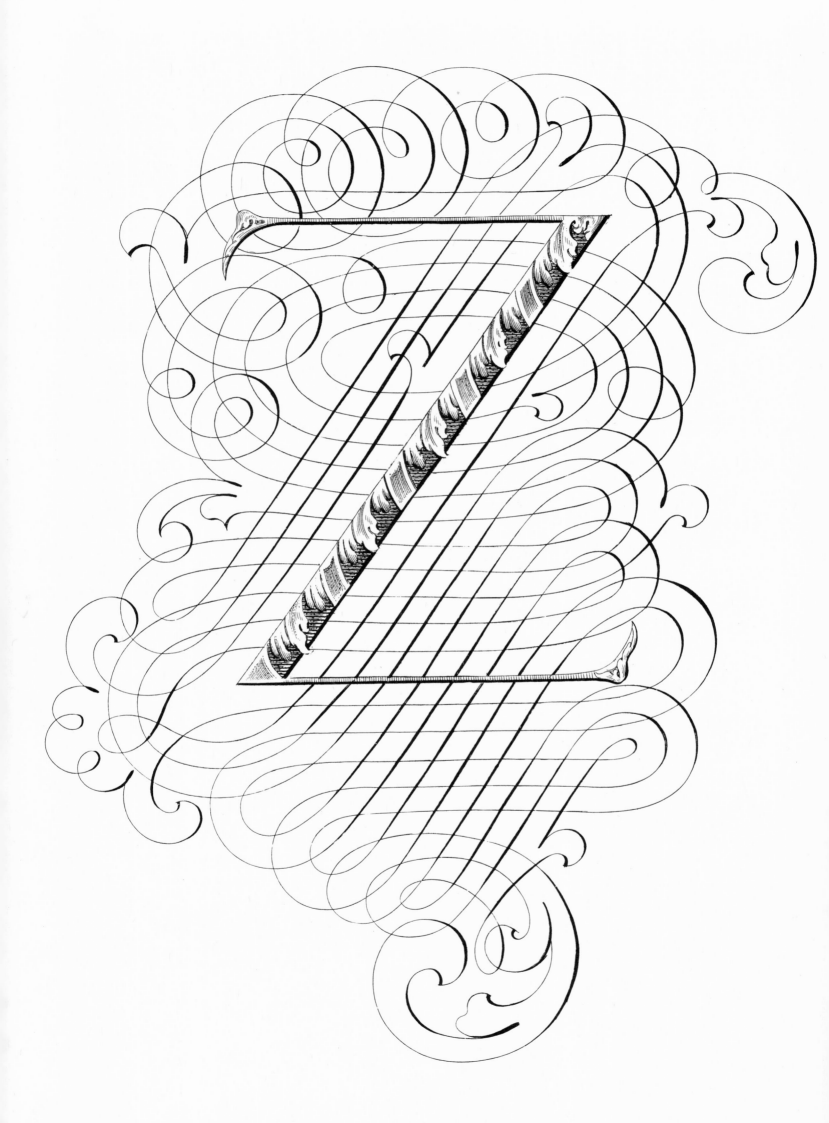

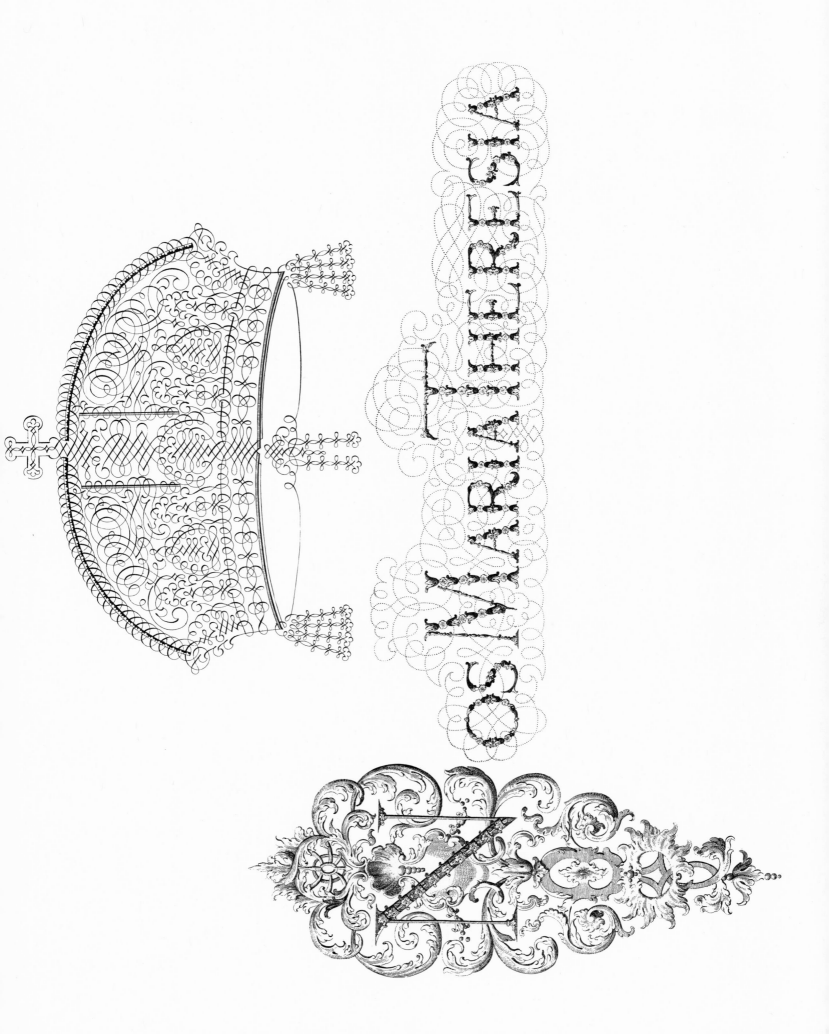

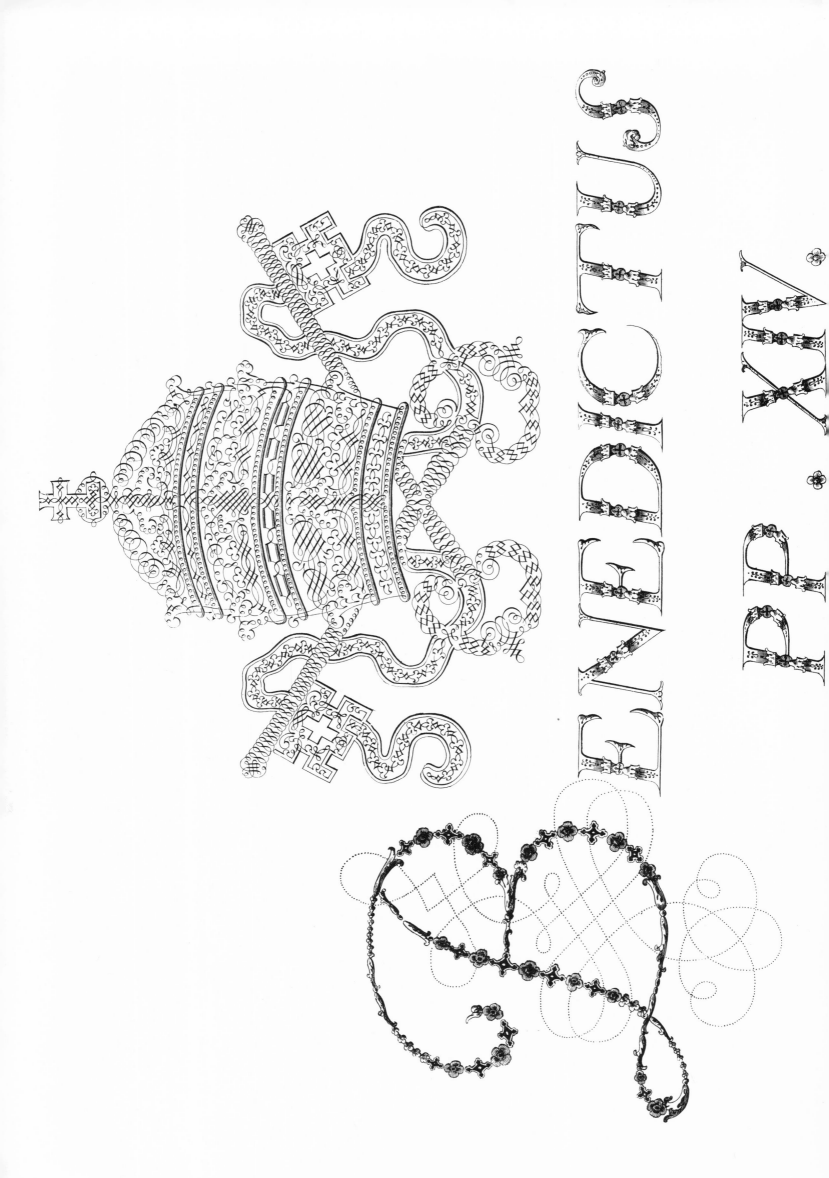

BENEDICTUS PP. XIV.

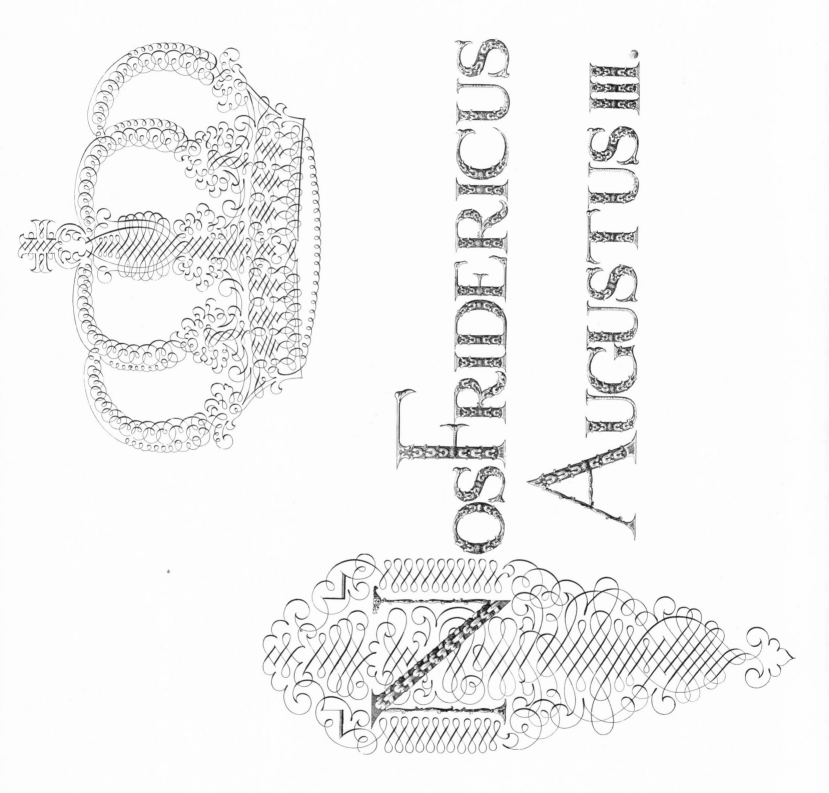

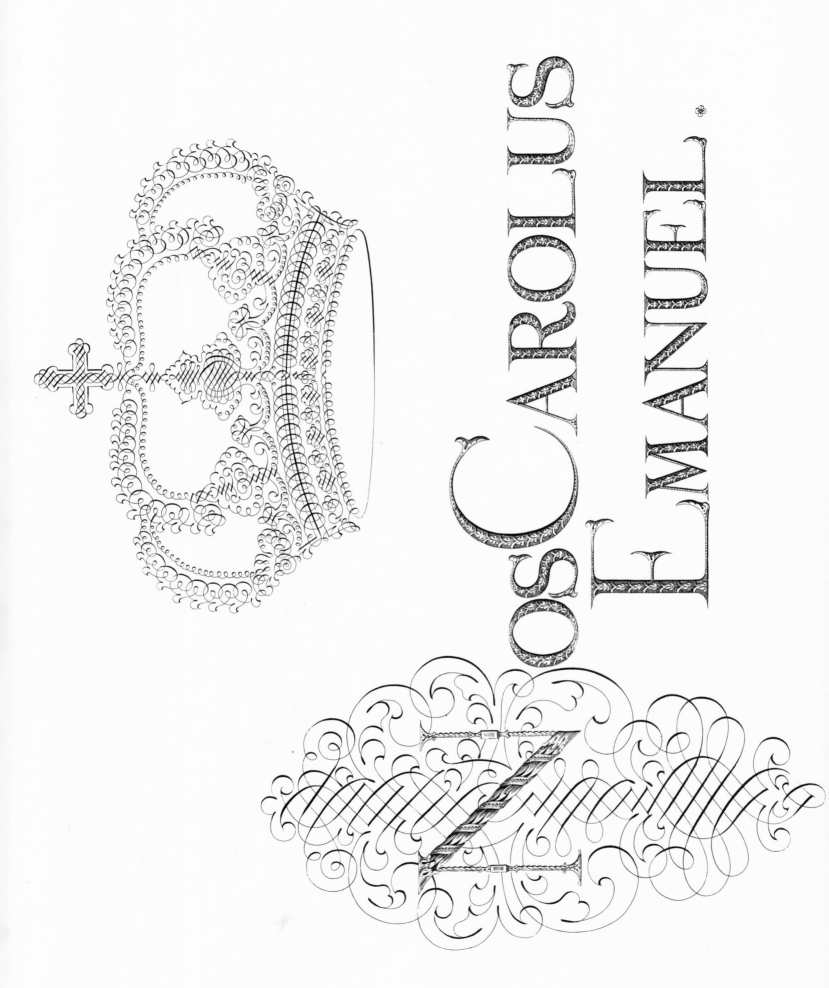

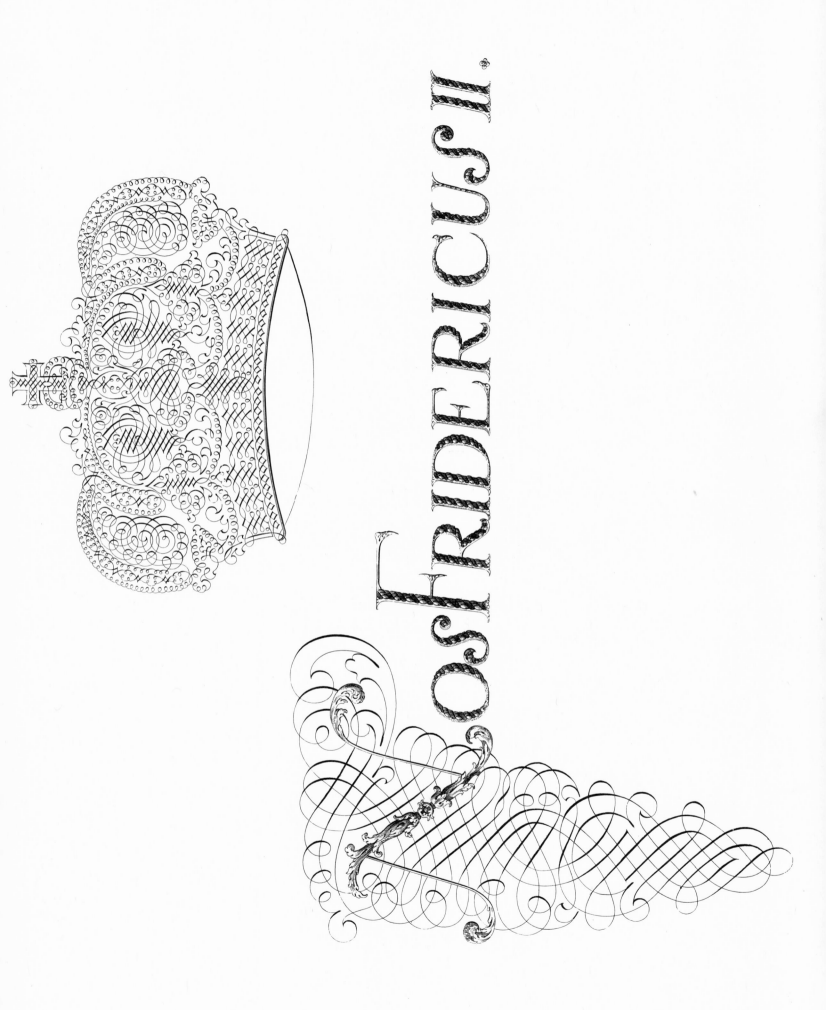

FRIDERICUS II.

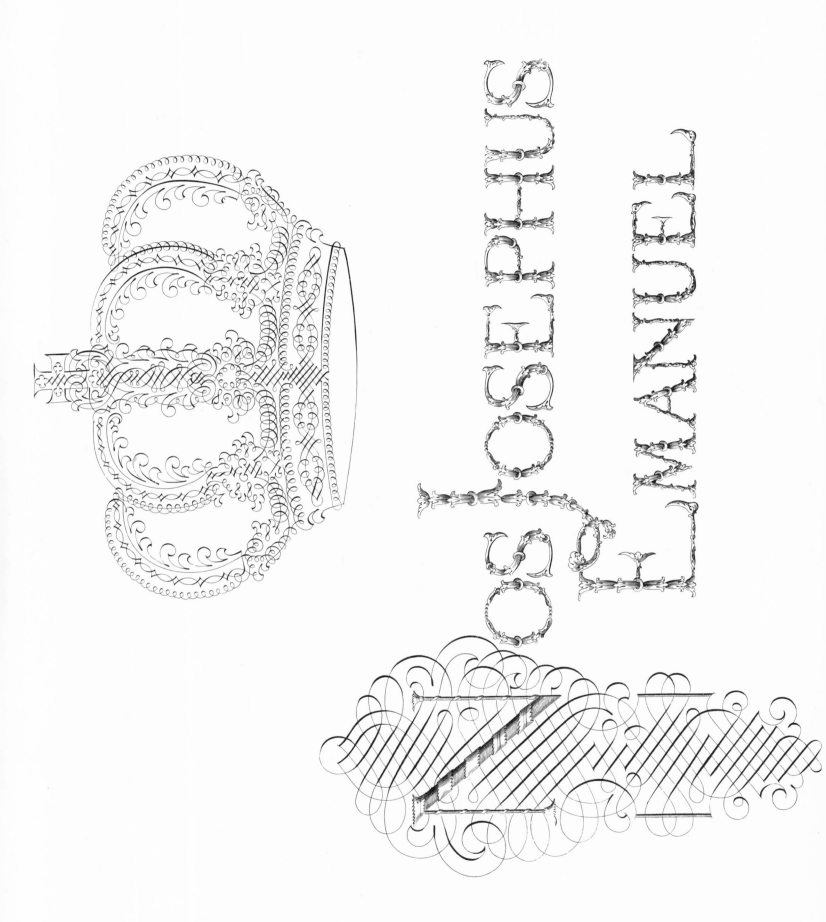

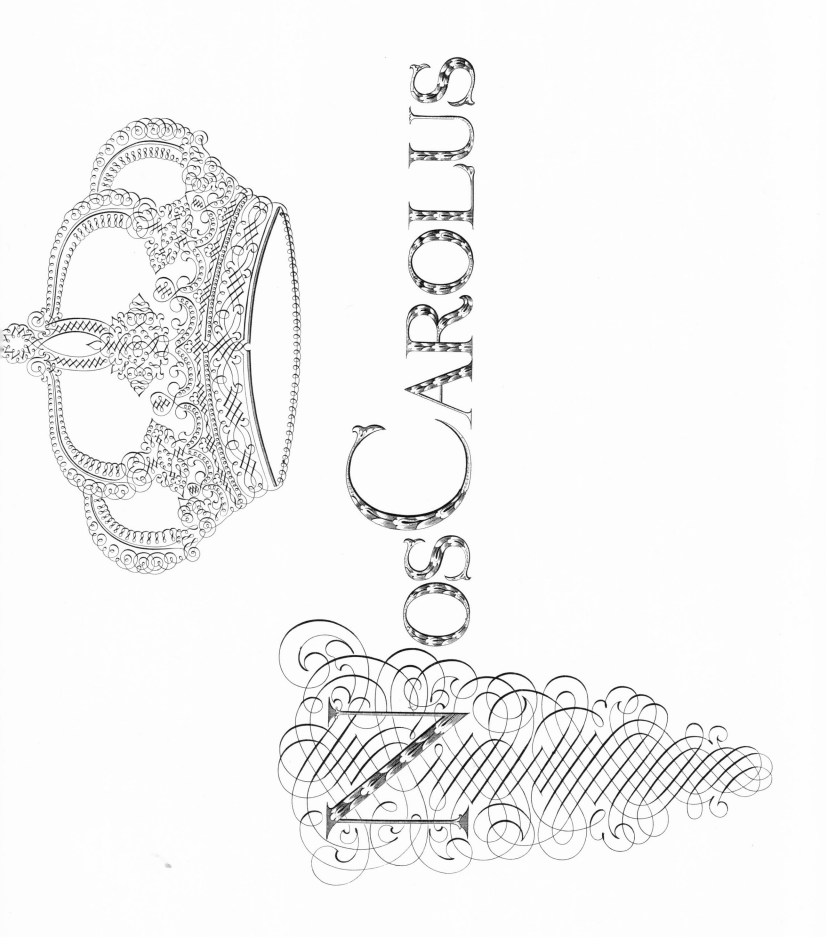

VOS CAROLUS

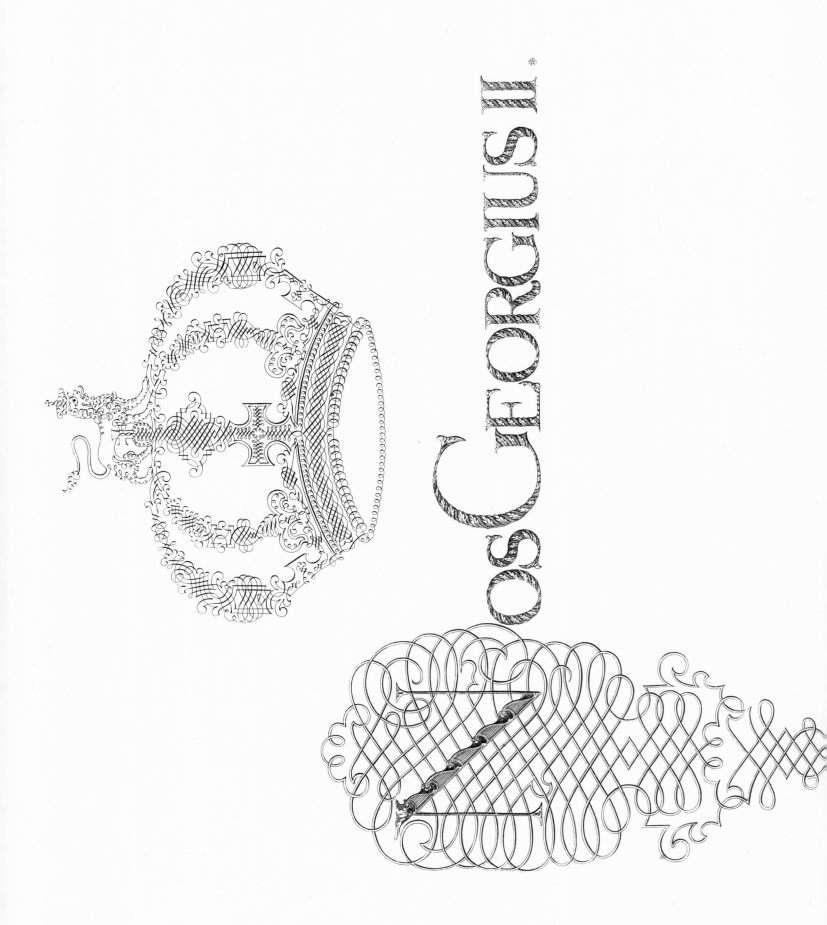

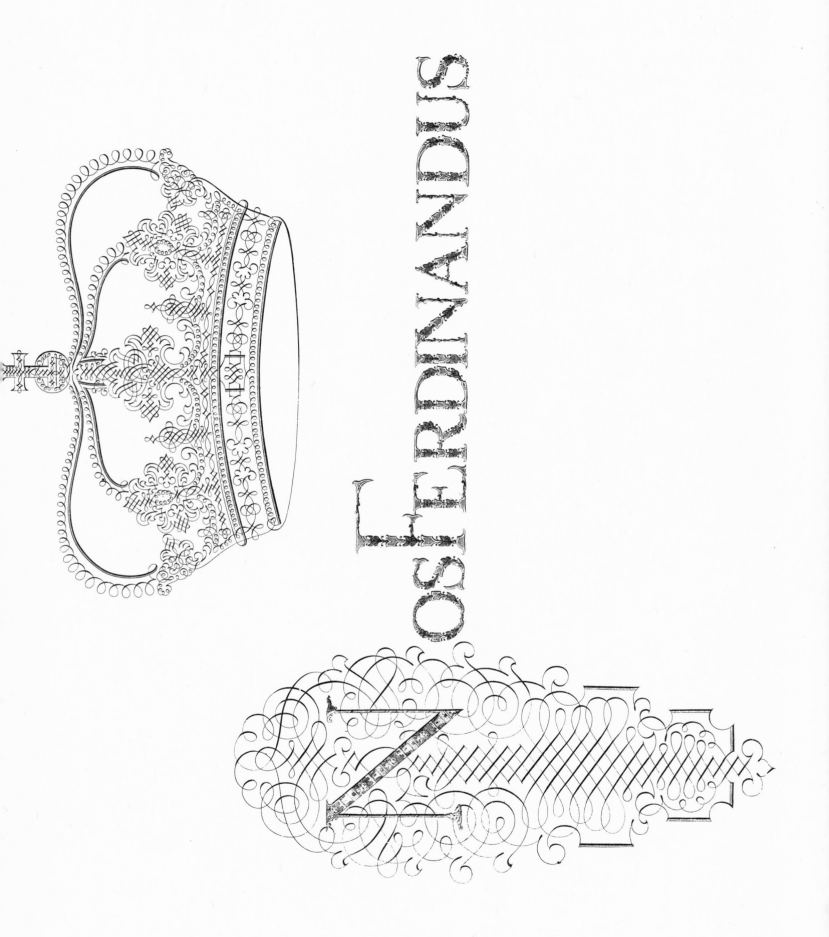

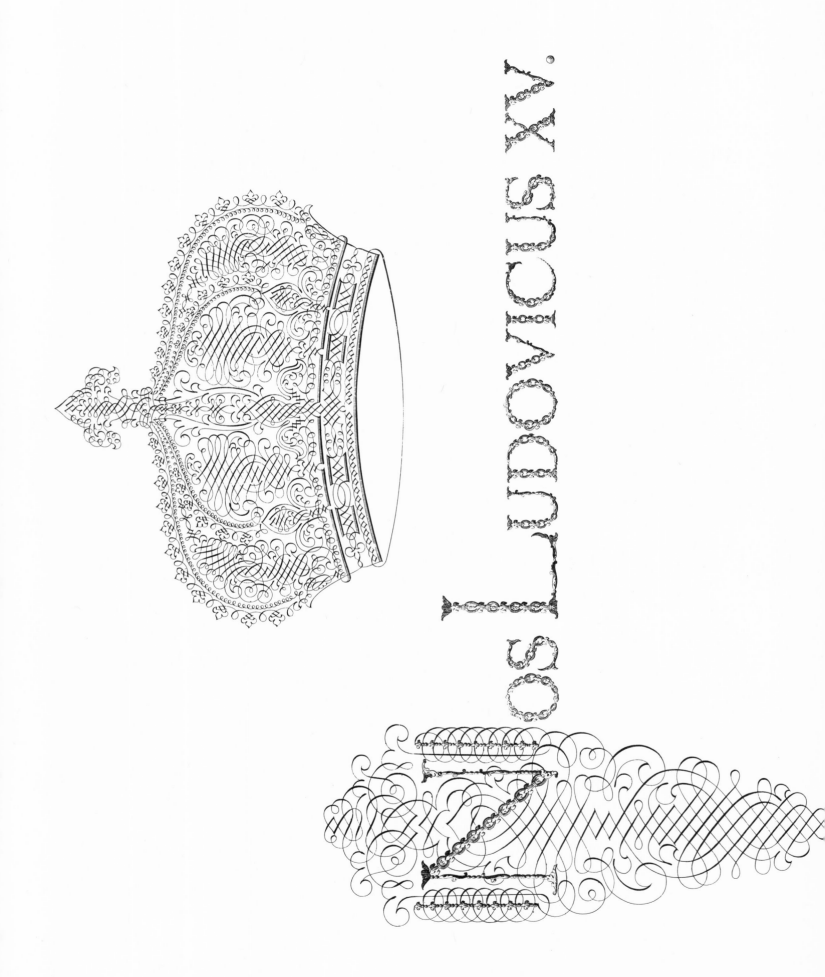

LUDOVICUS XV.

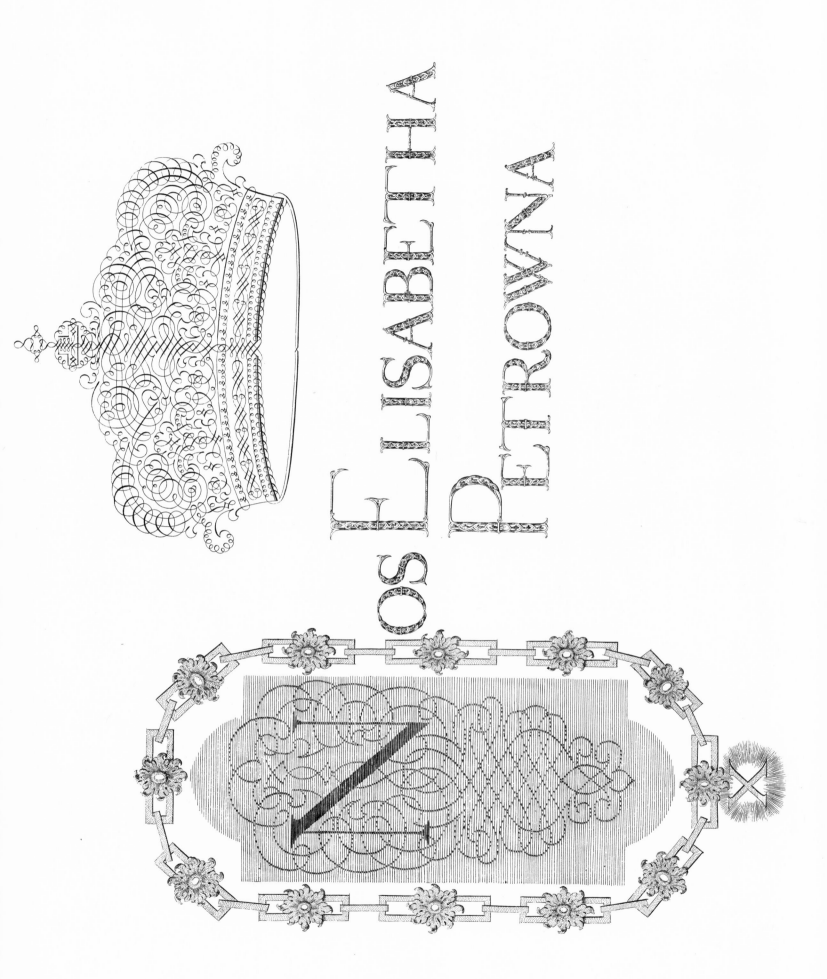

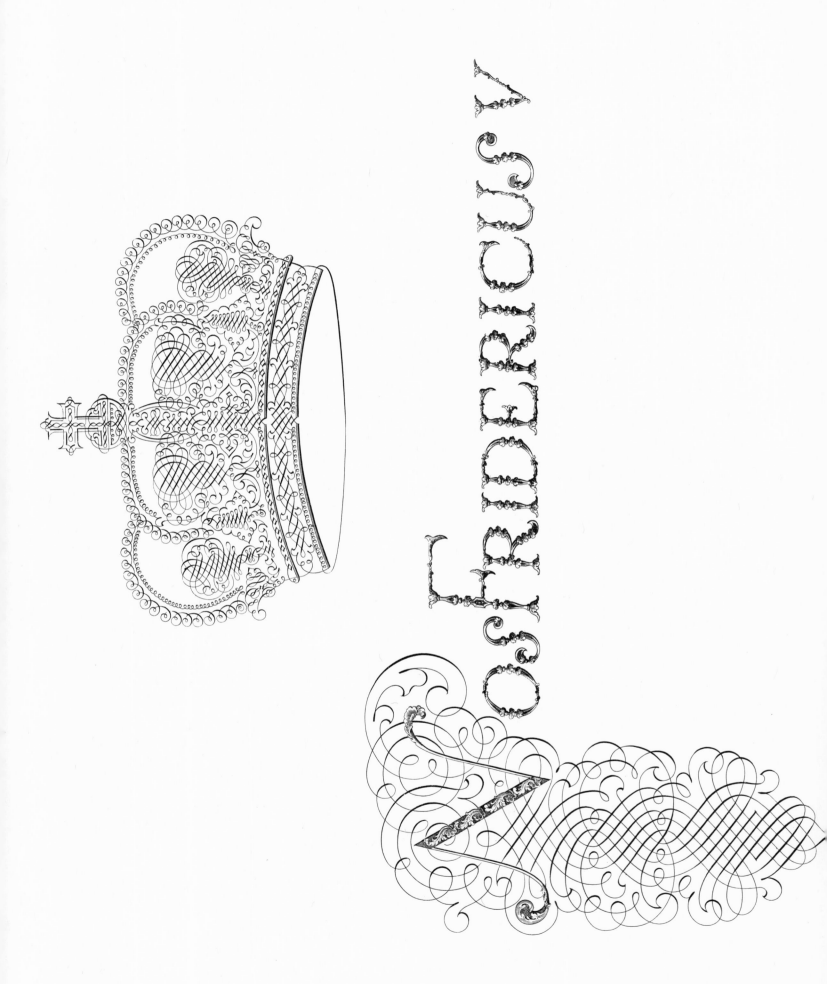

osFrancisCUS

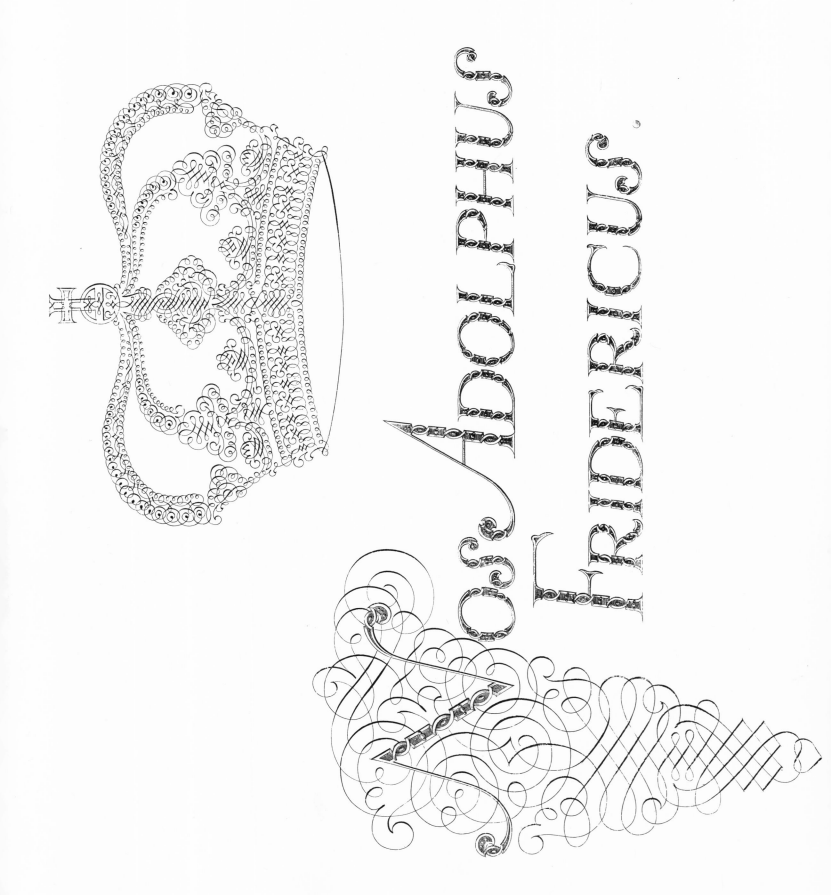

Adolphus Fridericus

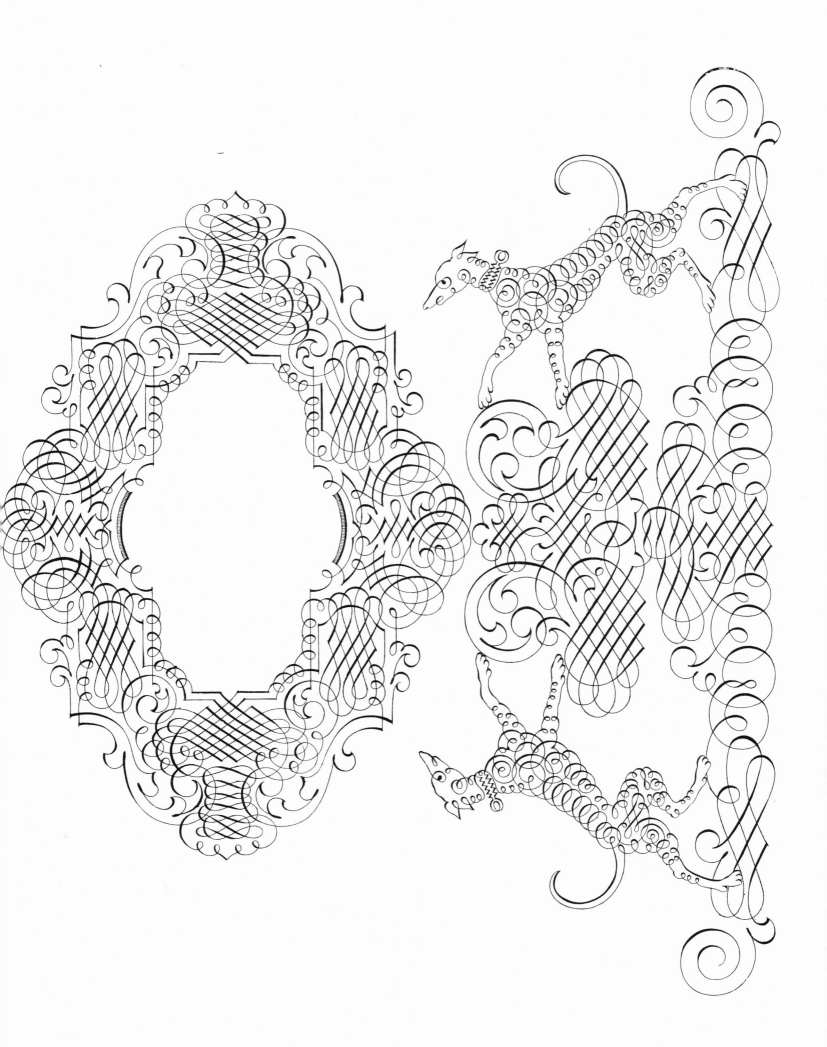

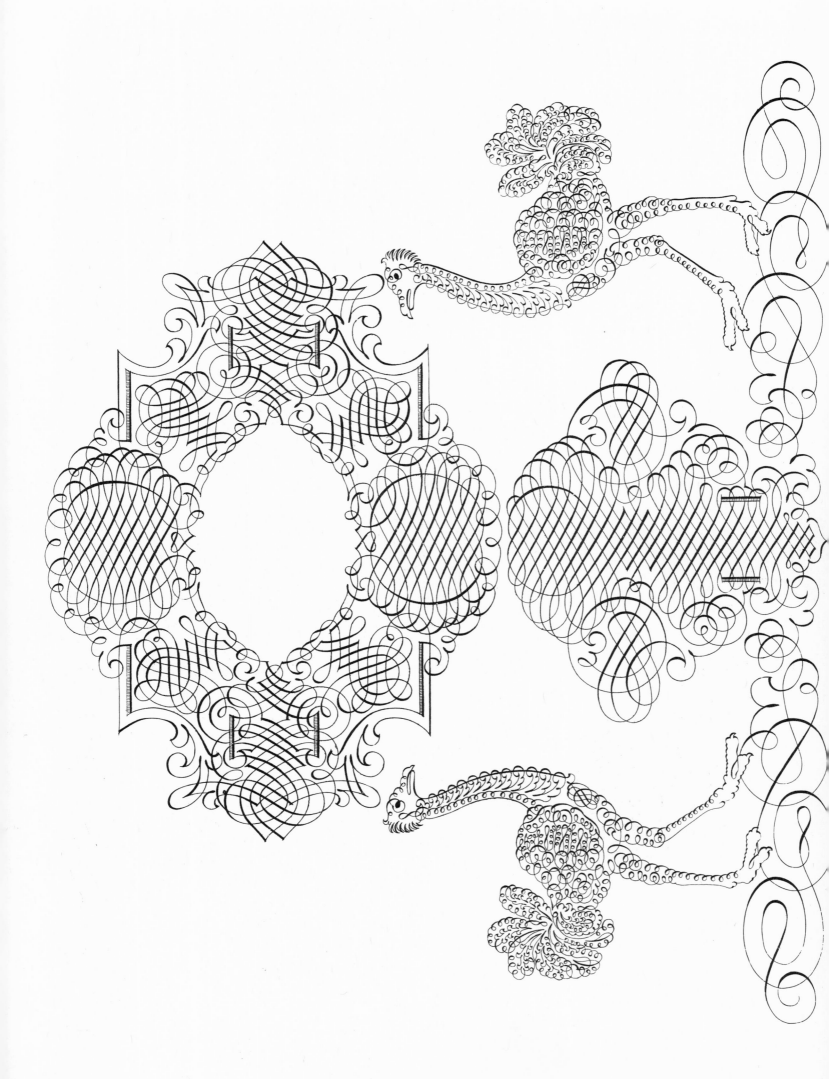

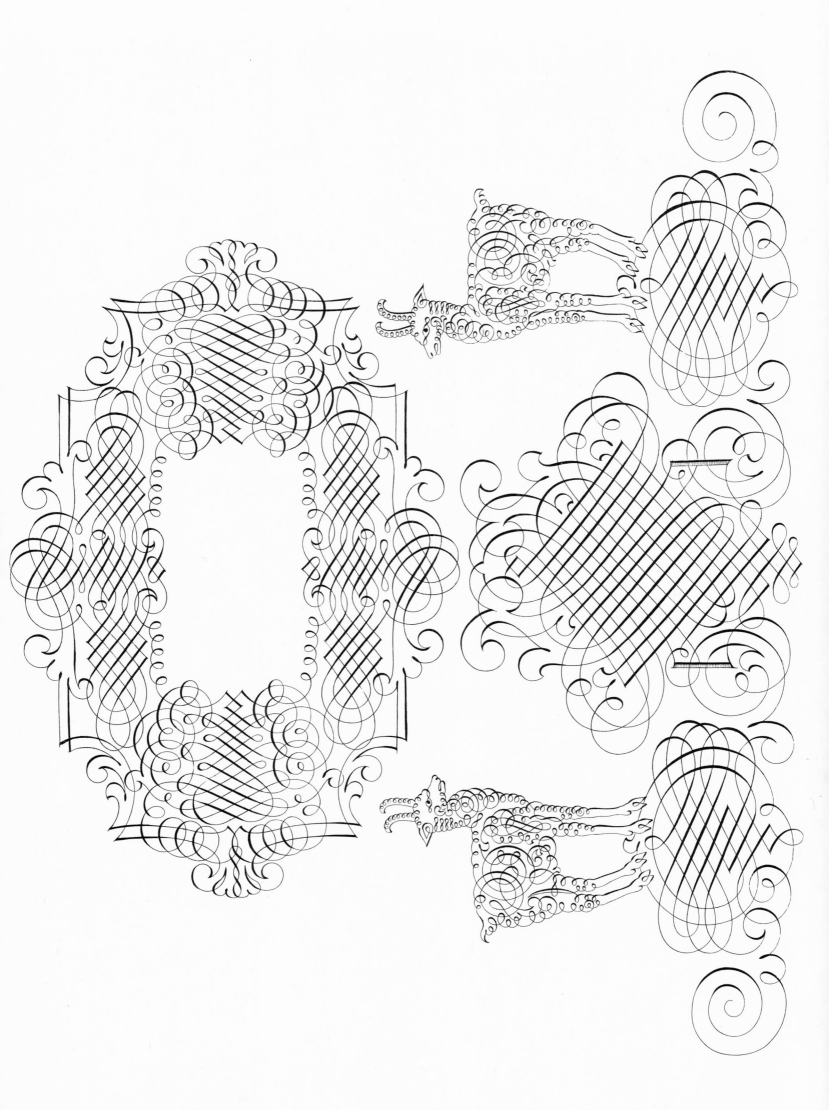

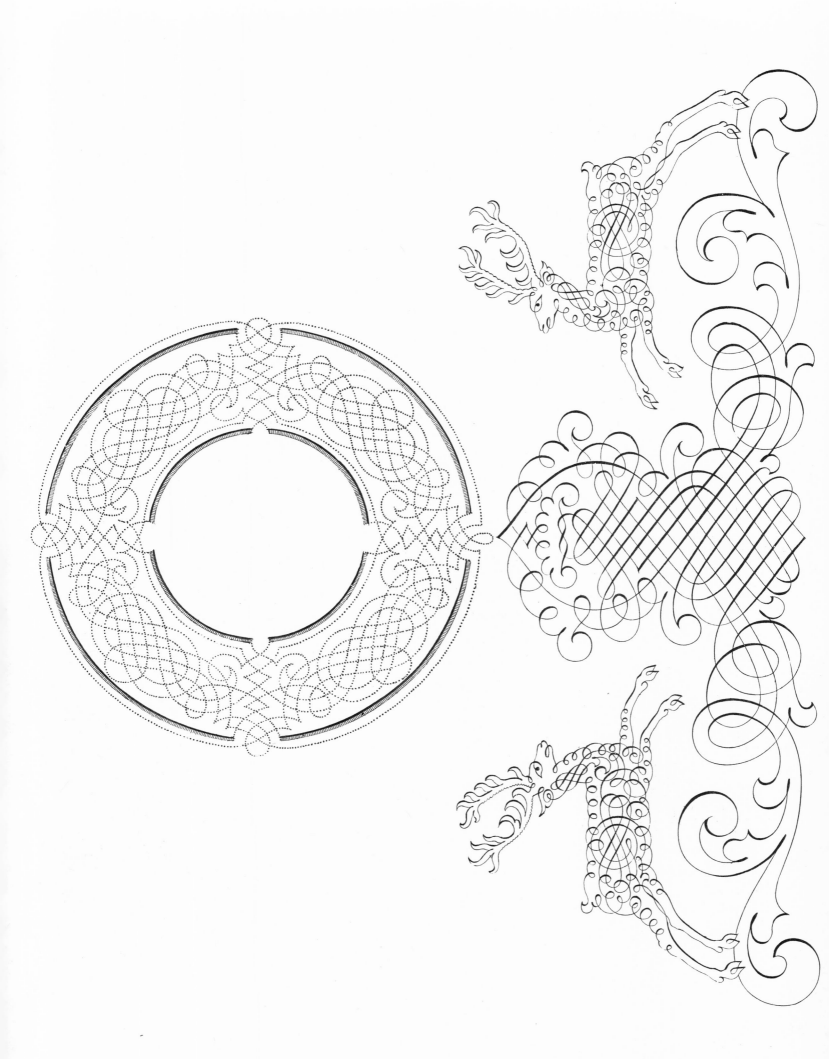

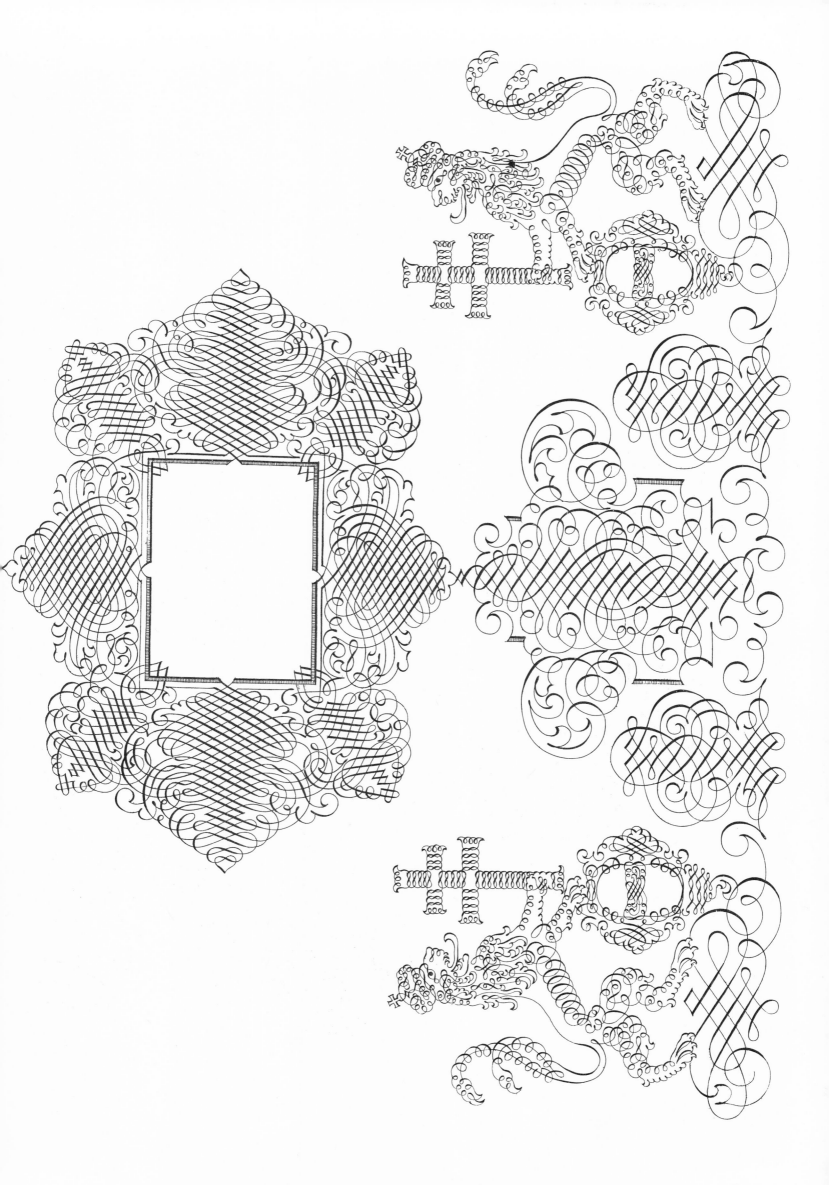

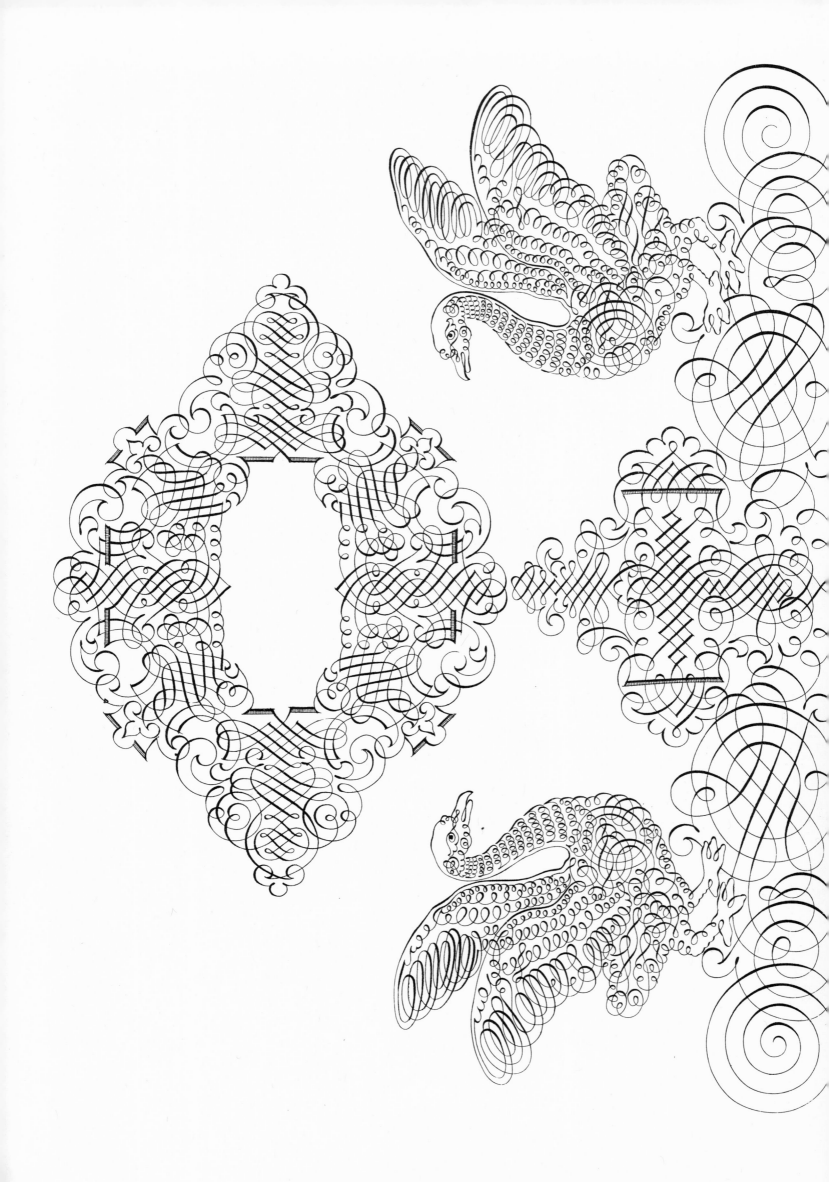

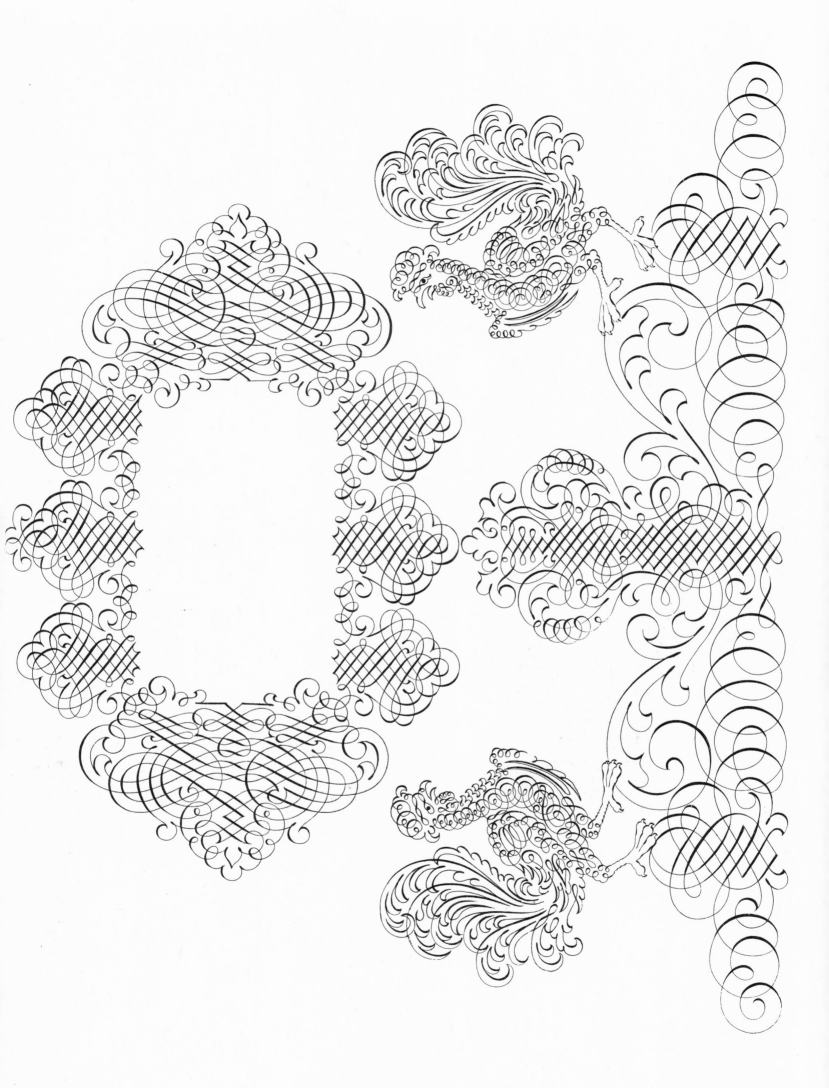

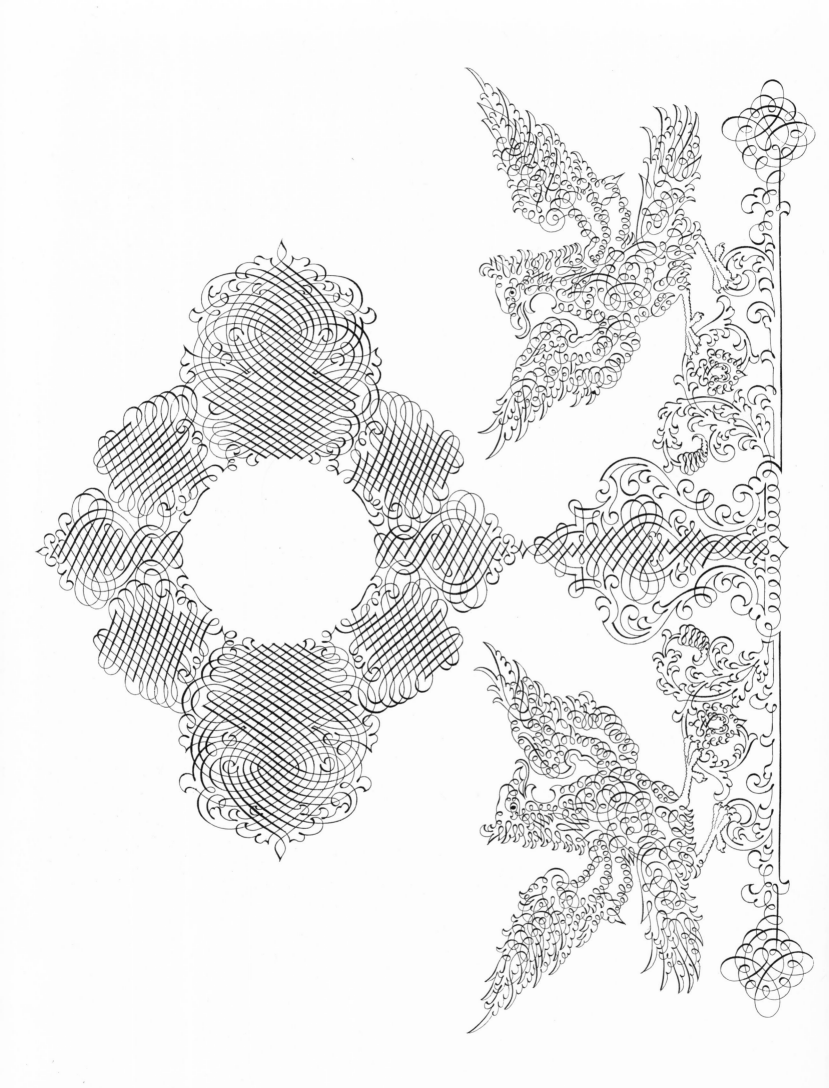

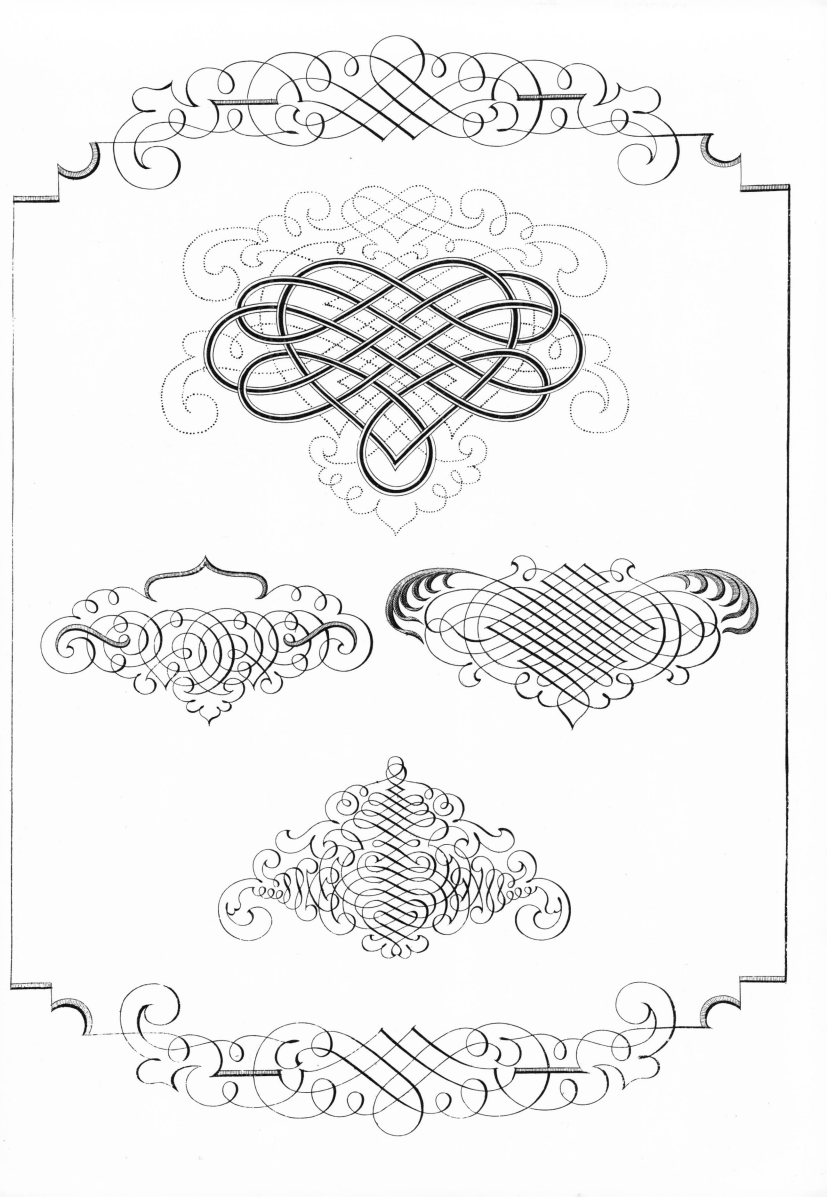

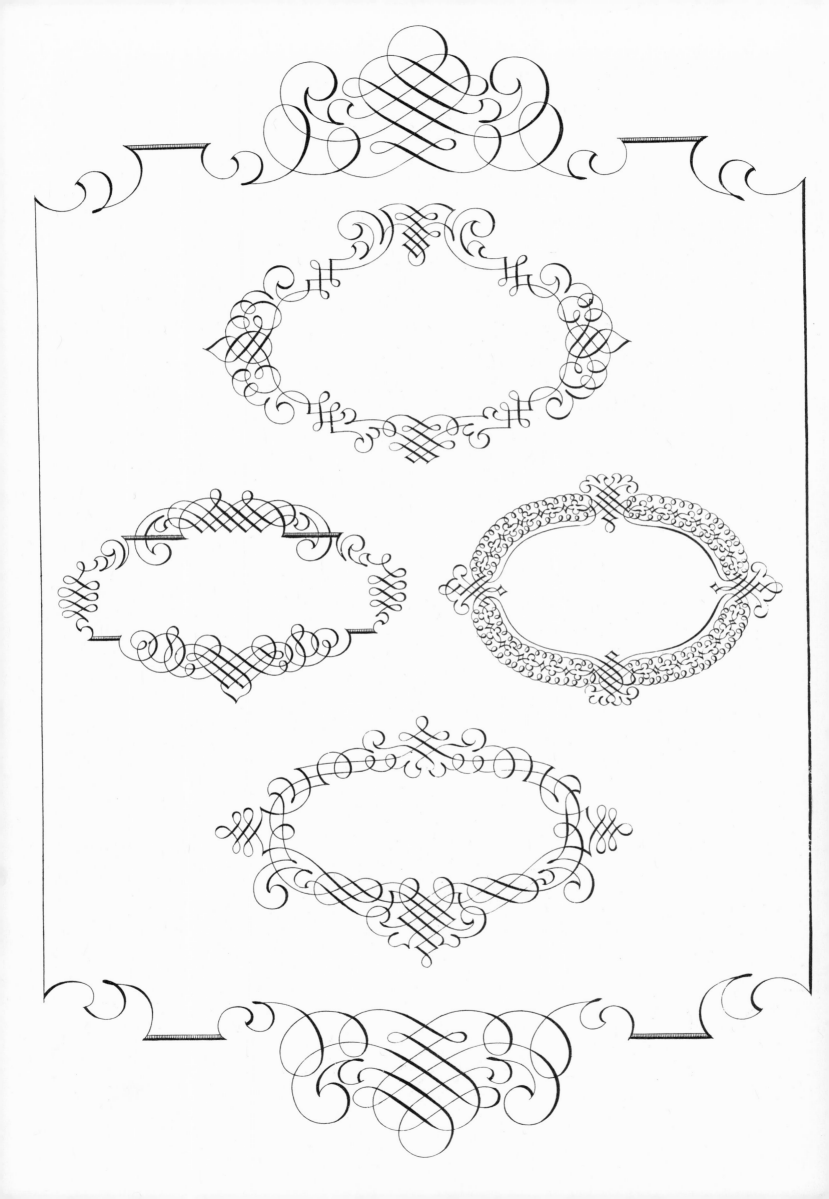

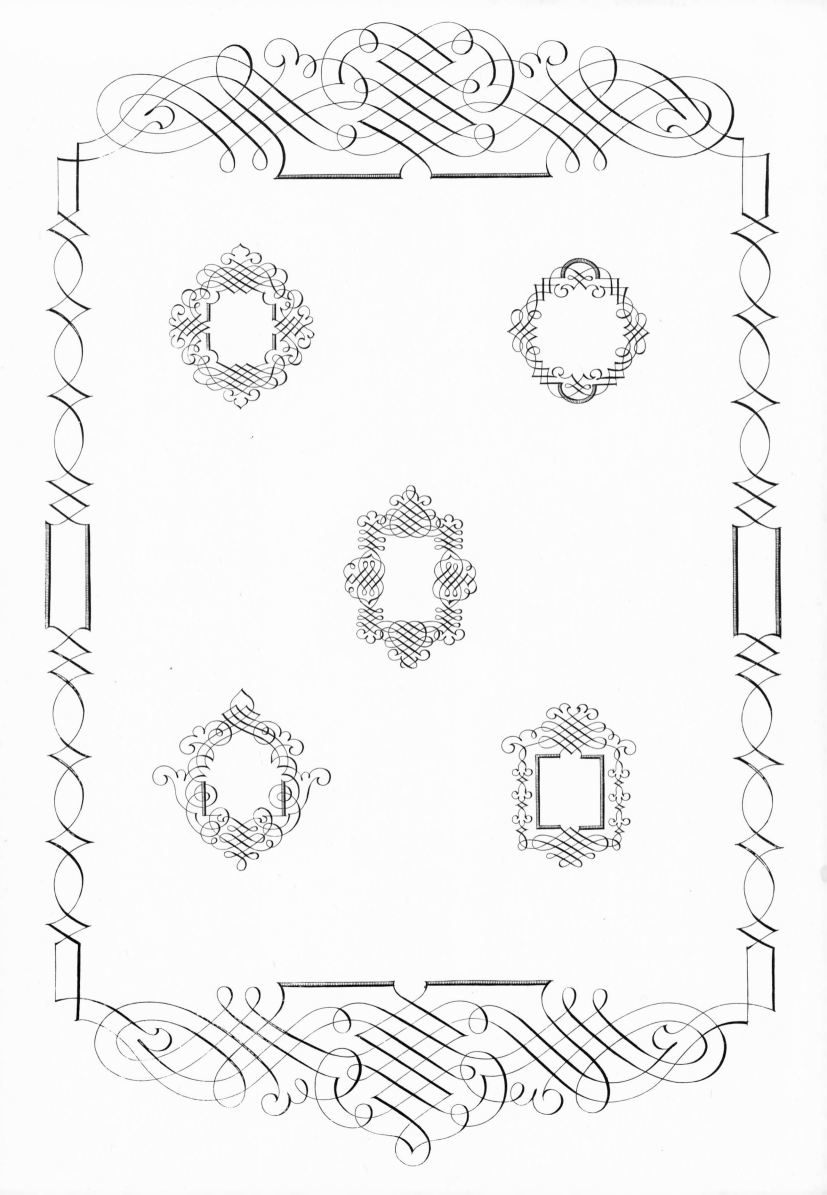

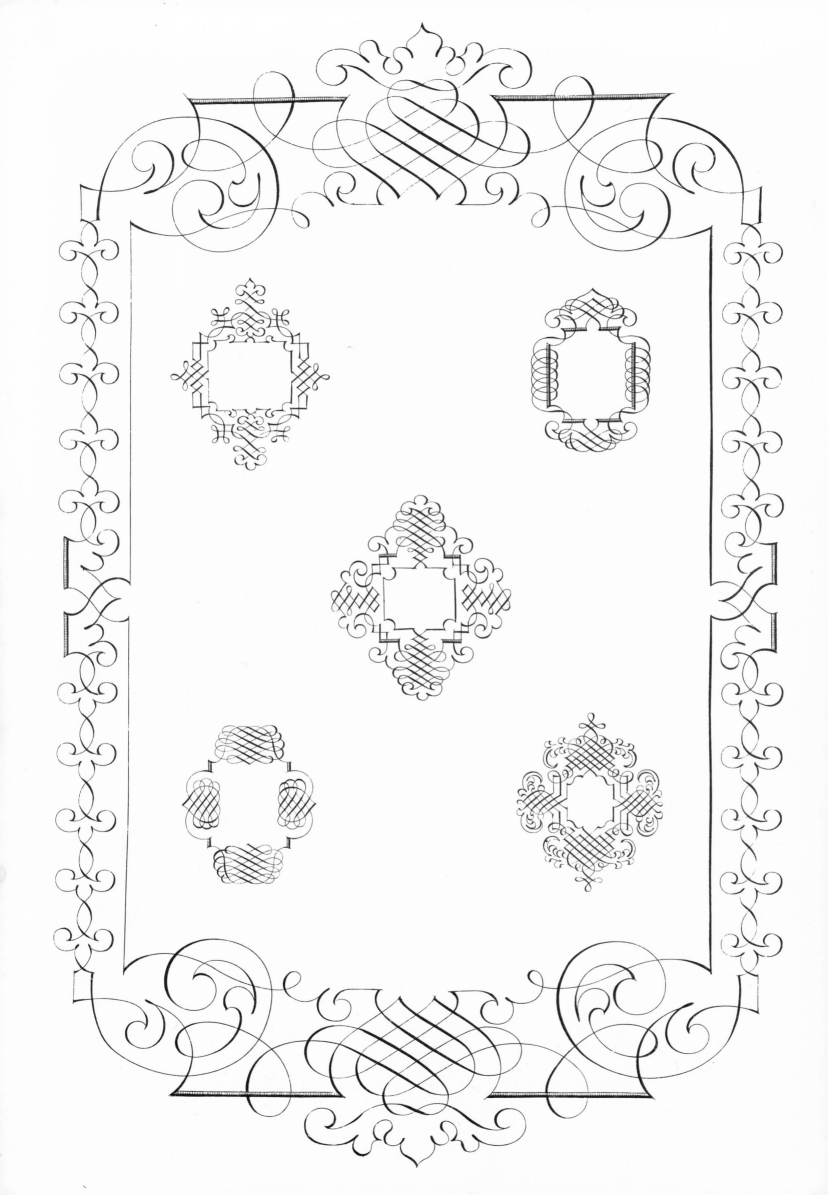

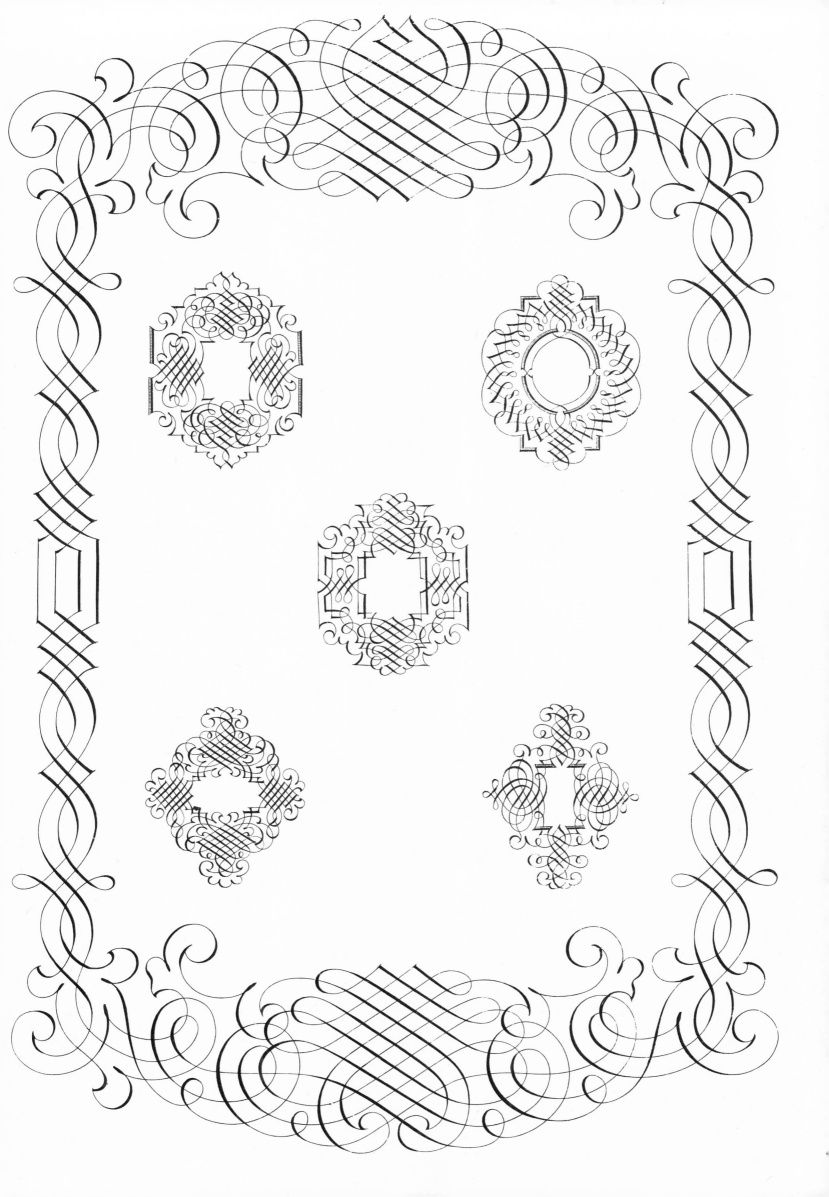

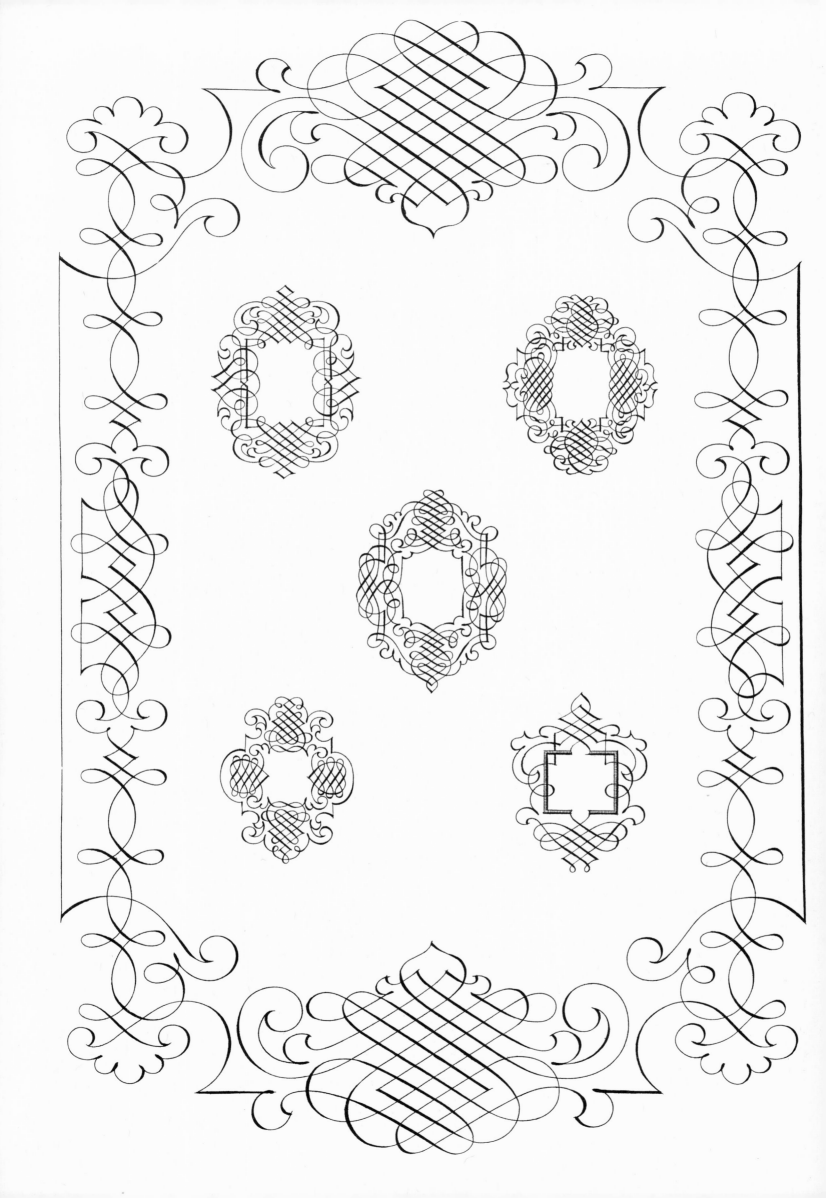

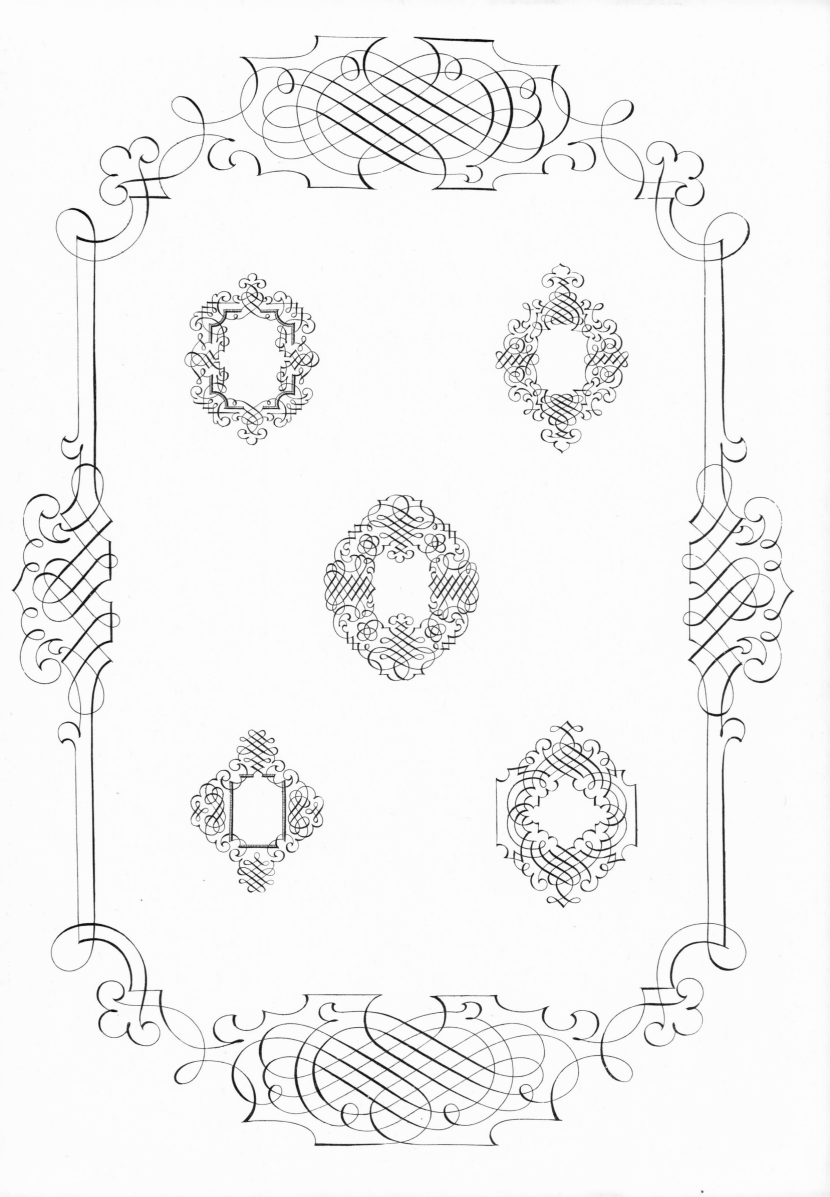

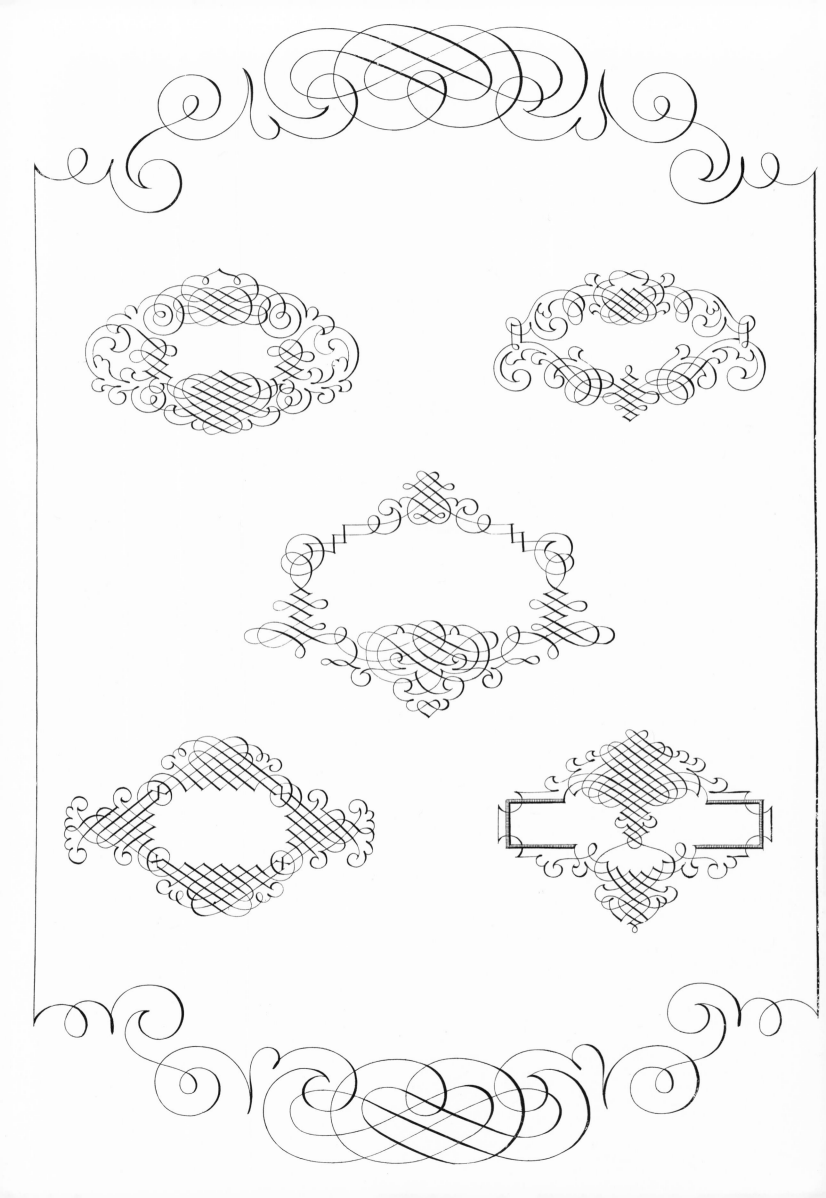

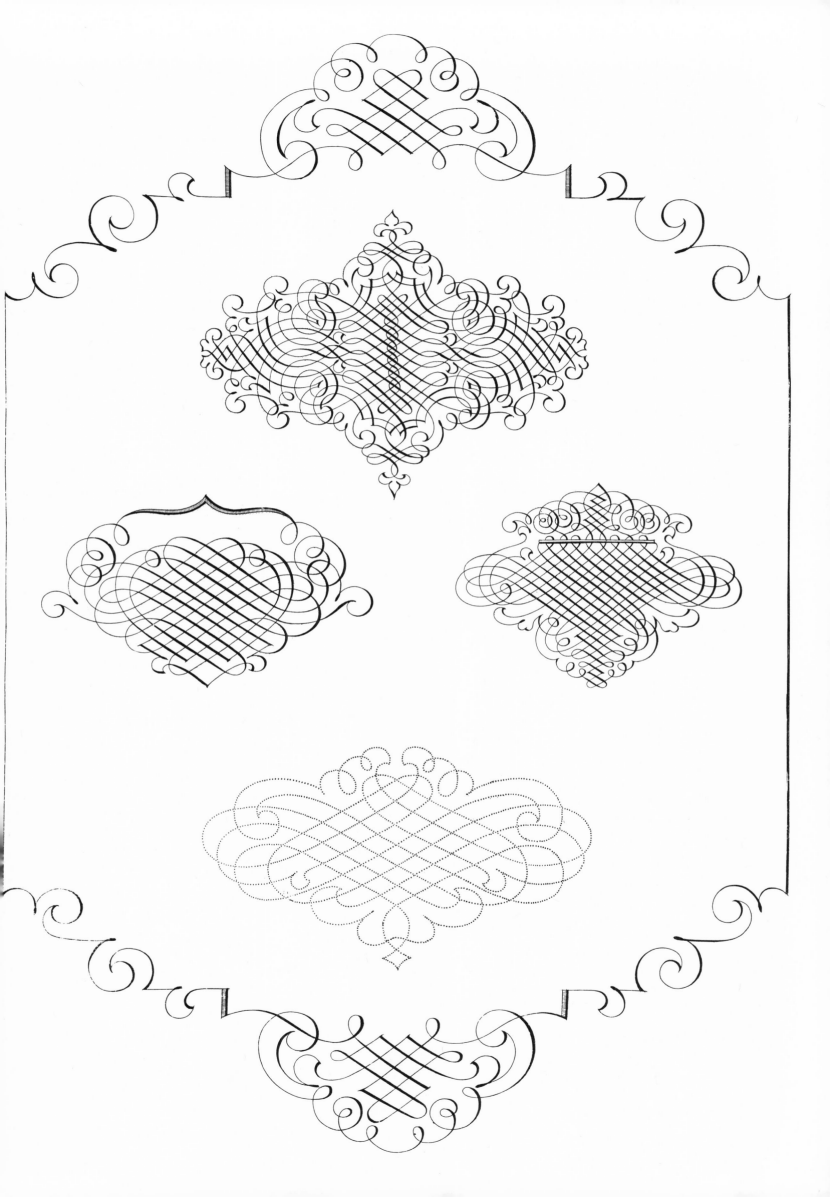

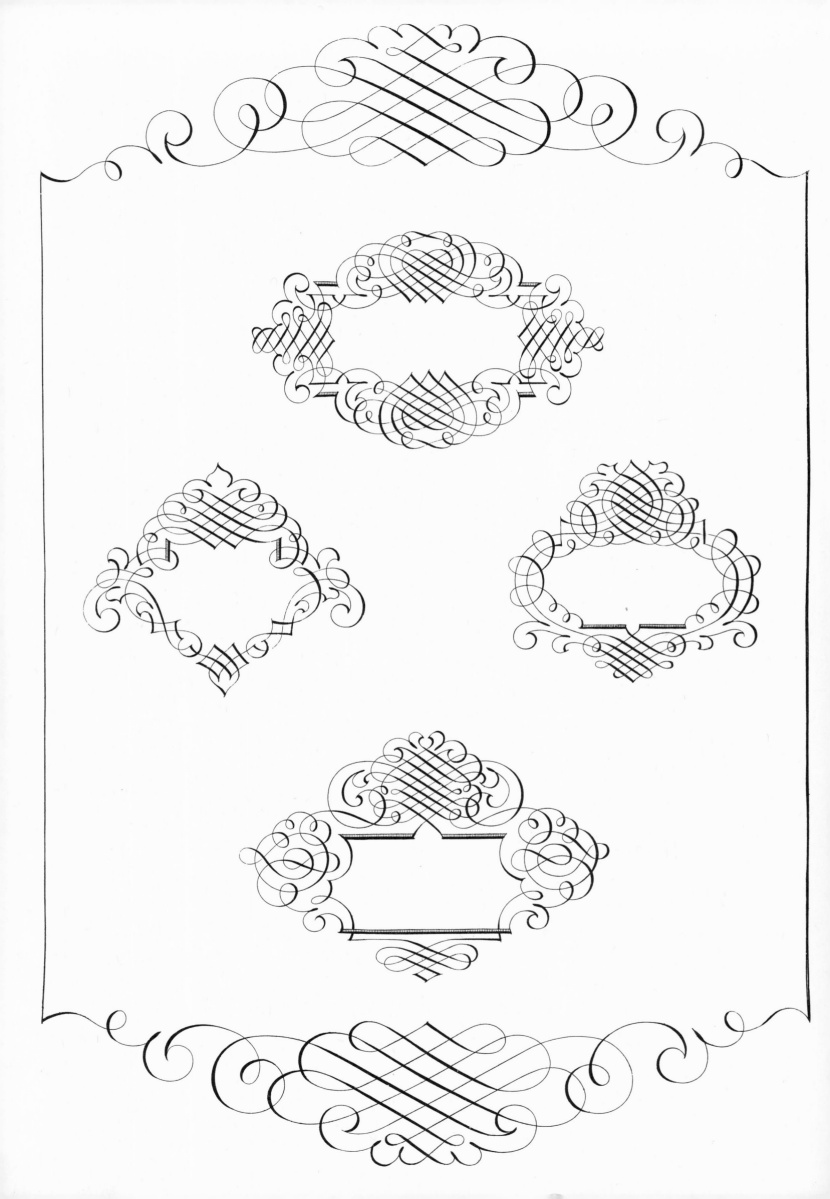

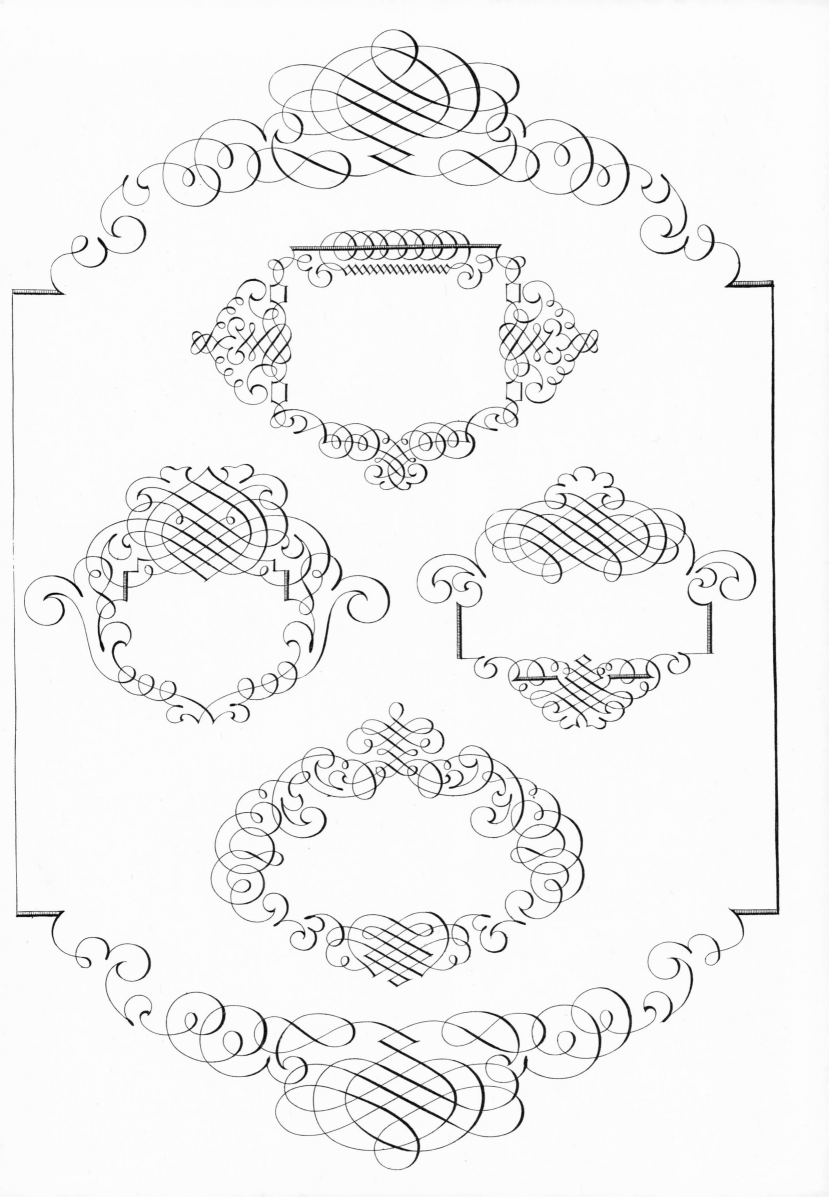

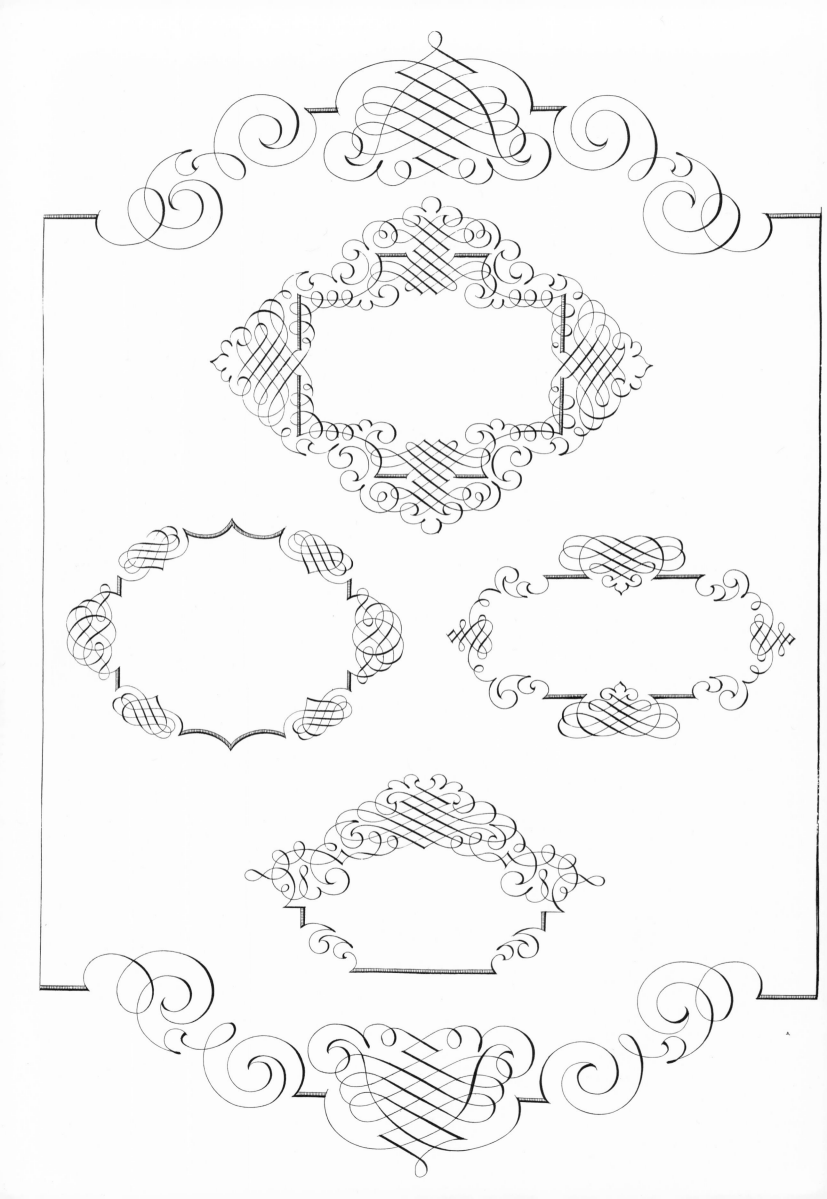

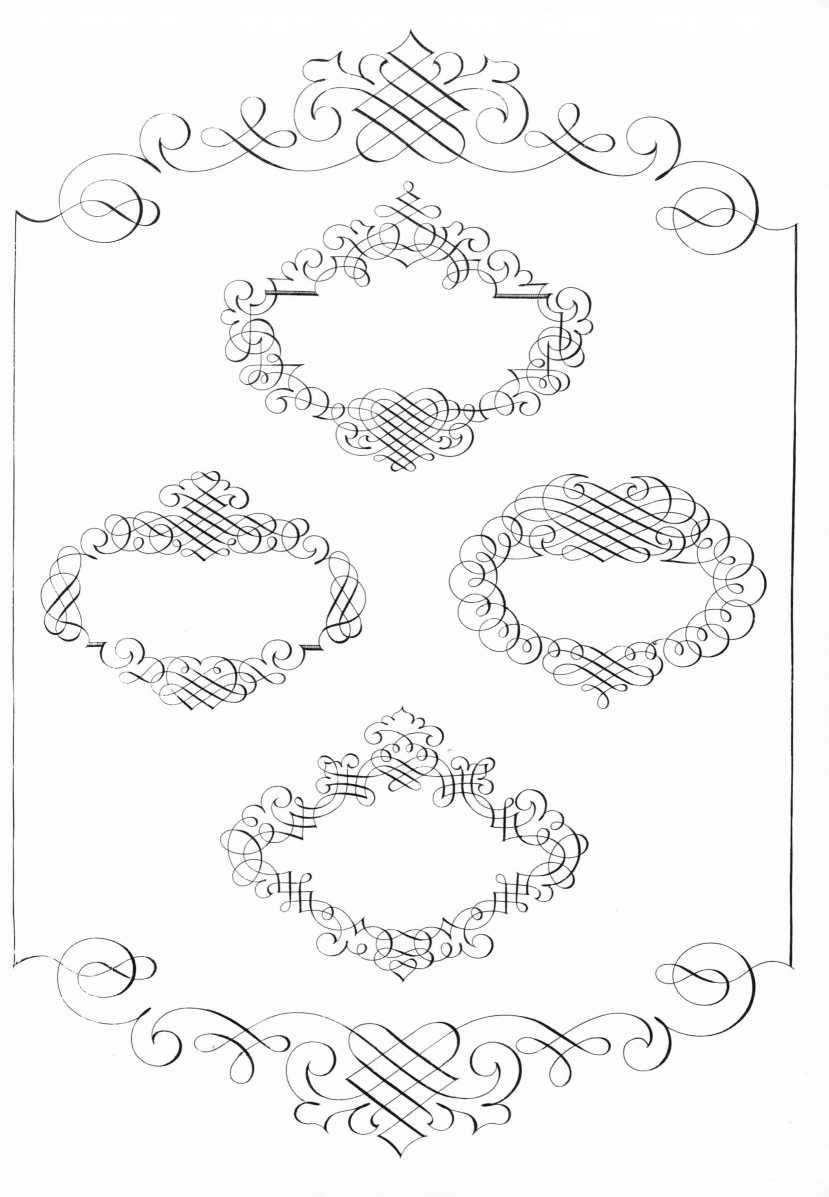

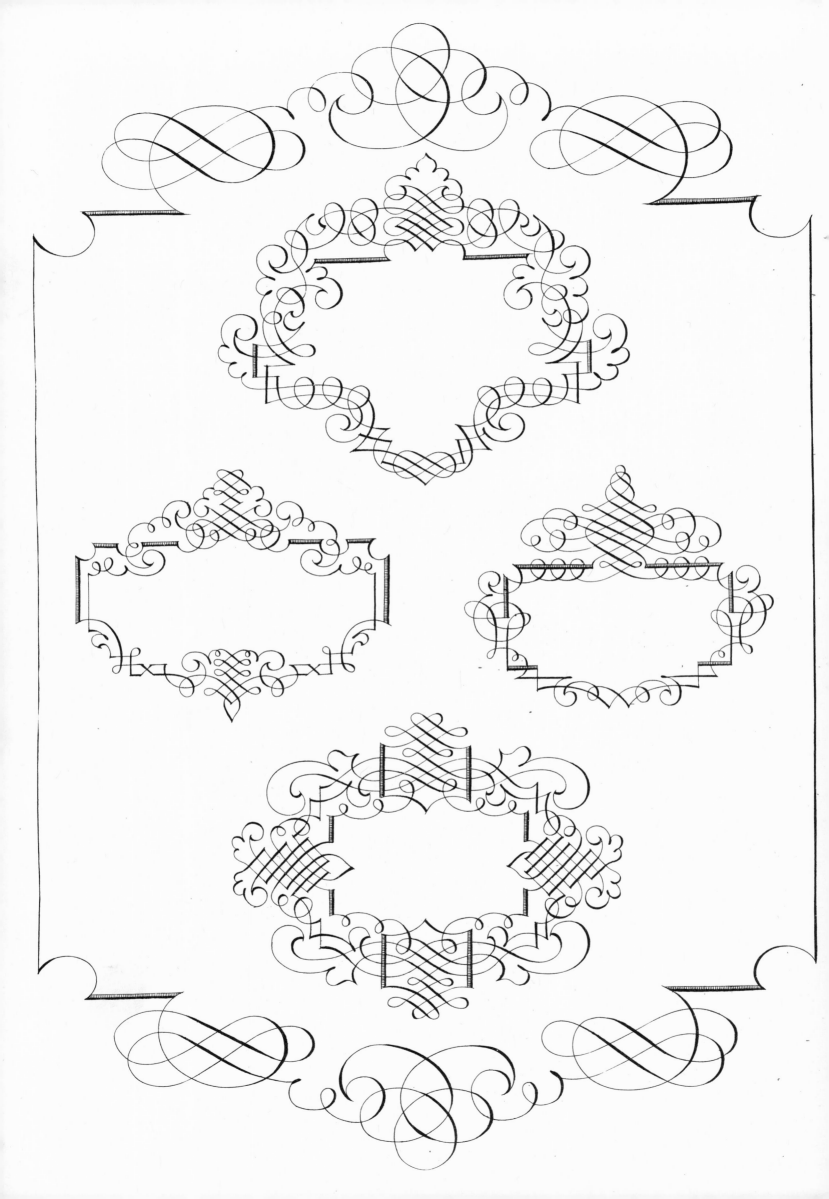

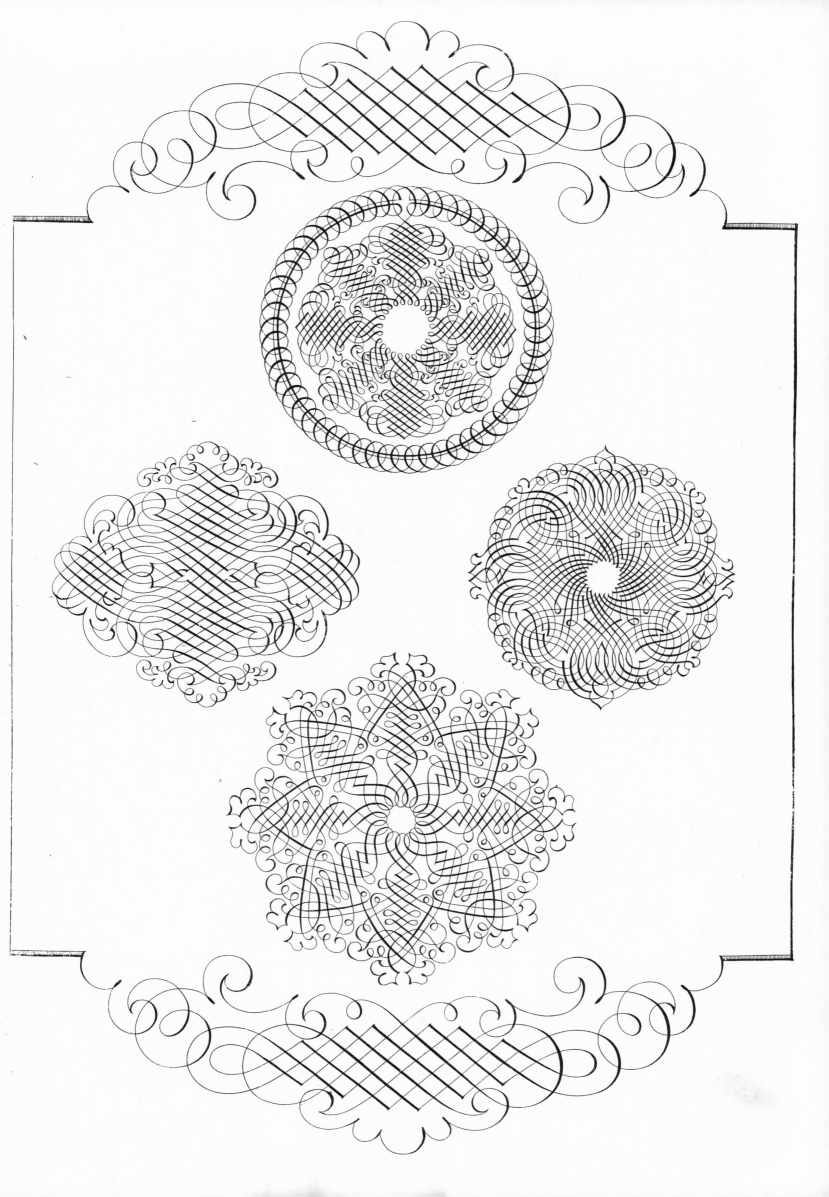

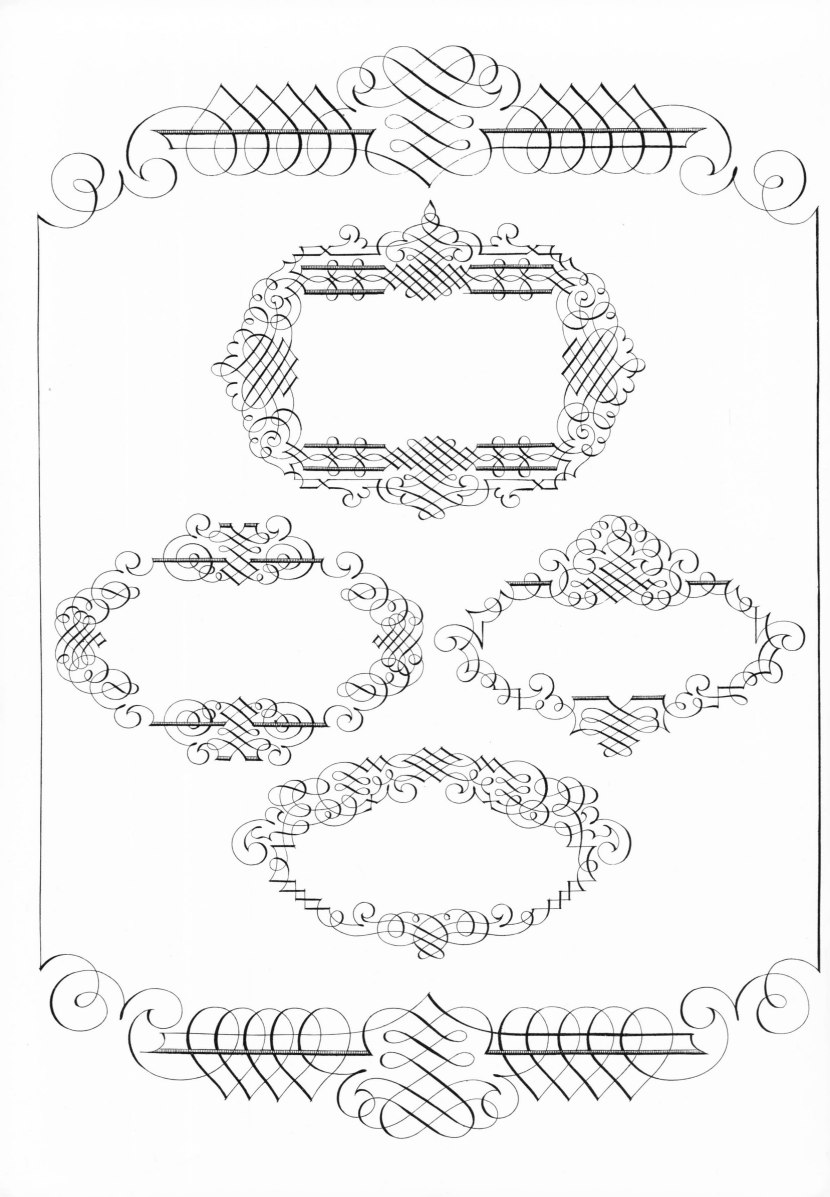

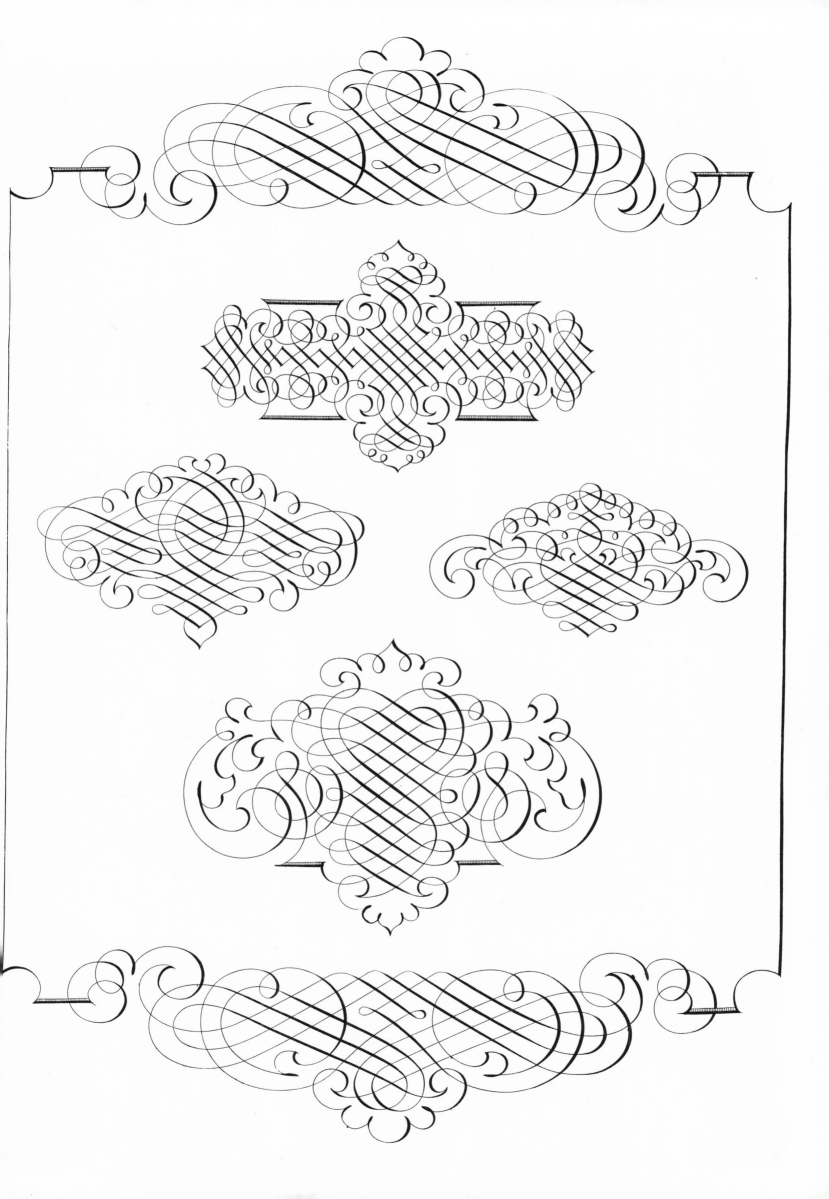

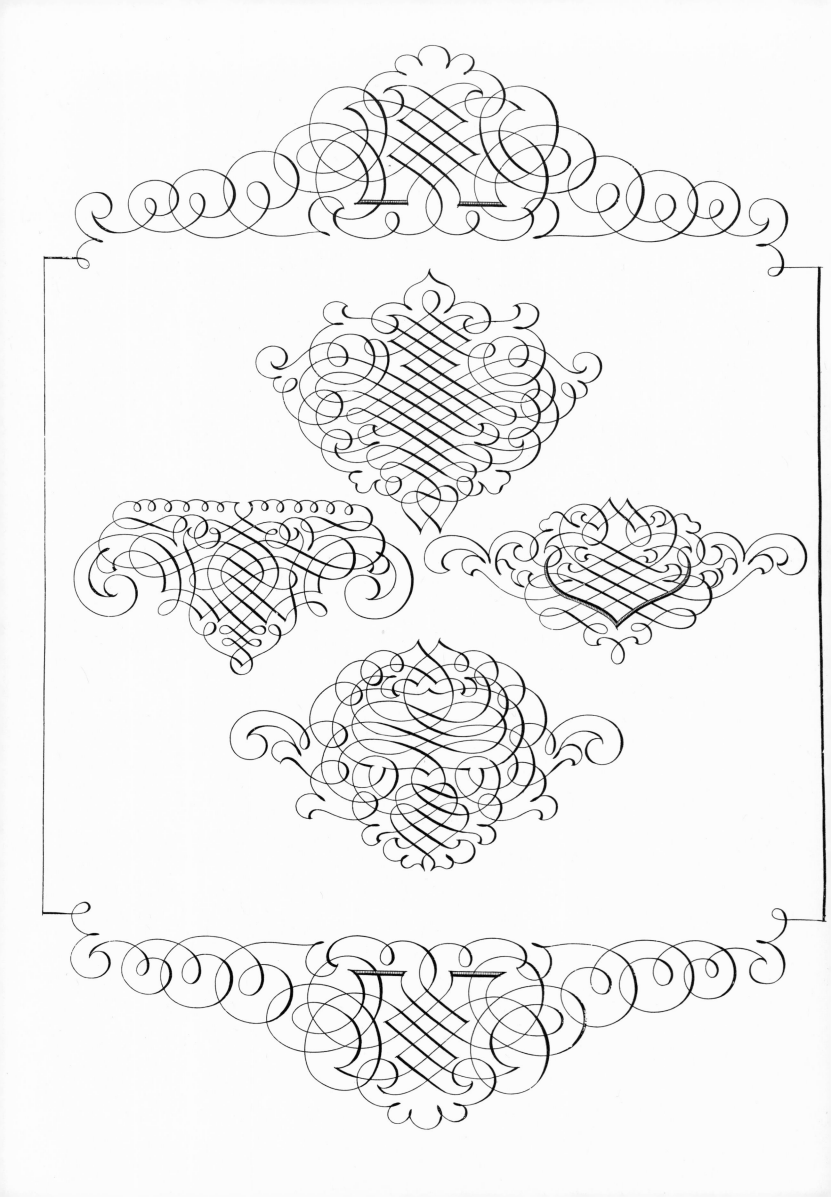

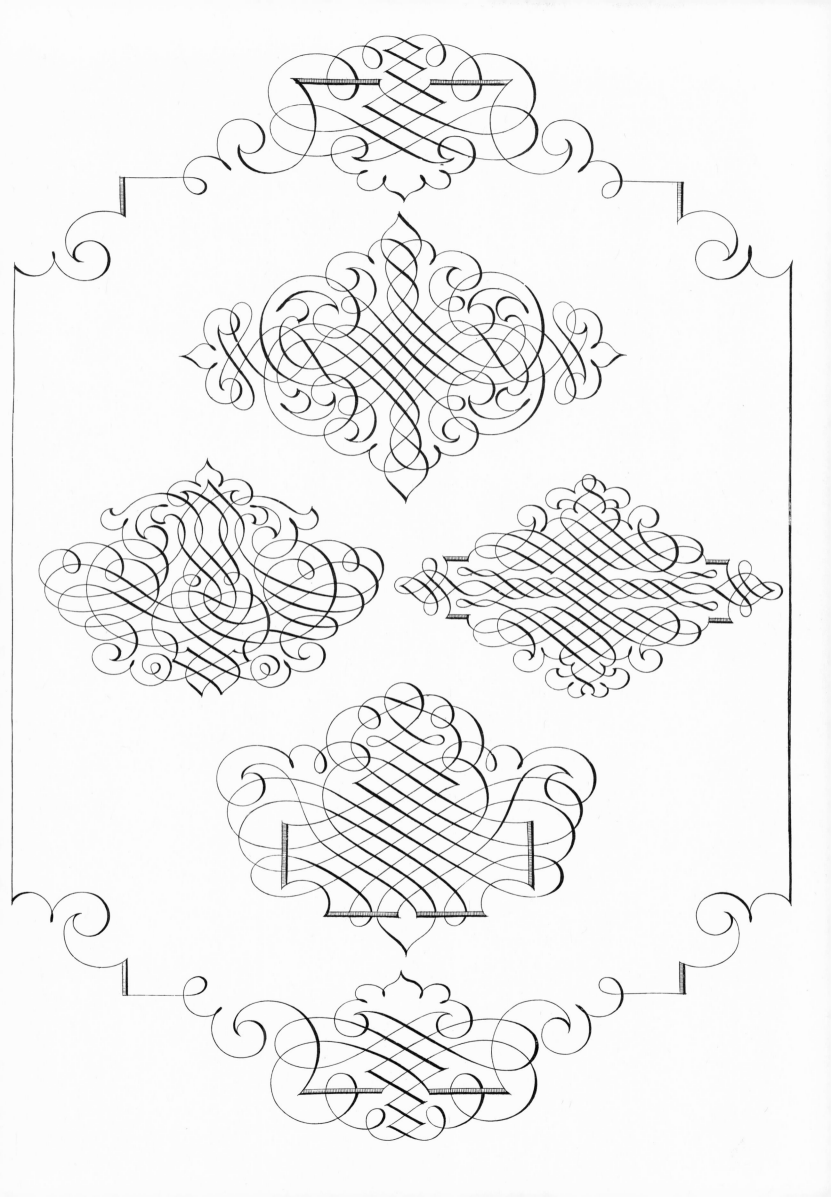

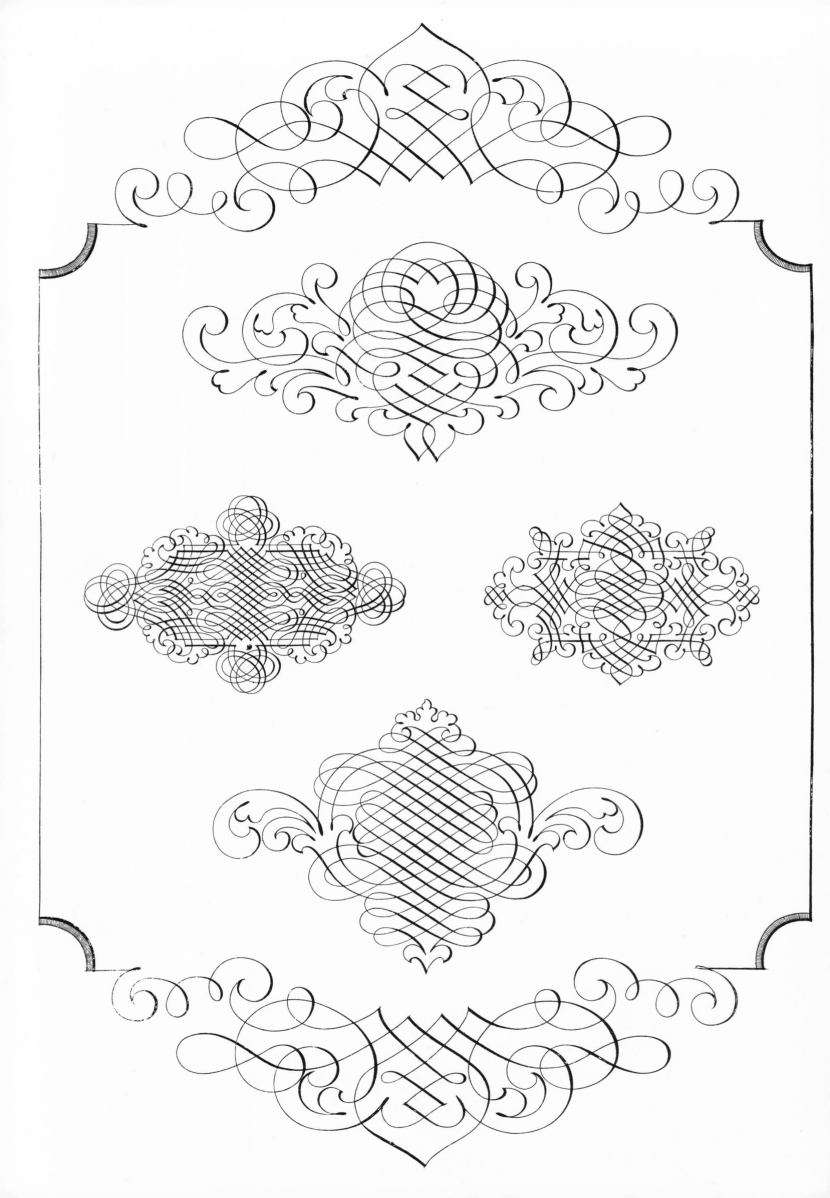

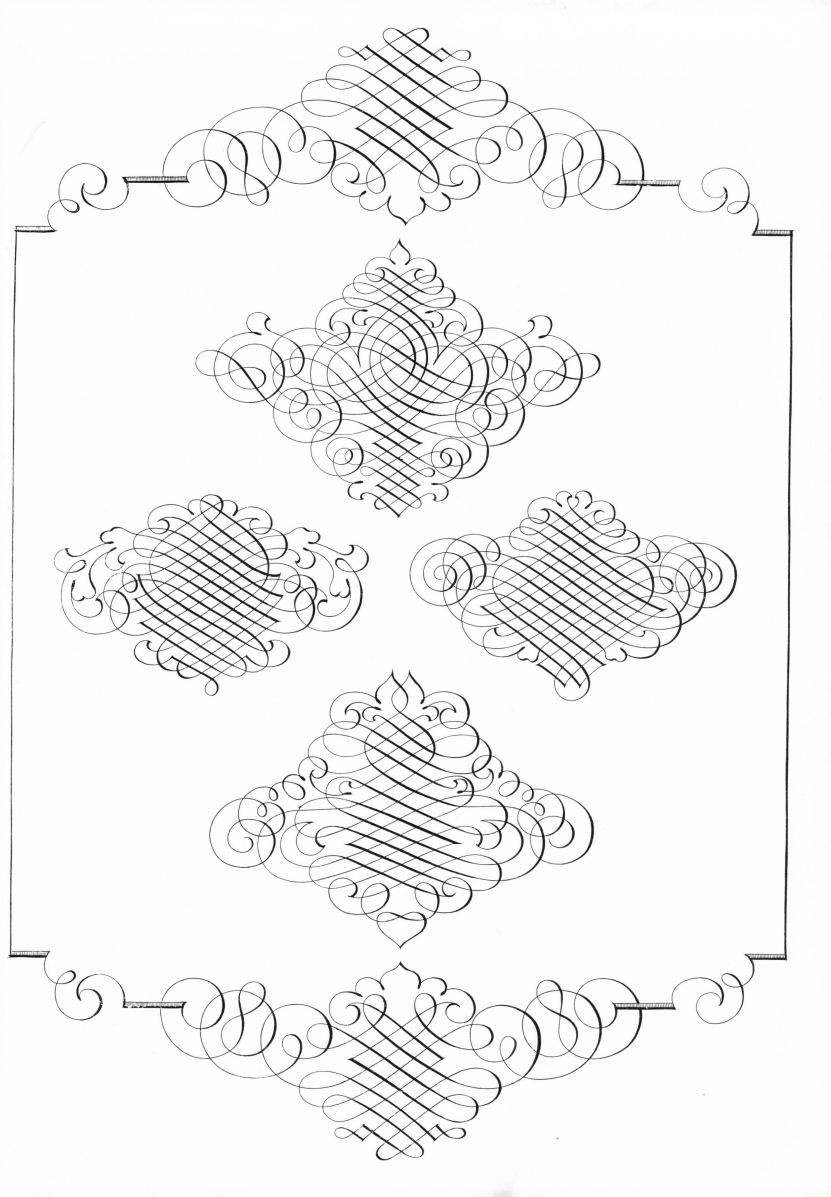

INVENTORY 74

FALL 77

INVENTORY 1983

1